The complete paintings of

Michelangelo

Introduction by **L. D. Ettlinger**

Notes and catalogue by **Ettore Camesasca**

Harry N. Abrams, Inc. *Publishers* New York

Table of contents

Photographic sources Colour plates : Archivio Rizzoli ; De Antonis, Rome ; Del Priore, Rome ; Novarese, Florence.
Black and white illustrations : A.C.L., Brussels ; Alinari, Anderson, Brogi, Florence ; Gabinetto Fotografico Nazionale, Rome ; National Gallery, London ; Royal Academy, London ; Soprintendenza alle Gallerie, Florence ; Vasari, Rome.

Introduction

Today we regard Michelangelo as one of the great universal men of the Italian Renaissance, perhaps the greatest. Sculptor, painter, poet, architect — listing his activities in this way we imply no descending order. We would be hard put had we to decide whether he was above all else a sculptor or a painter. Yet he himself never had doubts about his true vocation and he insisted vehemently on being nothing but a sculptor. He never claimed to be an architect, and in old age he told a friend that as a youth he had just 'dabbled' in writing sonnets. Moreover, throughout his life he tried to evade commissions for painting. Still, if under pressure he finally had to accept them, they became a challenge of a particular kind. For he felt that such tasks pitted him against those upon whom he looked — often with quite unjustified venom — as rivals. Such an attitude of mind, however, did not originate in personal spite, for Michelangelo never thought of Leonardo and Raphael as rivals for the favours of a patron. To him they were contestants in a far more serious clash, one concerned with the very essence of art.

Michelangelo's only undisputed panel, the *Holy Family* for Agnolo Doni, was painted in Florence soon after Leonardo's return from Milan when the cartoon with the *Virgin and Child with St. Anne* became the talk of the town. In later years Michelangelo claimed that he had undertaken this picture in order not wholly to give up painting. The phrase is significant and hints at the challenge he must have felt on seeing Leonardo's work. For a family idyll has been transformed into an intricate configuration of intertwined bodies, where nevertheless every movement and gesture has its psychological meaning. That clearly is a comment on Leonardo's no less complicated composition. But where the painter had avoided firm outlines in order to fuse his figures the better, the sculptor, modelling each of them with almost agressive firmness, has insisted on their separate entities.

The commission to paint the *Battle of Cascina* for the Sala del Gran Consiglio in the Palazzo Vecchio brought Michelangelo into direct competition with Leonardo who was to paint there the battle of Anghiari, and the two frescoes, had they ever been completed, would have been seen side by side.

Leonardo's theme characteristically was a fierce cavalry encounter — a contemporary called this expressive battlepiece simply 'The Horses of Leonardo' — set in a dust- and smoke-laden atmosphere, allowing the painter to employ every one of his refinements. Michelangelo, on the other hand, obsessed by his aim of encompassing a world through the rendering of the human figure, never took any interest in atmosphere, pictorial space and all the other preoccupations of Florentine Renaissance painters. It is clear from Vasari's account that horses took a secondary place in his battle, and although he chose a group of *Bathing Soldiers* surprised by the call to battle for the most prominent position in the fresco, there was no sunlit Tuscan landscape, only a dazzling, if austere, display of athletic bodies on a rocky ledge above a narrow strip of water. It is a comment on Leonardo's methods, much harsher than any he ever expressed in words. These *Bathing Soldiers* are the only part of Michelangelo's composition definitely known to us through a later copy, but there seems some historical justice in this survival. The sculptor had refuted the exclusive claims made for the greater powers of painting.

The frescoes on the vault of the Sistine Chapel were Michelangelo's response to the rising fame of Raphael. As is well known, he firmly believed that Pope Julius's commission was due to an intrigue of Bramante's, who wanted to prove the superiority of the young painter from Urbino. Michelangelo did his best to get out of it, but when he had to give in his answer to the challenge was more subtle than before. This time there are no 'corrections', there is

not even any allusion to his alleged opponent. Instead he decided to be completely himself, to the extent even of dismissing all assistants. This has often been interpreted as a sign of irascibility or pride in technical skill. But we should seek the true reason on a deeper level. Artistic creation, conceived as a whole, demands the hand of the inventor and none other. Thus with these frescoes a point of greatest significance for both Michelangelo's personal and historical position has been reached, for now a work of art — whatever its content and purpose — is seen as the realisation of an intensely personal vision, and creativity and skill are matched in an hitherto unheard of fashion. The narrative scenes from the Old Testament, the Prophets and Sibyls, and the Ancestors of Christ, with their infinite variations of the human form, expressing so many actions and emotions, seem to seek out artistic difficulties. But they do so only in order to render their meaning more forcefully. With the *Ignudi* seated on the framing cornice the case is different. They serve no purpose in the narrow or iconographic sense. Michelangelo's biographer Condivi (who must have heard the master himself speak on this matter) already makes this point and adds significantly, 'in all of them Michelangelo showed the highest art'. Yet in a deeper sense these 'beautiful youths' (as Vasari called them) have their definite place in the story of the Creation. The most perfect human form was to Michelangelo the most deeply felt truth of God's creation, and the artist as a second creator had to make this divine revelation manifest. Thus these at first sight seemingly irrelevant and decorative figures paradoxically demonstrate that art is not an end in itself.

While at work in the Sistine Chapel Michelangelo met Duke Alfonso d'Este and rather surprisingly promised him a painting. Less surprisingly he did nothing to make good this promise until some twenty years later after a visit to Ferrara when he was prevailed upon to paint a *Leda* for the Duke. Through a series of misunderstandings and misfortunes the picture was never delivered and is now lost. We only know it from copies and preparatory sketches.

We shall understand the choice of the unexpected mythological subject if we remember the kind of stimulus Michelangelo needed in order to paint. The Duke owned Giovanni Bellini's *Feast of the Gods* and Titian's *Bacchus and Ariadne*. Moreover, Michelangelo had been in Venice just before beginning work on his *Leda*. Now he was contesting Titian's standing as the supreme master of mythological *poésie*. He opposed to the magic charm of the colourful story teller, to the sensuous evocations of Titian's classical legends, his own intense yet severe vision of a divine union, taking as his model hardly by chance a classical relief of the utmost simplicity. 'He gives us indeed,' as Walter Pater observed, 'no lovely natural objects like Leonardo or Titian, but only the coldest most elementary shadowing of rock or tree; no lovely draperies and comely gestures of life, but only austere truths of human nature'.

When in 1533 the Medici Pope Clement VII invited Michelangelo to paint a *Last Judgement* on the altar-wall of the Sistine Chapel the master could hardly have resisted such a request from the member of a family with whom he had been closely linked since his youth. But once more he did his best to escape, and once more a challenge proved stronger than dislike of painting. The new monumental fresco in the Sistine Chapel meant competition with his own work of almost thirty years before. In fact, this time Michelangelo made some sketches even before a contract was signed and while he was still trying to tell the Pope that he had more pressing work in hand. When Clement's successor Paul III rather peremptorily demanded the execution of the *Last Judgement* Michelangelo complied without undue delay.

Where his early and late work would be seen side by side the master wanted to outdo himself. On the vault biblical scenes and single figures had been confined, being framed by a painted architecture. But the *Last Judgement* fills the immense wall without any interruption. Nor are Heaven and Hell described in the traditional manner. Human figures, their actions, movements, expressions and gestures are the sole elements of the composition. What cannot be said through them does not seem worth saying. Vasari summed up Michelangelo's intentions with a clarity which clearly betrays his source. He wrote: 'It is enough to say, that it was the purpose of this remarkable man to paint the most perfect and well-proportioned composition of the human body in varied attitudes, and to show the emotions and passions of the soul, displaying his superiority over all artists, his grand style, his nudes and his mastery over the difficulties of design'.

When Michelangelo undertook his last monumental commission, the frescoes for the Capella Paolina, he was almost seventy years old, and he confessed that they were hard labour since fresco painting is not

suitable work for an old man. Vasari, noting the austerity of these pictures, rightly felt that the lack of trees, buildings, and landscapes had to do with Michelangelo's quest for perfection through the human form alone. Even here, in his old age, he followed the dictate of his own mind, not the general trend of Renaissance taste, which asked for a colourful setting.

We have two contemporary biographies of Michelangelo, and they differ significantly in the account of his early training. Vasari, careful historian as he was, spoke of an apprenticeship with Domenico Ghirlandajo and published the contract drawn up between Michelangelo's father and the painter. Ascanio Condivi, writing his *Life* very much at the old master's command, on the contrary stressed that young Michelangelo had no assistance from Ghirlandajo and was largely self-taught.

Neither ingratitude nor dislike for all kinds of painting can have caused the latter version. The old Michelangelo, without any conscious attempt at falsification, saw his youth in the light of later convictions. The artist, interpreter of divine inspiration, owed everything to God and his own ability. Masters were therefore nothing more than insignificant teachers of skills.

Much has been made of Michelangelo's Neoplatonism. But this philosophy, which he had first met in the circle of Lorenzo the Magnificent, did not furnish him with an esoteric iconography. Rather a neoplatonic sense of beauty informs his art as well as his concept of the role of the artist. It made him devote to painting the same seriousness of purpose and principles which he applied to the art which was nearer to his heart, to sculpture — the supreme rendering of man as God's noblest creation.

L. D. ETTLINGER

Michelangelo *An Outline of the Artist's Critical History*

It is probable that, in the field of representational arts, no one has evoked such a gigantic mass of opinions, interpretations and hypotheses as Michelangelo, who, when barely thirty years old, was introduced by Gonfaloniere Soderini to the latter's cardinal brother as 'a good young man ... unique at his art in Italy, and perhaps even in the world'. On the other hand, despite the extraordinary accumulation of opinions, it is possible to perceive a main trend, which, starting with the hyperbolic praise of his contemporaries, leads to Vasari's discerning decantations, and then rises to new heights in subsequent criticism — from Armenini to Milizia — often arousing considerable favour despite a diminishing awareness of the artist's genuine qualities. This applies, however, when, filtering through the absurd comparison between Michelangelo and Raphael (which seemed *de rigueur* for centuries, a comparison started by Pietro Aretino, who had a personal grudge against Buonarroti), criticism does not degenerate into denials that are almost always obtuse,

because of their moralistic and pietistic inspiration.

It was to be the concern of Michelangelo's Romantic interpreters — from Stendhal to Shelley and beyond — to reevaluate Michelangelo for what they managed to find in him that was 'picturesque' and conceptual even though this provided a starting point for subsequent lucubrations of an ethical-spiritual nature and still inspires exegeses obscured by pedantry. Nevertheless, following in the footsteps of Montégut, Dvorák, Wölfflin and others, and as expressed by Voss, Bertini, Briganti, von Einem, Ragghianti, etc., albeit with results of varying significance, criticism finally seems to have achieved some insight into the Master's artistic personality. Such a commitment is to be credited, among other things, with the overcoming of certain 'motifs' — 'terribilità' and the like — which go back at least to Vasari and which, typical as they were for centuries, head various paragraphs of the present *Outline* and are, moreover, reflected in the opinions expressed on the single works.

Themes

Innovation

... the idea of a new nature lives hidden in your hands ... It is a great miracle that Nature, which cannot place a thing so loftily that you do not follow it with great skill, is unable to impress upon its works the majesty contained within the immense power of your style ...

P. ARETINO, letter to Michelangelo, 16 September 1537

... [Dante] was yet truly the first who, through the aforesaid wonderful union, led poetry to so high a grade that he can sooner be admired than equalled; and you, although before you and in your own times some have worked with very great praise in any one of the three arts, yet alone and before all others, wondrously embracing them all within yourself, you have so exalted the glory of those arts that one can and should sooner learn from you than hope to equal you.

C. LENZONI, *Difesa della lingua fiorentina*, Florence, 1556-57

Michelangelo, having vigorously overcome all obstacles, and similar to a thunderbolt, has dazzled the entire world with his immense style ...

RICHARDSON père et fils, *Traité de la peinture et de la sculpture*, Amsterdam, 1728

Our art ... now assumes a rank to which it could never have dared to aspire, if Michelangelo had not discovered to the world the hidden powers which it possessed.

J. REYNOLDS, Discourses Delivered to the Students of the Royal Academy, London, 1790

.... having acquired a deep knowledge of the organic forms of the structure of human bodies and the entire mechanism of their movements, having pondered the laws of optics and perspectives, which taught him to represent objects seen from any point, he left to more timorous minds that simplicity of outline and of movements, which up till then had still endowed all the productions of the arts with something precious; and proudly scorning any sort of servile dependence, he devoted himself to a completely new and daring style ...

L. CICOGNARA, *Studio della scultura dal suo risorgimento in Italia fino al secolo di Canova*, Venice, 1813-18

Aeschylus and Buonarroti, preferring a bold style, carved a new path for imitation. Man as portrayed by them has gigantic proportions: in both you can see the same scorn of the pleasant, and dangers sought for glory's sake. Both startled the soul of their contemporaries ...

G. B. NICCOLINI, *Del sublime e di Michelangiolo*, Florence, 1825

Terribilità

... he gave to his figures a form of the terrible extracted from the deep secrets of anatomy, understood by very few others, a form that is slow but full of dignity and majesty ...

G. P. LOMAZZO, *Idea del Tempio della Pittura*, Milan, 1590

Like Mozart in the statue in *Don Giovanni*, Michelangelo, aiming at terror, has gathered all that could displease in every aspect of painting : drawing, colour, *chiaroscuro*; and yet he has succeeded in moving the viewer.

H. BEYLE (STENDHAL), *Histoire de la peinture en Italie*, Paris, 1817

[Michelangelo] seems to me to have no sense of moral dignity and loveliness : and the energy for which he has been so much praised, appears to me to be a certain rude, external, mechanical quality.　P. B. SHELLEY, letter to Leigh Hunt, 3 September 1819

There are souls from which the impressions spring like lightning and whose actions are like bursts and flashes. Such are the figures of Michelangelo ... all sons and daughters of a colossal, militant race, for whom, however, their age has preserved the smile, the serenity, the pure joy, the grace of Aeschylus' Oceanids and of Homer's Nausicaä.

H. TAINE, *Voyage en Italie*, Paris, 1866

This loftiness he did not seek in the pathetic, but rather in the formidable; not that which rises from the mysterious majesty of a starry night, but rather that which erupts from a stormy sea, on which thunderbolts fall and on which float the corpses of the shipwrecked.
A. ALEARDI, in 'Relazione del Centenario di Michelangiolo ... 1875', Florence, 1876

Anatomy

Buonarroti justly perceived that the modern painters, and sculptors and also, as far as can be seen, the ancient ones, had on any other subject pursued and achieved some perfection, but that the human figure had not yet been seen or known by any in its perfect proportion, and he realized clearly that this could only have been due to the difficulty of its composition. And therefore, very ingenious as he was, he resolved with great skill and long study to take up and put into execution that which, perhaps because of its difficulty, had never been dared or attempted by others.

V. DANTI, *Il primo libro del trattato delle perfette proporzioni*, Florence, 1567

... to display the perfect knowledge he had of anatomy, he was slightly inclined to go to extremes and throw the muscles into relief as much as possible, to make them appear prominent and vigorous in those bodies where nature had made them slender.
G. P. LOMAZZO, *Trattato dell'arte della pittura*, Milan, 1584

... It is as though he had been afraid that no one would notice how profound a knowledge he had of this subject, since he threw into such vigorous relief the various parts of the body, that he seems to have been unaware of the existence, above the muscles, of the skin intended to attenuate them.

R. DE PILES, *Abrégé de la vie des peintres*, Paris, 1699

[A] preacher ... said publicly from the pulpit that, in order to paint a dying Christ, Michelangelo had caused a poor peasant to die a cruel death on the cross; and yet there are those credulous enough to hold this to be true ...

N. GABBURRI, letter to Mariette, 4 October 1732

That great artist sought the origin of beauty and deemed to have found it by means of anatomy, on which he carried out his greatest study, and he attained such excellence that he was immortalized by the new path he carved, although he did not find what he had sought : namely beauty ...

R. MENGS, *Opere*, Bassano, 1783

Solely given over to anatomical expression, he never knew true expression, moral expression, which is the great art of making visible the passions at their every level ... Hence the tedious monotony of his works ...

F. MILIZIA, *Dizionario delle belle arti del disegno*, Bassano, 1797

I really would not know what to understand by what you term Michelangelo's anatomical knowledge. It seems to me that he has purposely chosen twisted and convulsed movements ... just to have the opportunity of representing ... the most prominent parts and muscles, informing them with an unnatural violence.　A. CANOVA, letter to Cicognara, 25 February 1815

It looks as though, when making an arm or a leg, he only thought of that arm or of that leg, wholly ignoring any relationship, not merely to the action of the painting, but even to that of the figure whose limbs he was drawing. It must be admitted that some parts treated in such a way, in keeping with such exclusive intentions, are fascinating in themselves. Here resides his great merit: to have endowed with greatness and *terribilità* even an isolated limb.　E. DELACROIX, *Journal* (1822-63)

The Greek and Venetian treatment of the body is faithful, modest and natural; but Michael Angelo's is dishonest, insolent, and artificial.

J. RUSKIN, *The Relations between Michael Angelo and Tintoret*, London, 1872

In him anatomy becomes music. In him the human body is an *almost purely* architectural material. In the frescoes and in the statues the bodies are made to move outside their logical motif, and the melodic lines of the muscles follow one another according to musical law, not to a logical representational law.

U. BOCCIONI, *Dinamismo plastico*, Milan, 1911

Drawing

The difficulty of the contours (the highest science in the subtlety of painting) comes so easily to you, that you enclose within the outline of the bodies the culmination of art, a thing which art itself acknowledges as impossible to realize to perfection ...　P. ARETINO, 1537

Along with a fiery imagination, a ready and keen mind, he possessed a heart that was ignorant of the concepts of beauty and of sweet grace.

F. W. B. VON RAMDHOR, *Ueber Malerei und Bildhauerarbeit in Rom für Liebhaber des Schönen in der Kunst*, Leipzig, 1787

Michelangelo is grace at least as much as he is strenth.

E. MONTÉGUT, in 'Revue des Deux Mondes', 1870

Colour

... in colouring he has attended to the violence and depth of the design, partly neglecting the quality of the colours and pursuing only caprice and whimsy. Thus has he made the figures so beautiful and vigorous in keeping with his purpose, that whoever sees them, no matter how intelligent, admits that nothing greater could be done, in design and in colouring ...

G. P. LOMAZZO, 1590

... he ignored all that concerns colour.

R. DE PILES, 1699

... he was incapable of imitating the colours of nature and, like many others who flourished before and after him, did not understand aerial perspective ...

G. DELLA VALLE, in *Vite ... scritte da M. Giorgio Vasari*, Siena, 1791-94

What is not sufficiently known ... is that Michelangelo, a prodigious designer, was also a colourist, a colourist of light.

G. BLANC, 'Relazione del Centenario di Michelangiolo ... 1875', Florence, 1876

His works

Doni Tondo

... so conceived by industry and supreme skill is this painting, that the mind would tire of praising it, before exhausting the reasons for praise.

F. BOCCHI, *Le bellezze della città di Firenze*, Florence, 1591

The colour masses lack harmony; and they seem to have been placed at random.

RICHARDSON père et fils, 1728

Compared with the best artists of each school ... [his art] appears as the most skilful but the least attractive; its author stands out among all the others as the best designer but the weakest colourist.

L. LANZI, *Storia pittorica della Italia*, Bassano, 1795-96

The problem of the recherché pose .. is not entirely solved: with such ends, one should not paint Holy Families.

J. BURCKHARDT, *Der Cicerone*, Basel, 1855

In spite of *Messieurs les Connoisseurs*, and Michelangelo's fame ... for instance, here is the Blessed Virgin, not the '*Vergine santa d'ogni grazia piena*', but a Virgin whose brick-dust coloured face, harsh, unfeminine, and muscular, masculine arms, give me the idea of a washerwoman (*con rispetto parlando!*); an infant Saviour with the proportions of a giant; and what shall we say of the nudity of the figures in the background, profaning the subject and shocking at once good taste and good sense?

A. JAMESON, *The Diary of an Ennuyé*, Boston, 1865

This fabulous assemblage of balanced energies, the symbol of the ideal of the most mature Renaissance and a Mirror of the heroic and passionate soul of the artist .. .

M. MARANGONI, *Saper vedere*, Milan, 1933

Nothing could be less 'spiritual' than this composition.

M. BRION, *Michel-Ange*, Paris, 1939

The battle of Càscina

... all the attitudes and emotions that might occur in such circumstances, were expressed in the most natural way.

S. FORNARI, *Sposizione sopra l'Orlando furioso*, Florence, 1550

From which very skilful cartoon drew inspiration all those who later put their hand to a brush ...

A. CONDIVI, *Vita di Michelagnolo Buonarroti*, Rome, 1553

... never among the works of the masters of antiquity nor of any other modern ones, was any seen that reached so high a mark ...

B. CELLINI, *Vita* (1559)

It was executed with such subtlety, with such diligence, elegance and skill, that when it was unveiled in the Pope's chamber, where those who were in Florence had assembled in incredible numbers, all the artists remained spellbound, numbed and frightened and all were full of amazement; and raising their eyes to heaven in wonder and tightening their lips, and almost struck dumb, they stated that never before had been created, never since would be created ... a thing that could even resemble it, much less equal it.

B. VARCHI, *Orazione funerale ... nell'essequie di Michelagnolo Buonarroti*, Florence, 1564

Sistine ceiling

... in comparison with Michelangelo's, it must be admitted that all other things are merely daubed; and although they can benefit from the example of such a unique teacher, nevertheless they were unable to imitate him ...

Il libro di Antonio Billi (16th century)

This ceiling, [like] all of Michelangelo's things, is wonderful and as rare as it is possible to be, and the finest that has been seen in our times and perhaps even in all past centuries.

ANONIMO MAGLIABECHIANO, *Notizie sopra l'arte* (1537-42)

... all the manners, all the complexions, all the movements, all the attitudes, all the possible postures of a human body and all the emotions of the soul are here displayed ... so natural, so alive, so apt, that it could almost be said that nature itself could hardly add to them ... M. TRAMEZINO, *Roma trionfante*, Venice, 1544

... no painter should strive any longer to find novelty and inventions of poses, attire worn by the figures, new modes of expression and *terribilità* of variously painted things; because all the perfection that can be given to a thing done in this profession, he gave to this work. G. VASARI, *Le vite*, Florence, 1568

11

All this vault ... is without effect, the colour verges on brick and grey; but the design makes up for these shortcomings ...

M. DE LALANDE, *Voyage en Italie*, Paris, 1768

The Sistine Chapel is the production of the greatest genius that ever was employed in the arts ...

J. REYNOLDS, letter to J. Barry, 1769

In this great work [Michelangelo] had the courage to take the bandage of ignorance from the eyes of the world (which had been hitherto captivated only with the brightest ultramarine azure, with the most glaring lac in grain, and with blazing vermilion heightened with gold itself) and the success to introduce the true colours composed of simple earths alone.

C. ROGERS, *A Collection of Prints in Imitation of Drawings*, London, 1778

With respect to the colouring ... there is little attention to variety of tints, but a greatness and simplicity pervade the whole ... and the general effect is grand and harmonious.

R. DUPPA, *The Life of Michelangelo Buonarroti*, London, 1806

Colour would greatly impair that work : it would cease to be the mental vision of a fact that is above human concepts ...

G. B. NICCOLINI, 1825

One begins with confusion, reaches enthusiasm, concludes with annihilation. Michelangelo has surpassed man ...

A. DE LAMARTINE, *Vie de Michel-Ange*, in 'Cours familier de Littérature', XXVI, Paris, 1868

... Michelangelo's colour is an integral part of the composition, completing its meaning, and thus is Michelangelo again distinguished from any other painter ... At the first glance, we are fascinated; at the second, enchanted and — if I may use the expression — engarlanded : thanks to the insinuating magic of colour, this world of giants has become almost familiar.

E. MONTÉGUT, 1870

You can read all the treatises on the sublime, and you will be hard put to really understand this concept ... But lift your eyes to the Sistine ceiling; there is the sublime, there the disproportion between our weak being and the infinite forces of an idea that confounds and annihilates you with its immeasurable greatness.

E. CASTELAR Y RIPOLL, *Recuerdos de Italia*, Madrid, 1872

They [the Sistine ceiling frescoes] have been criticized as low in scale. This is true of their present state, but when first painted, they were forcible and brilliant.

C. H. WILSON, *Life and Works of Michelangelo Buonarroti*, London, 1876

No words can describe the beauty of the flesh-painting, especially in the figures of the Genii [the *Ignudi*], or the technical delicacy with which the modelling of limbs, the modulation from one to another, have been carried from silvery transparent shades up to the strongest accents.

J. A. SYMONDS, *The Life of Michelangelo Buonarroti*, London, 1893

By means of dark colour in the secondary zones — the background of the roundels is violet, while the triangular one of the thrones is green — he emphasizes the principal figures, which are light in colour; thus the internal rhythm of the composition moves from the centre to the sides, then again to the centre, without pause ... It is truly a miracle that so multiform and complex a whole could have been assembled so as to bring about a sense of unity ... The elegant and many-coloured variety of the fifteenth century would certainly have been out of place in this case ...

H. WÖLFFLIN, *Die klassische Kunst*, Munich, 1899

... the abnormal ... becomes in her [the Cumean Sibyl] monstruous deformity ... But in this indulgence there is nothing prosaic : the intellectual inspiration, though dilating the datum of sense, achieves a complete fantastic concreteness.

A. BERTINI, *Michelangelo fino alla Sistina*, Turin, 1942

Both spandrels [*Brazen Serpent* and *Haman*] are united by the Cross [of the *Judgement*], the instrument of purification in one, deliverance in the other. Both point toward Jonah and his gourd vine. Through the purging of the soul and the healing of the wounds of sin (*Dic verbum et sanabitur anima mea*) the sacrifice of Christ under the overshadowing arms of the Creator achieves man's salvation in the draught of fishes. And the parable of the green and withered Tree moves to completion, for the Tree of Knowledge in the *Crucifixion of Haman*, the Tree of Life in the *Brazen Serpent*, are united and fruitful at last in the gourd vine of *Jonah*, the oak of [pope] Julius II that is to feed the celestial sheep.

F. HARTT, in 'The Art Bulletin' 1950

... the spandrels and the lunettes of the *Salvations* and of the *Ancestors*, in which Michelangelo achieved his incredible salvaged remains of early biblical history by dint of sarcasm and of blasphemy.

R. LONGHI, in 'Paragone', 1953

Last Judgement

Oh! sacred Rome at last you may well say:
No such triumphant pride was given me
by Caesar or by any famous Augustus.

G. PORRINO, sonnet for the unveiling of the *Judgement* (1541?)

... a thing of such extremely varied attitudes, that he who has not seen it could never picture it.

ANONIMO MAGLIABECHIANO, 1537-42

... Although the beauty of the work is such as Your Lordship can imagine ... the Very Reverend Theatines are the first to claim that the nudes are inappropriate to such a place, since they display all their things ...

N. SERNINI, letter to Cardinal E. Gonzaga, 19 November 1541

The fame of the *Judgement* is ringing in my ears and I think that, given its beauty, on that day when Christ will come in His glory it will deserve that He impose on all to strike those attitudes, display that same beauty, and hell keep that darkness which you have painted, as they cannot be improved ...

A. F. DONI, letter to Michelangelo, 21 January 1543

... upon seeing your tremendous and venerable *Day of Judgement* my eyes were moistened by the waters of emotion.

P. ARETINO, letter to Michelangelo, April 1544

... there are a thousand heresies, signally St. Bartholomew's beardless skin ...

M. PITTI, letter to Vasari, 1 May 1545

... anyone who is still a Christian ... cannot but be truly dismayed both by the decorum disregarded in the martyrs and in the virgins, and by the attitude of the man being dragged down by his genital members, that even the brothel would shut its eyes in order not to see it.

P. ARETINO, letter to Michelangelo, November 1545

... he who sees that Papal chapel need look at no other painting, for it would not be worth it.

A. CALMO, letter to Michelangelo, 1552

I do not find it commendable that the eyes of children and of matrons and maidens should openly see in those figures the shamelessness which they display, while only the scholars can understand the profundity of the allegories which they conceal.

L. DOLCE, Dialogo della pittura, Venice, 1557

... no figure ... does the same thing as another, and none resembles another; and to achieve this [Michelangelo] has put aside devotion, reverence, historical truth and honour ...

G. A. GILIO, Due dialogi, Camerino, 1564

... His stupendous Judgement is now the norm and the model for all who strive to be painters.

P. MINI, Difesa della città di Firenze, Lyon, 1577

... in the whole world it is impossible to see anything more elaborate, more perfect, and more absolute.

J.-J. BOISSARD, Romanae urbis topographiae et antiquitatum, Frankfurt, 1597-1602

Referring to the covering of some of the figures in the Judgement ... [El Greco] burst out saying that, if the whole work were destroyed, he would make it, with propriety and decency, not inferior to that one in the quality of the painting.

G. MANCINI, Considerazioni sulla pittura (1617-24)

... one of the best paintings in the world.

H. PEACHAM, The Compleat Gentleman (1622)

The most important article of our faith ... was figured or, rather, disfigured, by that braggart of painting, Michelangelo ...

R. FRÉART, Idée de la perfection de la peinture, Le Mans, 1662

... in many of those figures there does not seem to be a good observance of perspective ... C. C. MALVASIA, Felsina pittrice, Bologna, 1678

... it is a confused theme, in which disorder is in its proper place ... colours without harmony ...

C. DE BROSSES, Lettres familières sur l'Italie (1739-55)

... the groups are so arranged that there is no link between them ... M. DE LALANDE, 1768

... a confused heap of figures with neither order nor colour ...

J.-O. BERGERET DE GRANCOURT, Voyage en Italie (1773-74)

When one thrills, when all the senses are startled, when an unrestrainable tumult breaks loose within the soul, one does not ask oneself how the artist worked, whether or not he abided by the rules ... Abbé HAUCHECORNE, Vie de Michel-Ange Buonarroti, Paris, 1783

I could only look and contemplate. The inner certainty and the force of the Master, his grandeur, are beyond expression.

W. GOETHE, Italienische Reise (1786)

Nowhere, perhaps, would it be possible to find a similar absence of moral or pathetic effects ...

A.-C. QUATREMÈRE DE QUINCY, Histoire de la vie et des ouvrages de Michel-Ange Buonarroti, Paris, 1835

... a colossal work that rises like a world in the annals of painting. E. DELACROIX, in 'Revue des Deux Mondes', 1837

... this Divine Comedy in action ...

C.-C. DE LAFAYETTE, Dante, Michel-Ange, Machiavel, Paris, 1852

I perceive in it nothing but startling details, startling, that is, like being punched; but interest, unity, attraction, are completely lacking. E. DELACROIX (1822-63)

It is impossible to conceive of anything loftier, anything more abstract: that Michelangelo was able to translate into such concrete form such a metaphysical concept, this alone would suffice to prove the force of his genius.

E. MONTÉGUT, 1870

... a cold and profane work ...

F. GREGOROVIUS, Geschichte der Stadt Rom im Mittelalter, Stuttgart, 1858-72

... it is like a boundless sculpture against a dark background, mysteriously illuminated here and there by an indescribable light ...

G. MONGERI, in 'Michelangiolo Buonarroti, Ricordo al popolo italiano', Florence, 1875

However great this peerless composition, however bold the skilful detail, the work lacks one quality: persuasive eloquence.

P. MANTZ, in 'Gazette des Beaux-Arts', 1876

Wonderful as the figures in the Last Judgement are for power and drawing, they are marked by ... monotony ...

C. H. WILSON, 1876

... this Italic Apocalypse ...

D. LEVI, La mente di Michelangelo, Milan, 1883

... convulsed and almost blasphemous peroration for an end-of-the-world that is not pagan, not Christian, but downright Italo-revolutionary. A. TARI, Saggi di critica, Trani, 1886

One feeling alone reigns, that of violent terror.

E. OLLIVIER, Michel-Ange, Paris, 1892

... it remains a cause for astonishment, rather than a source of emotions. L. ROGER-MILÈS, Michel-Ange, sa vie, son oeuvre, Paris, 1893

He felt the need to relieve his feelings in an immense play of masses ... to make use, in the actual representation, of all the possibilities of movement, attitudes, foreshortening and grouping of the nude human figure. He wanted to make these masses all-invading, he positively wanted to submerge the onlooker, and this he achieved. The fresco seems too large in relation to the setting; the extraordinary scene spreads incontinently ... The detail cannot acquire relief ...

<div align="right">H. WÖLFFLIN, 1899</div>

All these bodies no longer possess the perturbing charm of the ceiling paintings. Formidable as they are for proportions, they are only Michelangelo's imitation of himself.

<div align="right">J. DAVRAY, Michel-Ange, Paris, 1937</div>

That concentrated Michelangelesque will ... of grouping the figures in several non-communicating cells, constraining the forms within the close limits of groups which no longer had any relation of positive complement with the setting, but sought only a reciprocal rhythmic order ...

<div align="right">G. BRIGANTI, Il Manierismo, Rome, 1945</div>

Pauline chapel

Michelangelo has attended only to the perfection of art, for there are neither towns, nor trees, nor dwellings, nor even certain varieties and ornaments ...

<div align="right">G. VASARI, 1568</div>

In the tremendous Judgement he adopted a second, less admirable style, and in the Pauline Chapel ... a third, inferior to all the others.

<div align="right">G. P. LOMAZZO, 1590</div>

... paintings expressed with the power of very profound intelligence ...

<div align="right">F. SCANNELLI, Il microcosmo della pittura, Cesena, 1657</div>

... the languid remains of his power ...

<div align="right">M. PILKINGTON, The Gentleman's and Connoisseur's Dictionary
of Painters, London, 1770</div>

... the execution ... is deficient in spirit and energy.

<div align="right">J. S. HARFORD, The Life of Michael Angelo Buonarroti, London, 1857</div>

The absence of any study of nature is still more evident than in the frescoes of the Last Judgement ...

<div align="right">C. H. WILSON, 1876</div>

The suppleness, the elasticity, the sympathy with which Michelangelo handled the nude, have disappeared ...

<div align="right">J. A. SYMONDS, 1893</div>

It is no longer the classical style; but on the other hand it is not senile indifference either: in the power of the representation Michelangelo surpasses himself ... Forceful and imperious lines run through the painting like a flash; heavy and concentrated masses alternate with gaping voids.

<div align="right">H. WÖLFFLIN, 1899</div>

Nothing, in these two compositions, recalls the great Michelangelo: confusion in the whole, dryness of the details, inadequacy of the colours ...

<div align="right">G. CLAUSSE, Les San Gallo, Paris, 1900-02</div>

We find ourselves hesitant and pensive before the plastic concreteness and the grandeur of most of the figures ...

<div align="right">V. MARIANI, Gli affreschi di Michelangelo nella Cappella Paolina, Rome, 1932</div>

The shortcomings, concealed in the Judgement by the overwhelming qualities, infest the two frescoes of the Pauline Chapel ...

<div align="right">P. TOESCA, 'Michelangelo', Enciclopedia italiana, XXIII, Rome, 1934</div>

... extreme phase of the process of formal transformation already noted in the Judgement, a sorrowful and violent assertion of the expressionistic tendencies that are emphasized in Buonarroti's later works.

<div align="right">E. CARLI, Michelangelo, Bergamo, 1942</div>

... already in the Judgement the composition had been released from any complementary relation to the space that encloses it ... the motif of the isolated figures in the Pauline Chapel is no more than a subsequent development of such a compositional conception, which has not only been released from any complementary relation to the setting, but has reached the stage where it does not coincide in any way with the space it encloses.

<div align="right">G. BRIGANTI, 1945</div>

Conversion of St. Paul

... with a total lack of propriety [Christ] appears to come hurtling down from the sky in an unglorious attitude ...

<div align="right">G. A. GILIO, 1564</div>

The Fall of St. Paul cannot be represented with a power greater than this.

<div align="right">H. WÖLFFLIN, 1899</div>

The composition is articulated in single figures and in groups of figures which, through the cubist-oriented solutions and the centrifugal forces, make it more conspicuous, condensing in it an extraordinary tension of outlines.

<div align="right">M. DVORÁK, Geschichte der italienischen Kunst im Zeitalter
der Renaissance, Munich, 1927-28</div>

... it is as though the artist had tried to concentrate his power of expression into a whole that is polemically much more forceful than the action which takes place in the Judgement ...

<div align="right">V. MARIANI, in 'Il Vaticano' 1946</div>

... a funereal and disconsolate poem ... which reflects the sorrowful state of mind that characterised the artist's old age ...

<div align="right">E. CARLI, Tutta la pittura di Michelangelo, Milan, 1951</div>

Crucifixion of St. Peter

... with such a crowd of figures and such perfect design, and beautiful and vigorous colours, that undoubtedly art can rise no higher.

<div align="right">A. TAJA, Descrizione del Palazzo Apostolico Vaticano, Rome, 1750</div>

... The Crucifixion of Peter is a failure.

<div align="right">B. BERENSON, The Florentine Painters of the Renaissance,
New York - London, 1896</div>

This last fresco places us before a Michelangelo renewed in his late years, in possession of a spiritual certainty ... so grandiose and firm: the colour also contributes in increasing such a feeling of expressive assurance ... almost a confident return to the Florentine plasticity of the Quattrocento.

<div align="right">V. MARIANI, 1946</div>

The paintings
in colour

List of plates

In the captions at the foot of the colour plates, the number placed in square brackets after the title of each work refers to the numbering of the paintings followed in the Catalogue of works *(pages 85-106). The actual size (width) of the painting, or of the detail, reproduced is given in centimetres on each plate.*

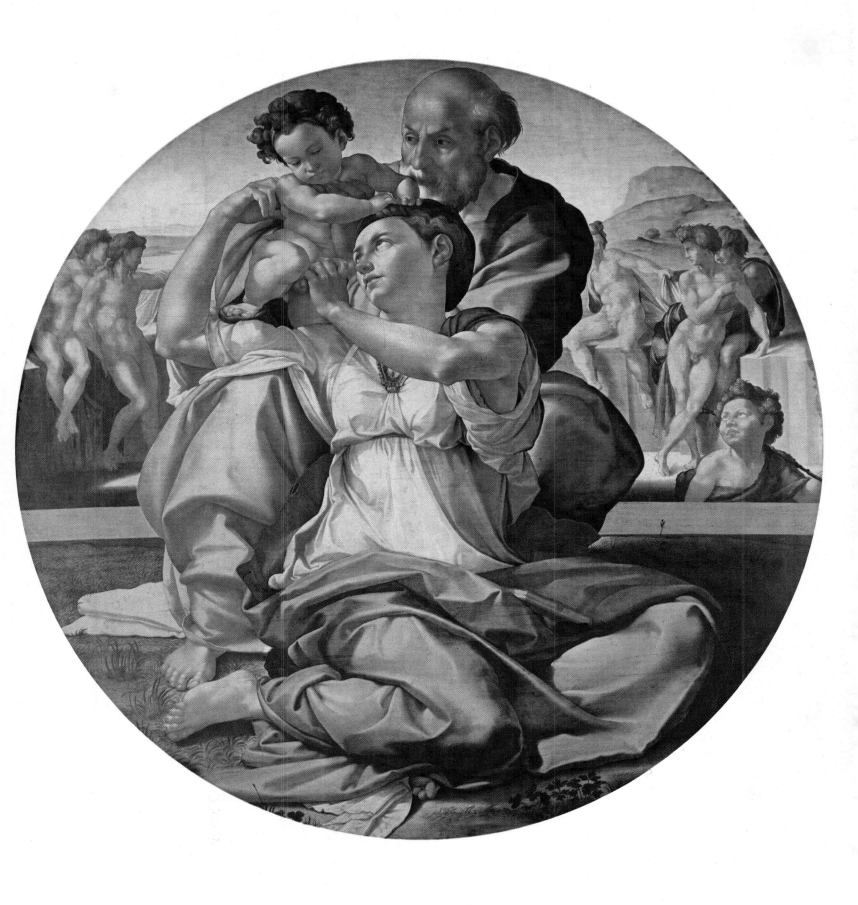

PLATE I DONI TONDO Florence, Uffizi [No. 8]
Whole (diameter 120 cm.)

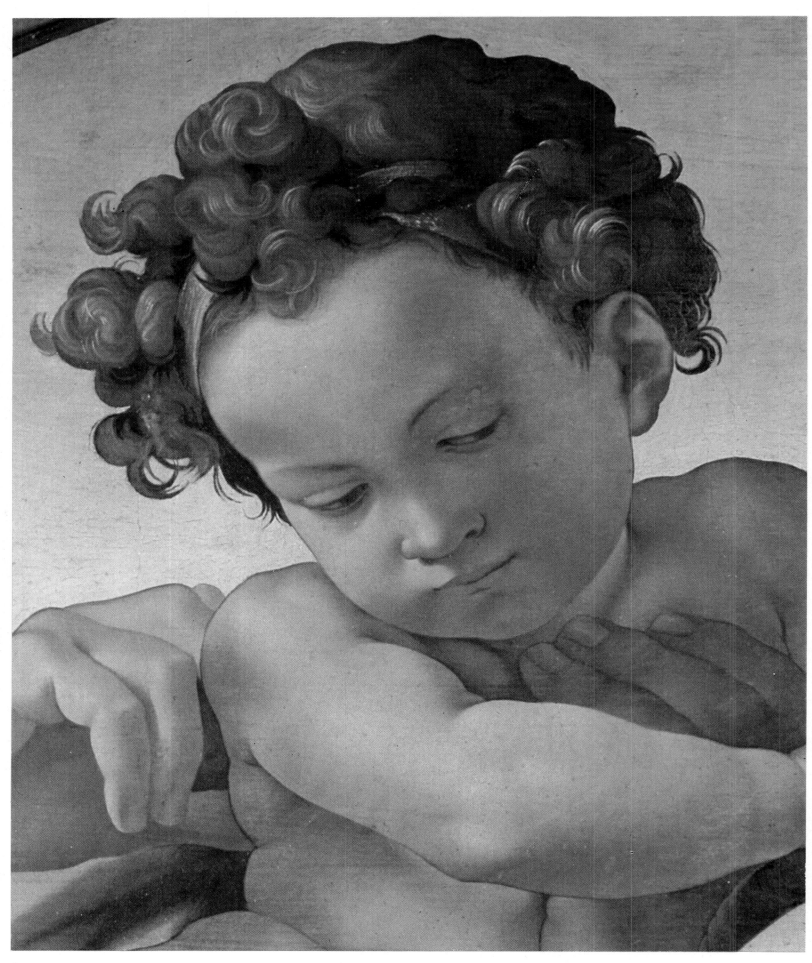

PLATE II DONI TONDO Florence, Uffizi [No. 8]
Detail (actual size)

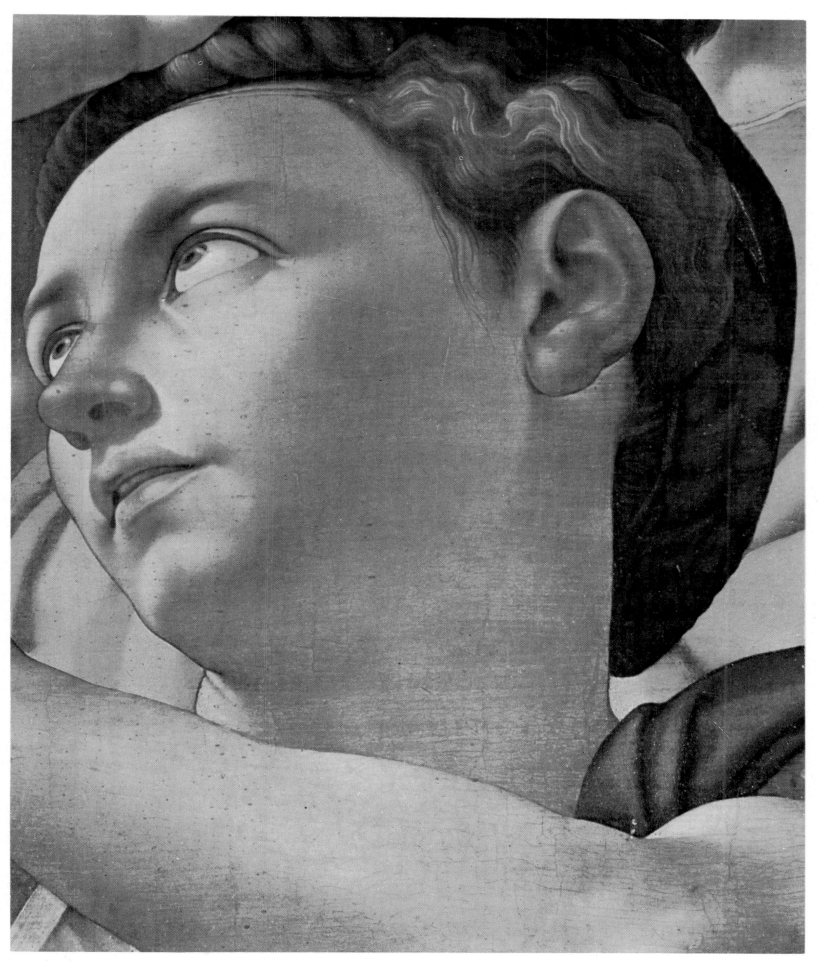

PLATE III DONI TONDO Florence, Uffizi [No. 8]
Detail (actual size)

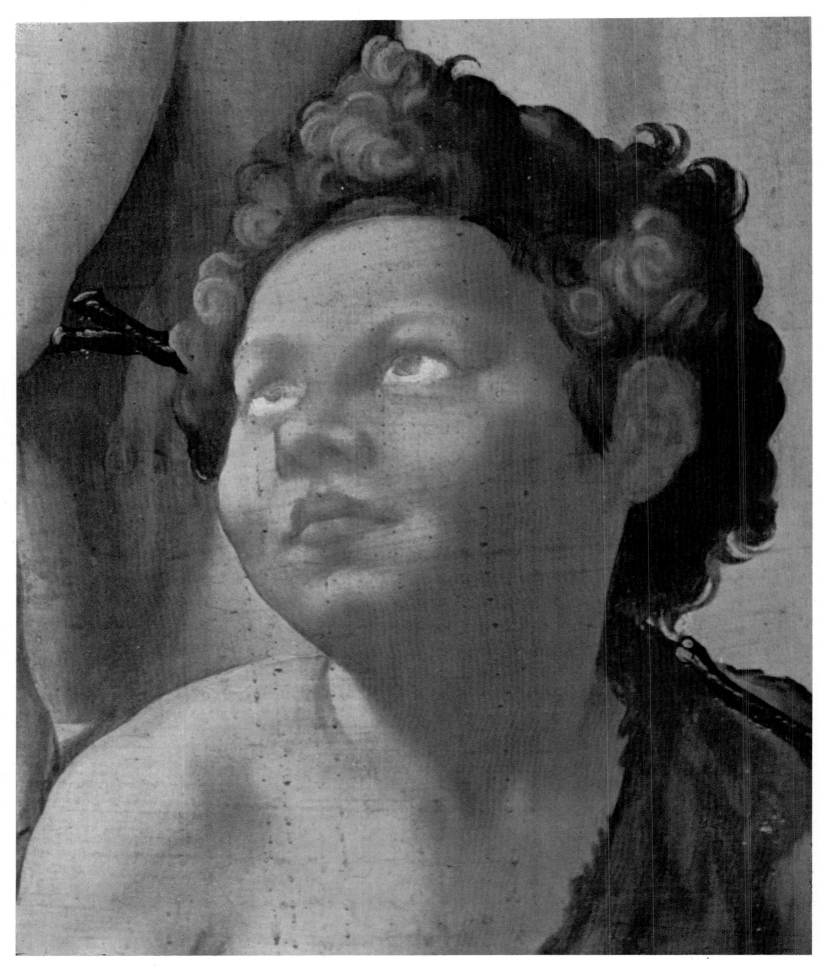

PLATE IV DONI TONDO Florence, Uffizi [No. 8]
Detail (actual size)

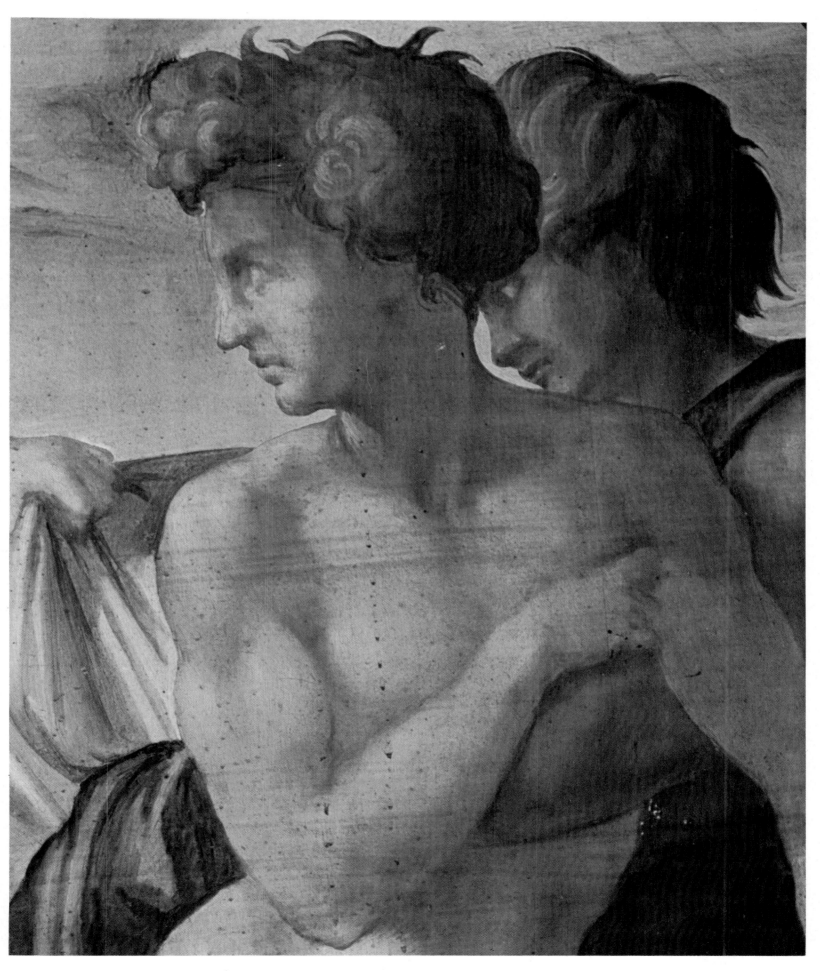

PLATE V DONI TONDO Florence, Uffizi [No. 8]
Detail (actual size)

PLATE VI SISTINE CHAPEL CEILING Vatican [No. 15]
Detail of the *Flood* (actual size)

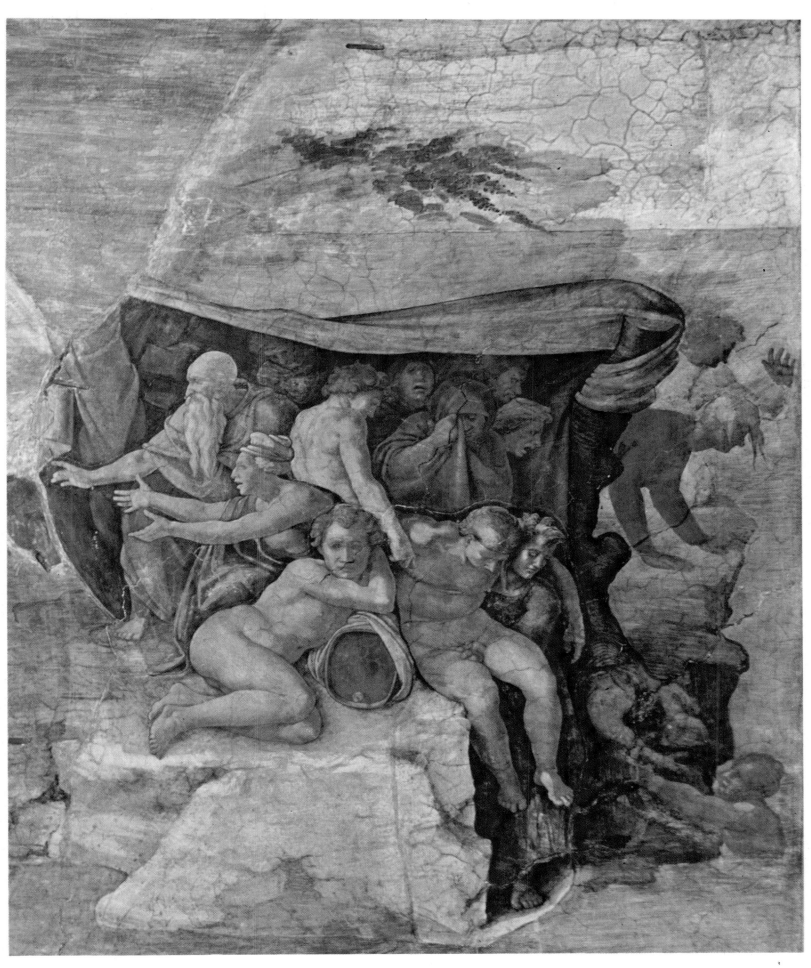

PLATE VII SISTINE CHAPEL CEILING Vatican [No. 15]
Detail of the *Flood* (175 cm.)

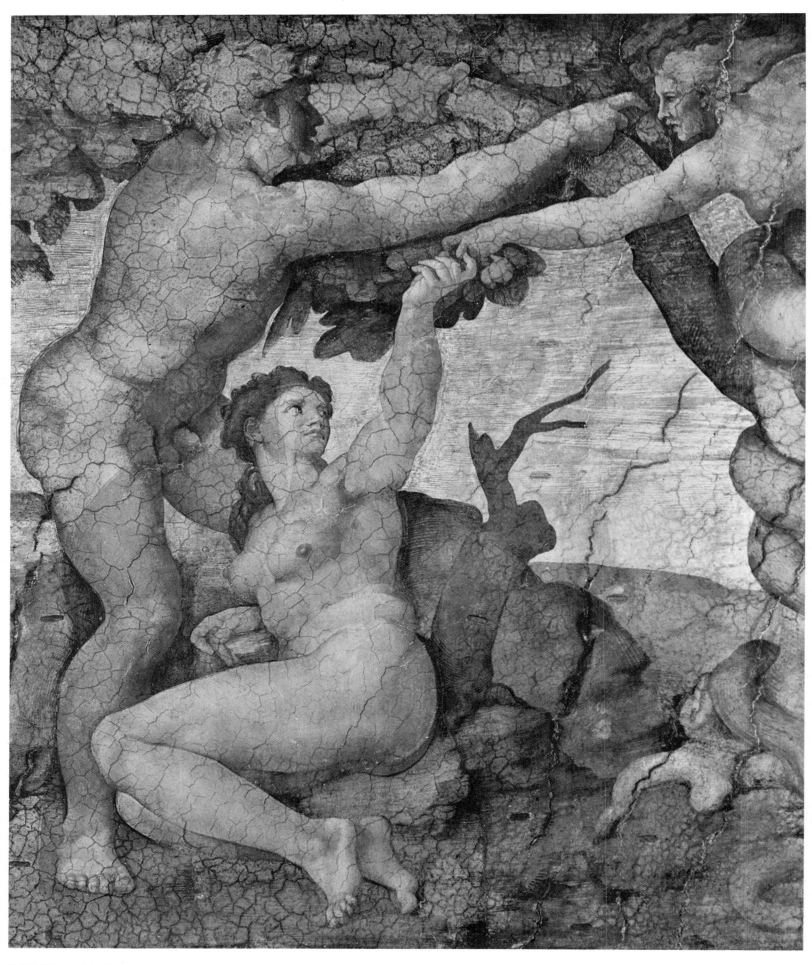

PLATE VIII SISTINE CHAPEL CEILING Vatican [No. 17]
Detail of the *Fall* (230 cm.)

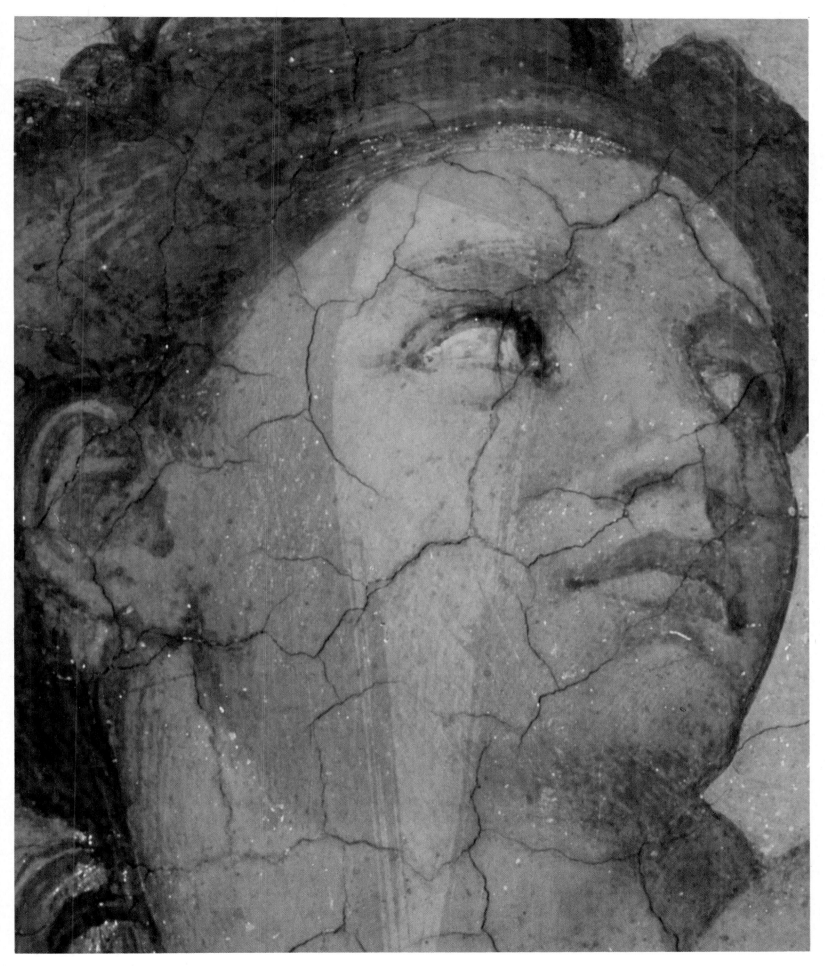

PLATE IX SISTINE CHAPEL CEILING Vatican [No. 17]
Detail of the *Fall* (actual size)

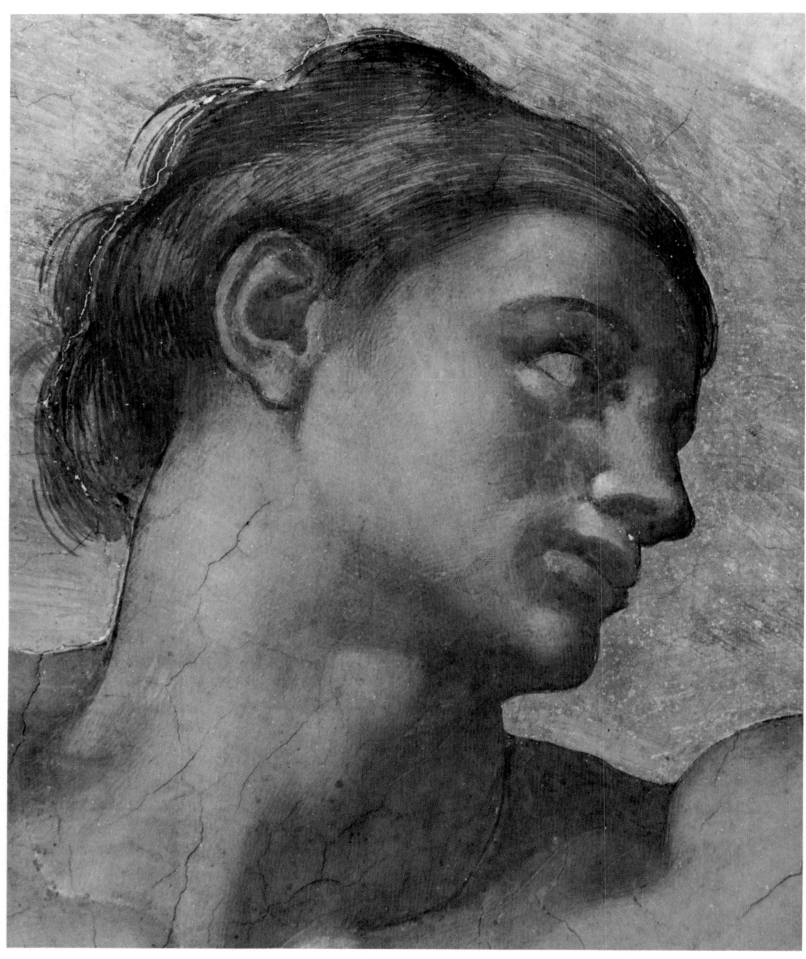

PLATE X SISTINE CHAPEL CEILING Vatican [No. 19]
Detail of the *Creation of Adam* (42 cm.)

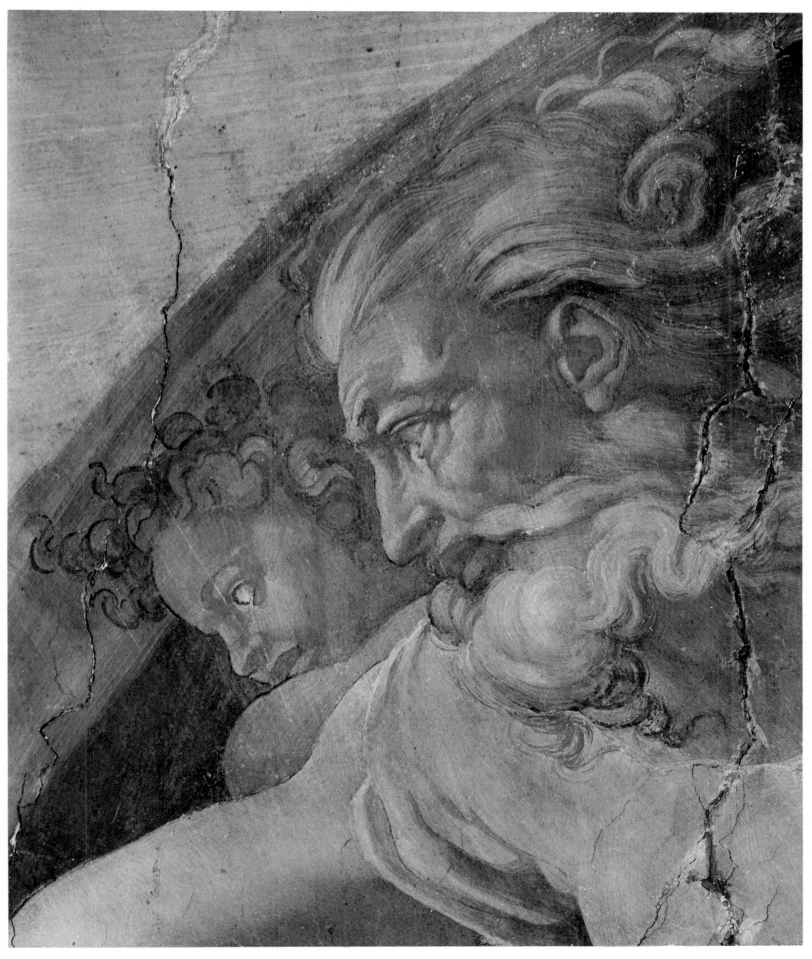

PLATE XI SISTINE CHAPEL CEILING Vatican [No. 19]
Detail of the *Creation of Adam* (60 cm.)

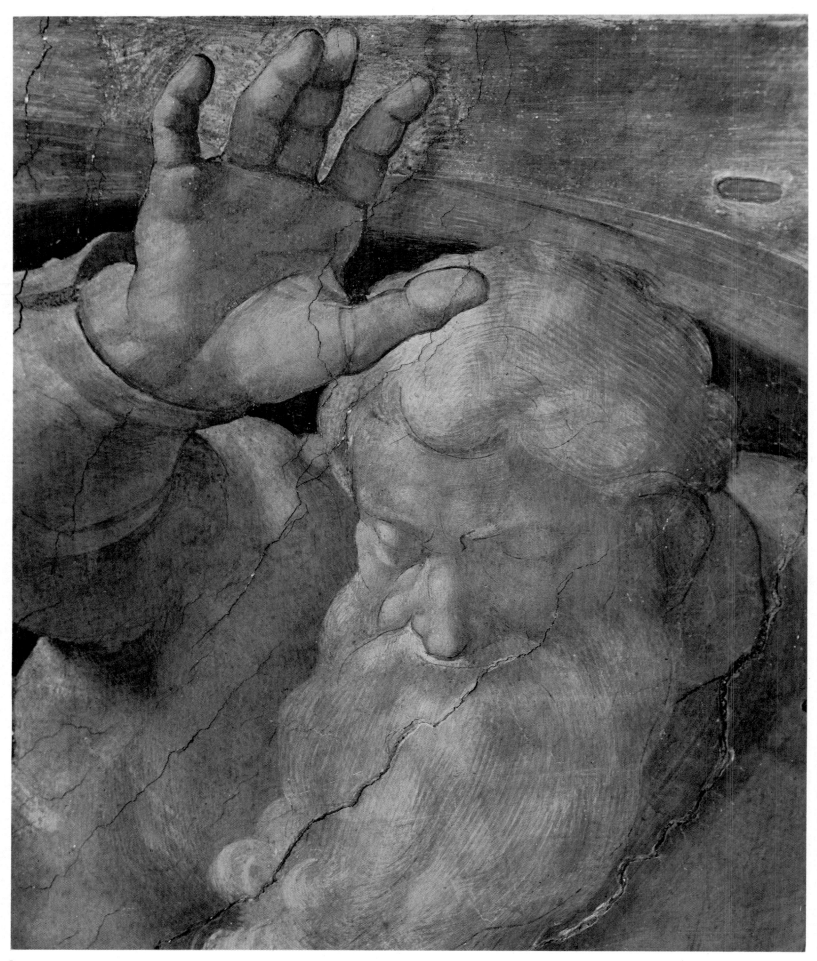

PLATE XII SISTINE CHAPEL CEILING Vatican [No. 20]
Detail of God Separating the Waters from the Earth (37 cm.)

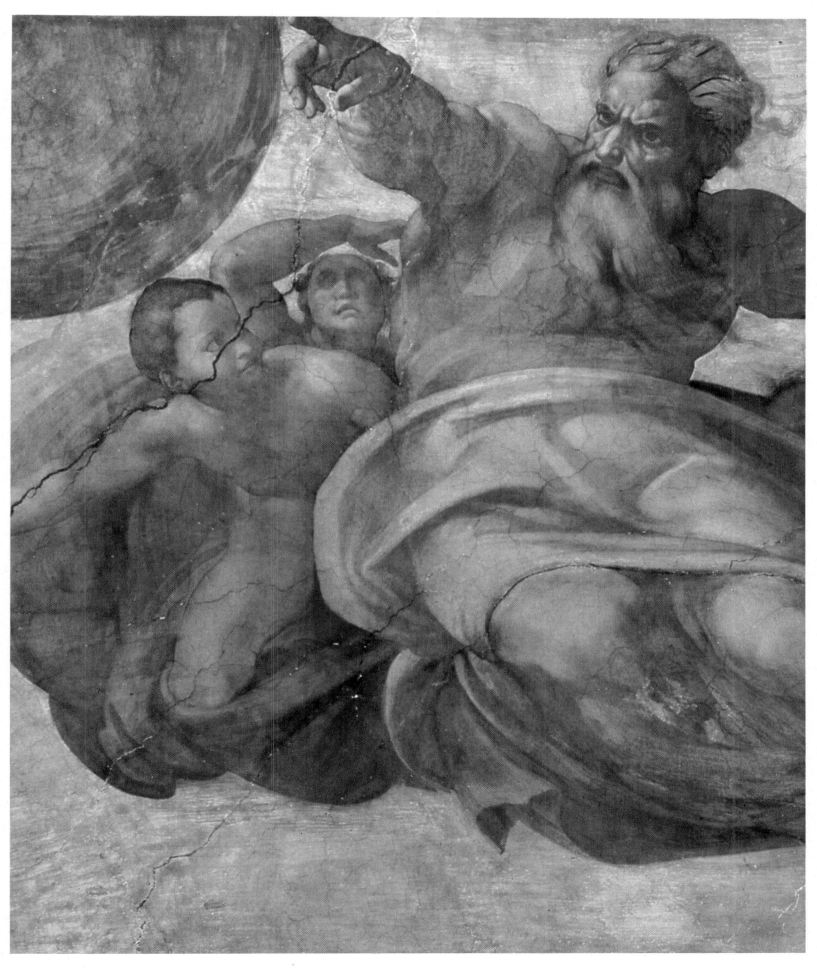

PLATE XIII SISTINE CHAPEL CEILING Vatican [No. 21]
Detail of the Creation of the Sun and the Moon

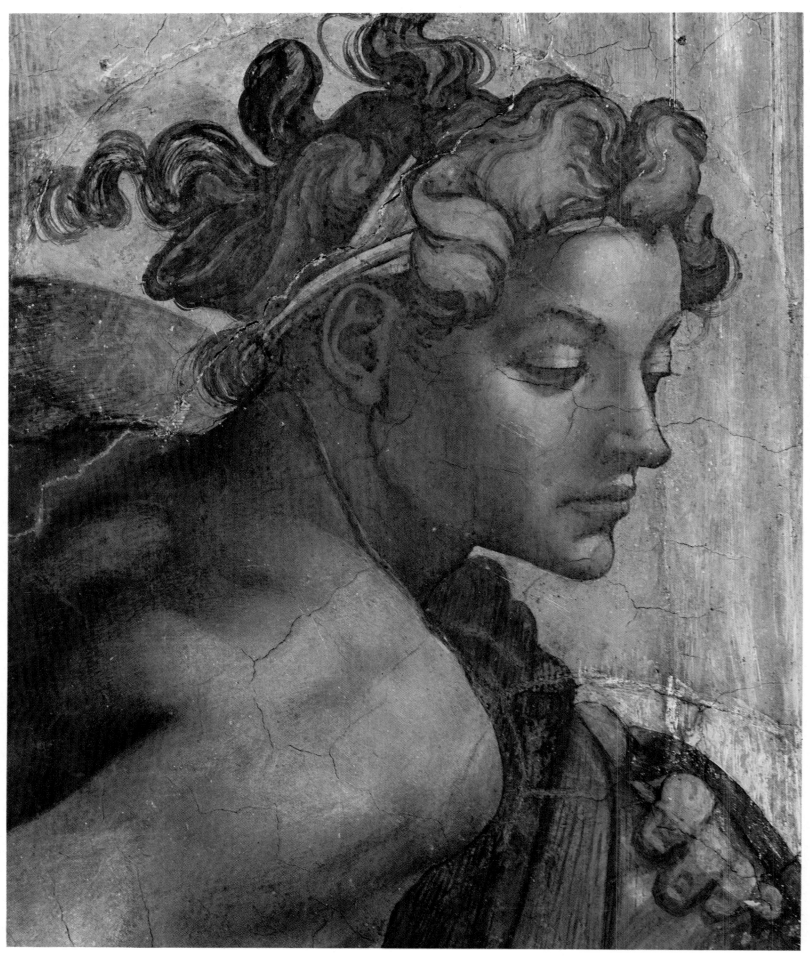

PLATE XIV SISTINE CHAPEL CEILING Vatican [No. 24 A]
Detal of *Ignudo* (50 cm.)

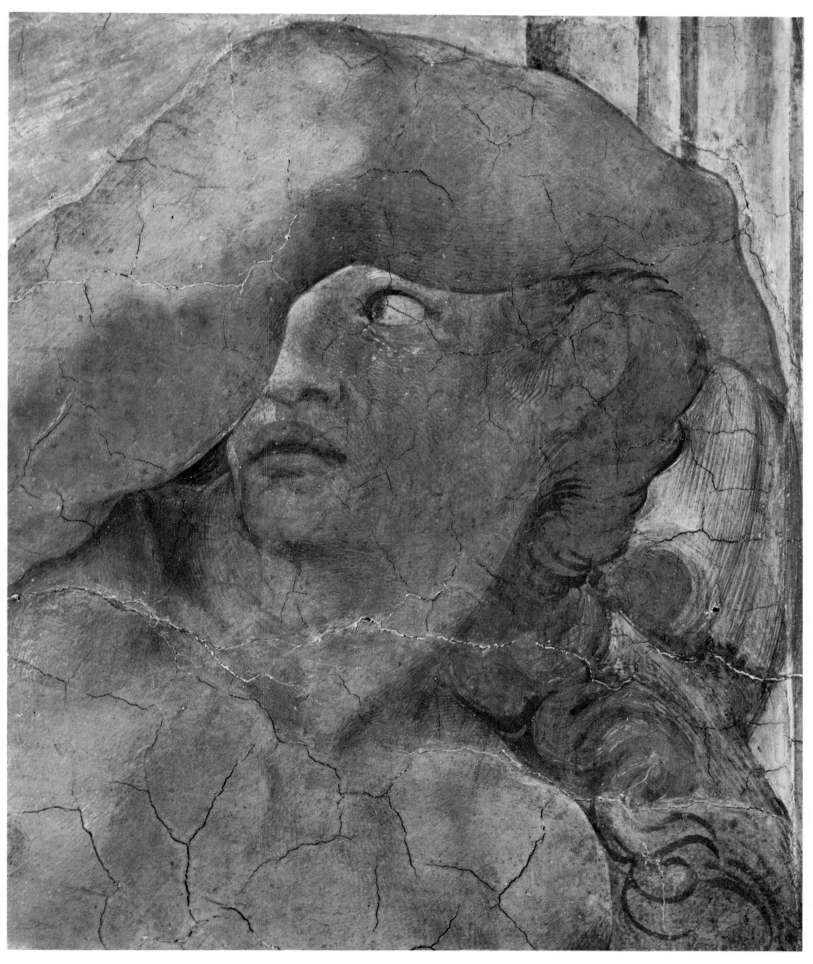

PLATE XV SISTINE CHAPEL CEILING Vatican [No. 25 B]
Detail of *Ignudo* (50 cm.)

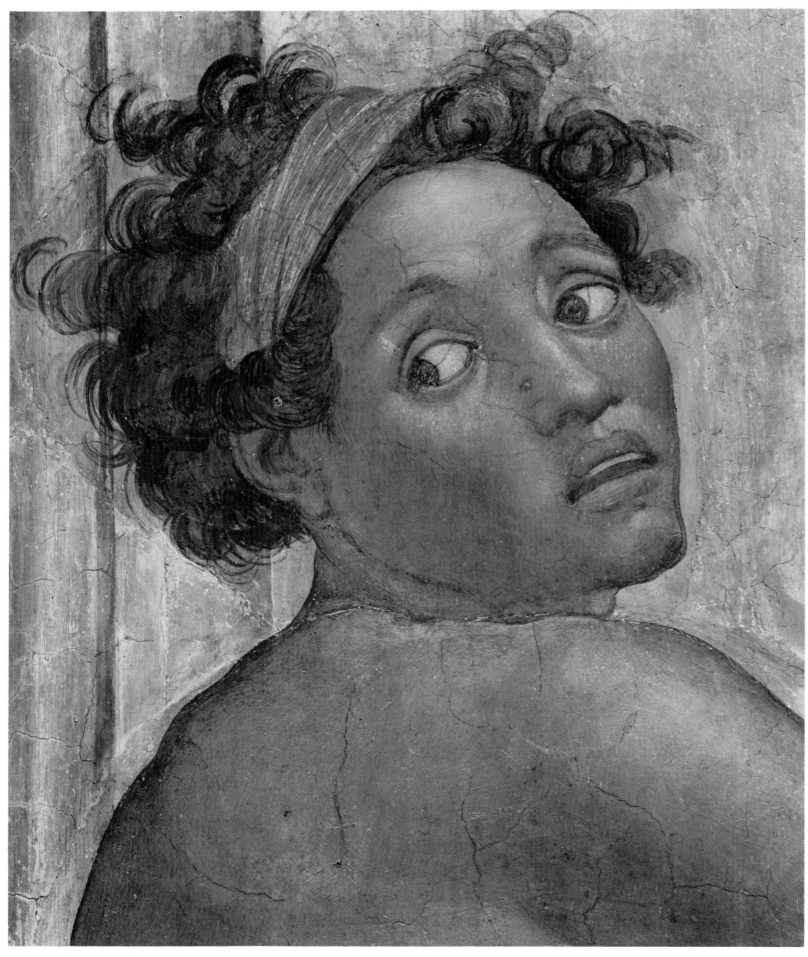

PLATE XVI SISTINE CHAPEL CEILING Vatican [No. 26 A]
Detail of *Ignudo* (50 cm.)

PLATE XVIII SISTINE CHAPEL CEILING Vatican [No. 30 B]
Detail of *Ignudo* (51 cm.)

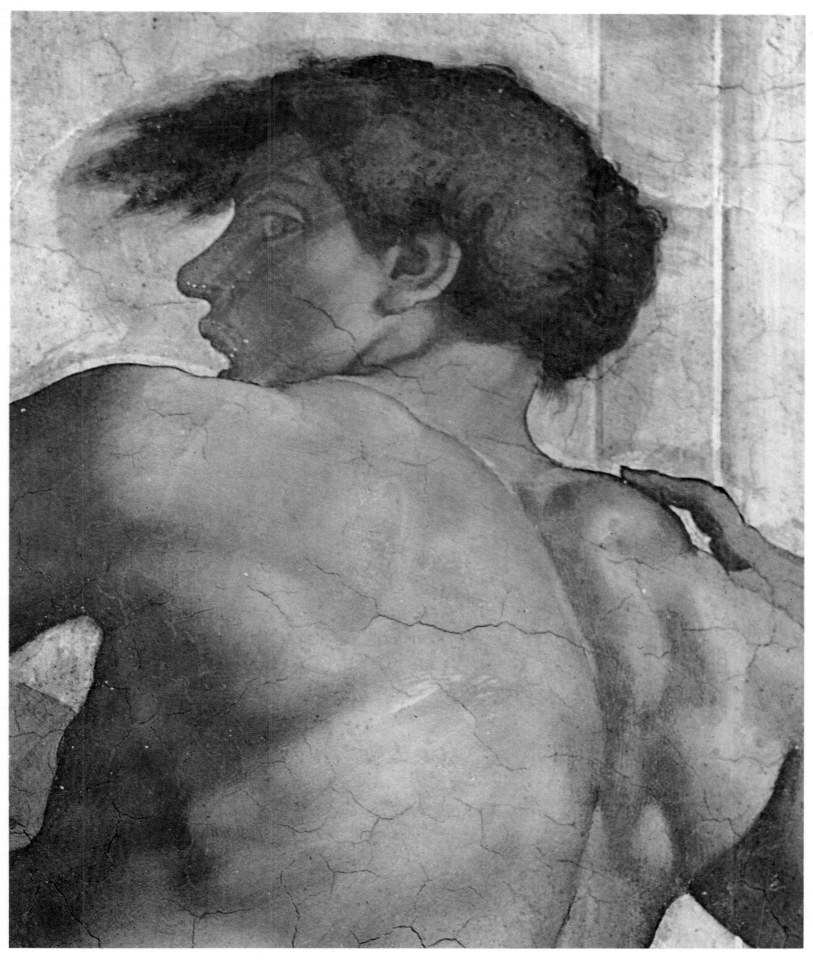

PLATE XIX SISTINE CHAPEL CEILING Vatican [No. 30 B]
Detail of *Ignudo* (67 cm.)

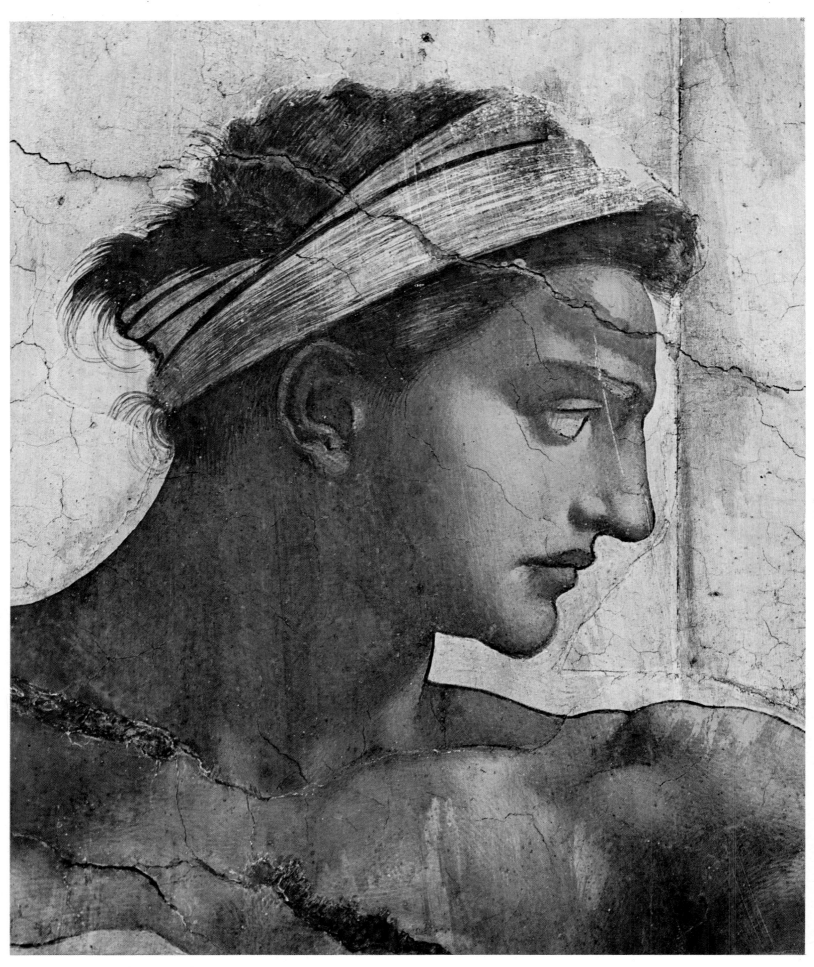

PLATE XX SISTINE CHAPEL CEILING Vatican [No. 32 A]
Detail of *Ignudo* (42 cm.)

PLATE XXI SISTINE CHAPEL CEILING Vatican [No. 32 A]
Detail of *Ignudo* (84 cm.)

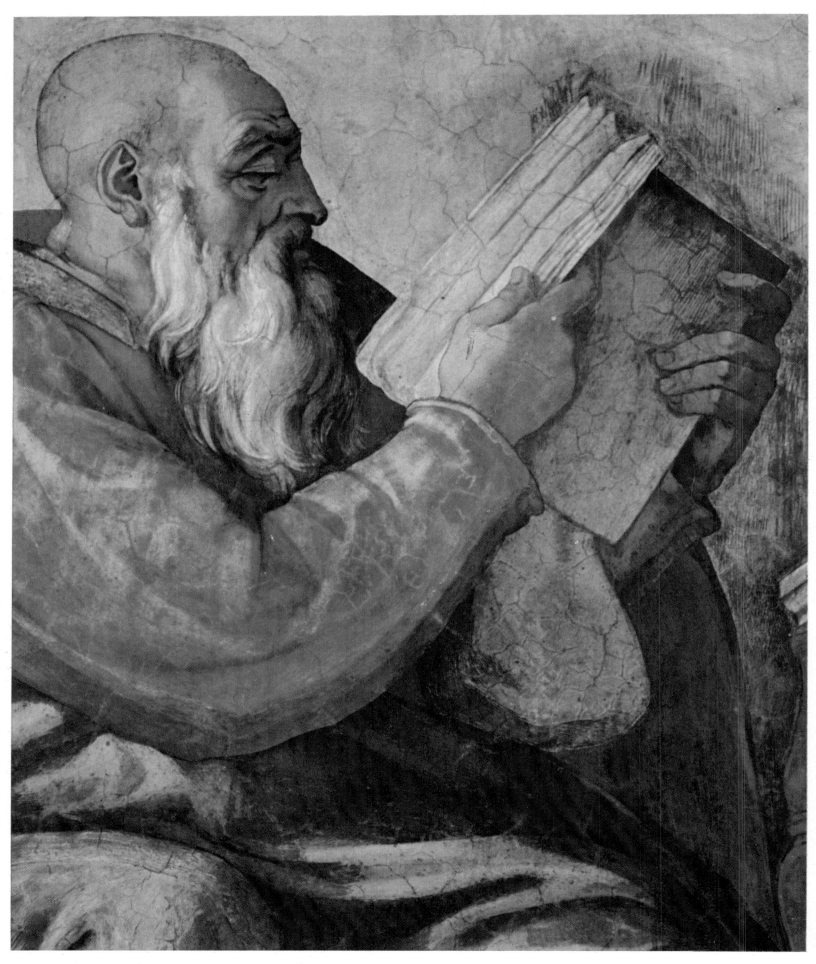

PLATE XXII SISTINE CHAPEL CEILING Vatican [No. 33]
Detail of the Prophet Zechariah (180 cm.)

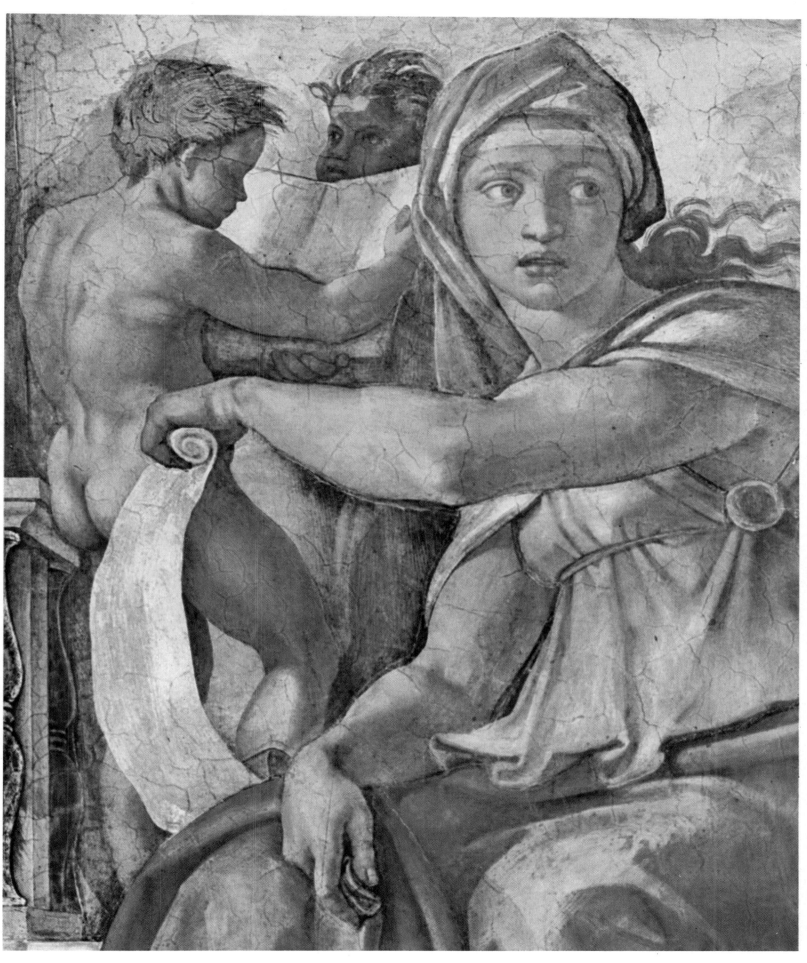

PLATE XXIII SISTINE CHAPEL CEILING Vatican [No. 34]
Detail of the Delphic Sibyl (130 cm.)

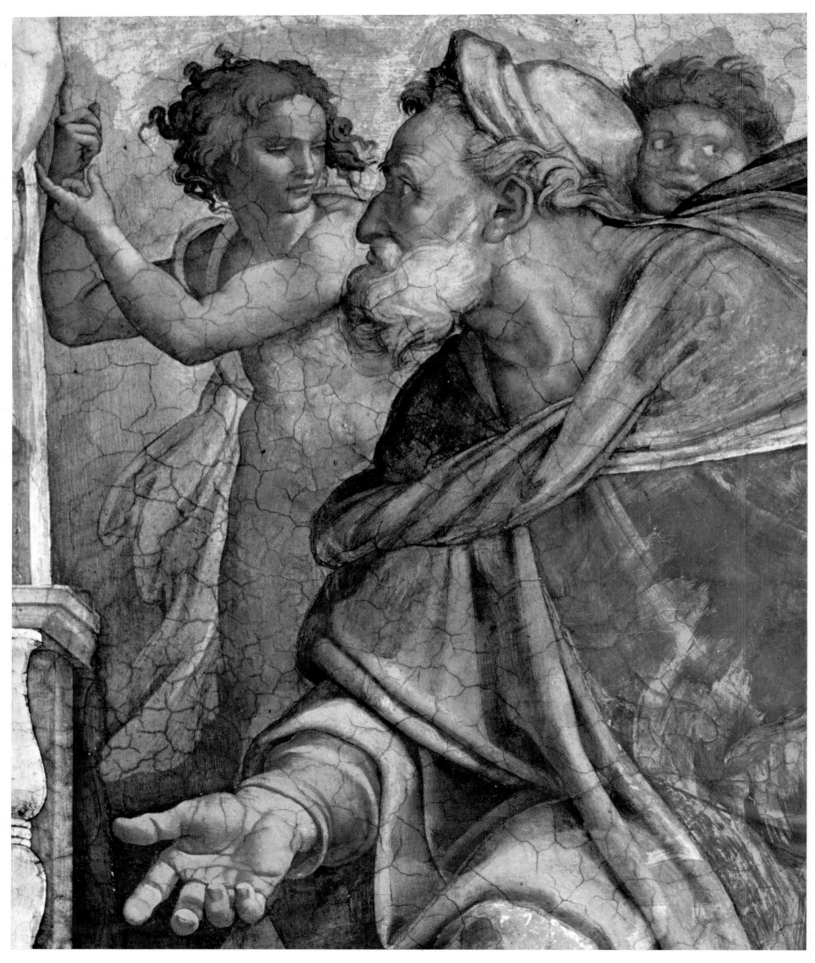

PLATE XXIV SISTINE CHAPEL CEILING Vatican [No. 39]
Detail of the Prophet Ezekiel (135 cm.)

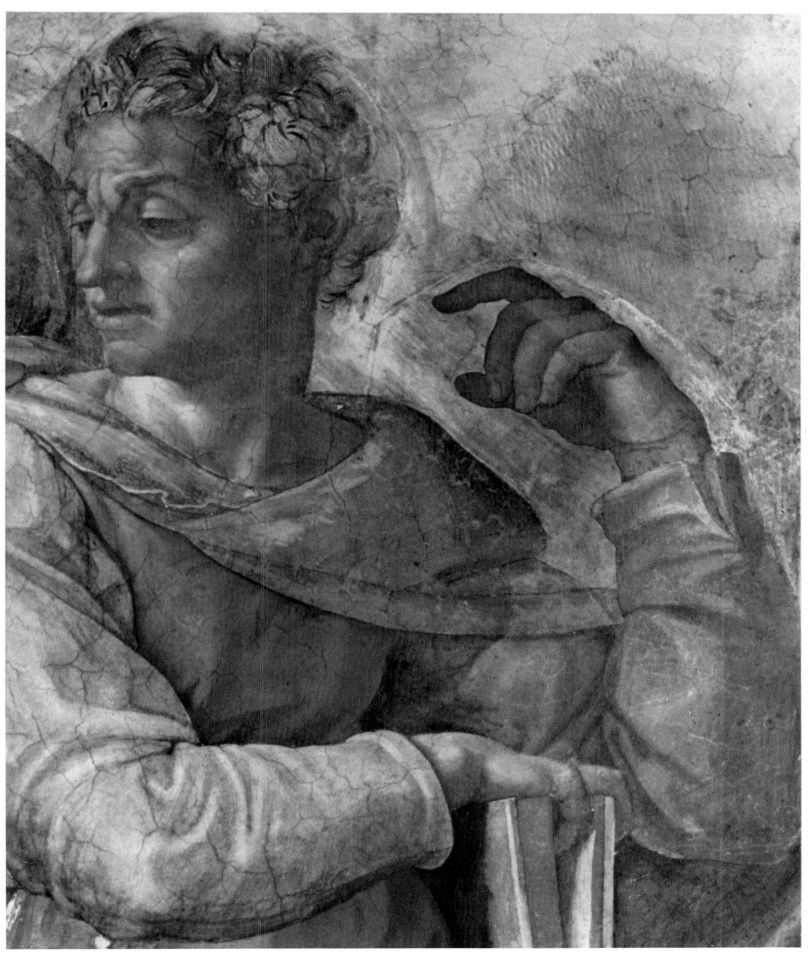

PLATE XXV SISTINE CHAPEL CEILING Vatican [No 36]
Detail of the Prophet Isaiah (101 cm.)

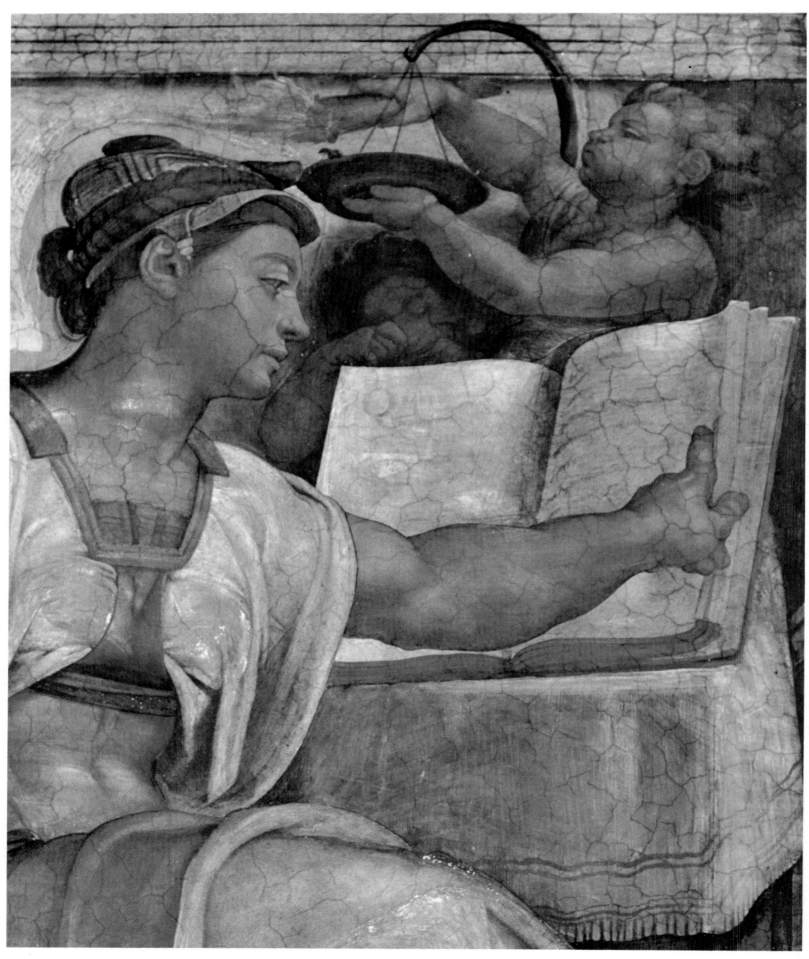

PLATE XXVI SISTINE CHAPEL CEILING Vatican [No. 37]
Detail of the Eritrean Sibyl (134 cm.)

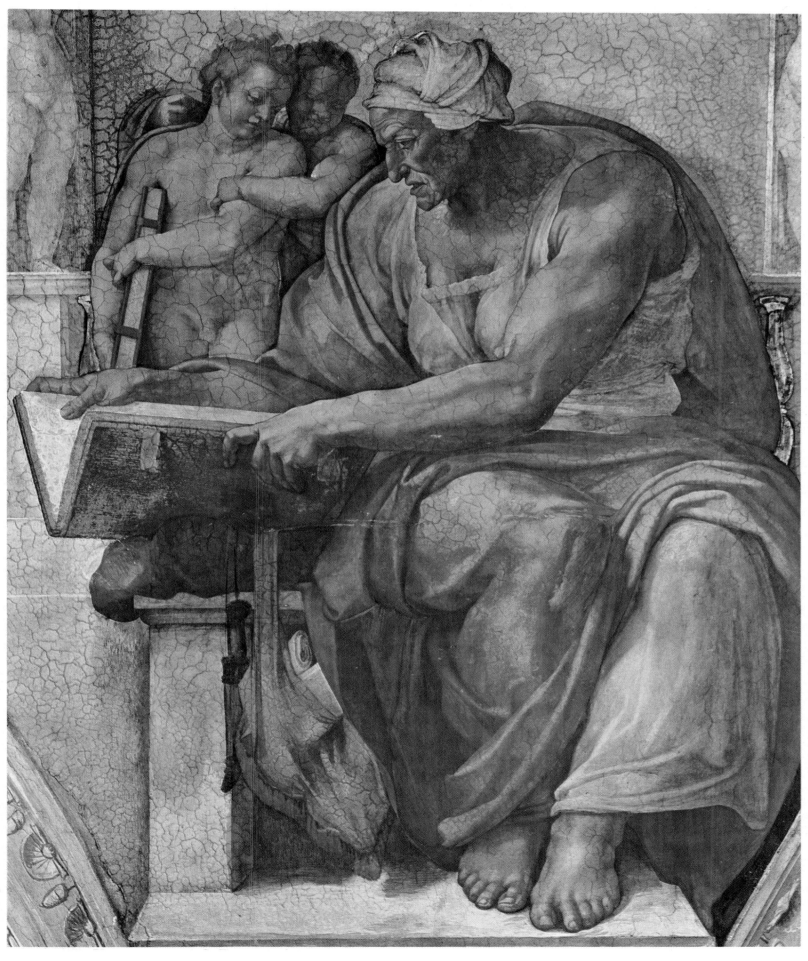

PLATE XXVII SISTINE CHAPEL CEILING Vatican [No. 38]
The Cumean Sibyl (230 cm.)

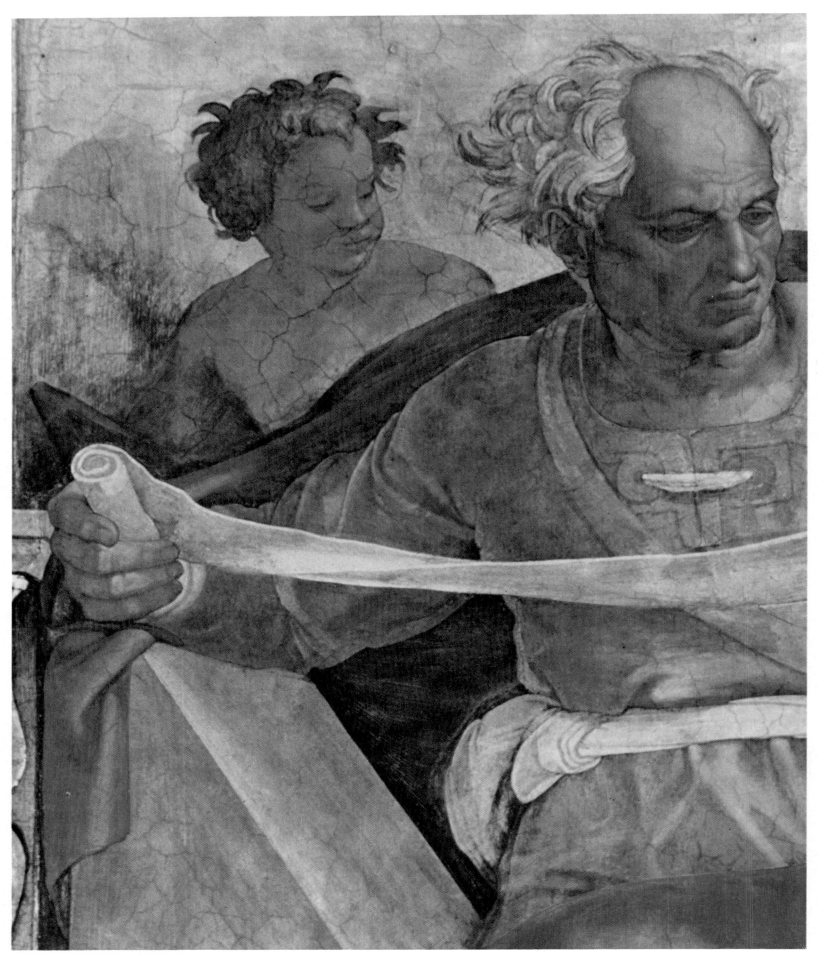

PLATE XXVIII SISTINE CHAPEL CEILING Vatican [No. 35]
Detail of the Prophet Joel (106 cm.)

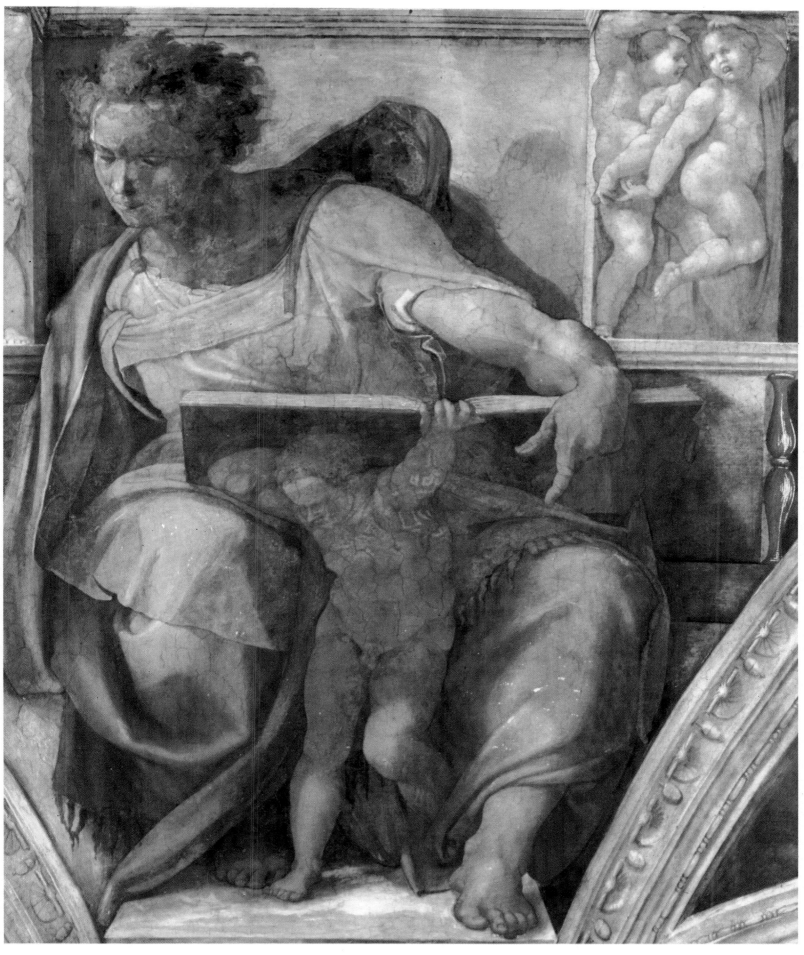

PLATE XXIX SISTINE CHAPEL CEILING Vatican [No. 40]
The Prophet Daniel (261 cm.)

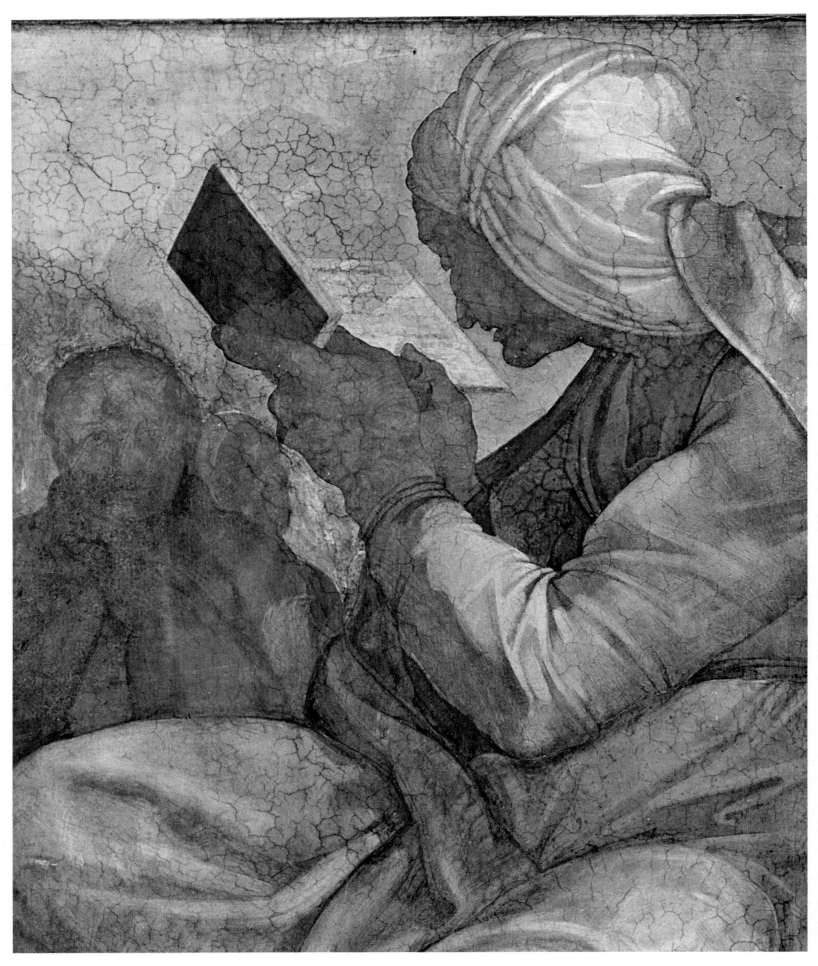

PLATE XXX SISTINE CHAPEL CEILING Vatican [No. 41]
Detail of the Persian Sibyl (142 cm.)

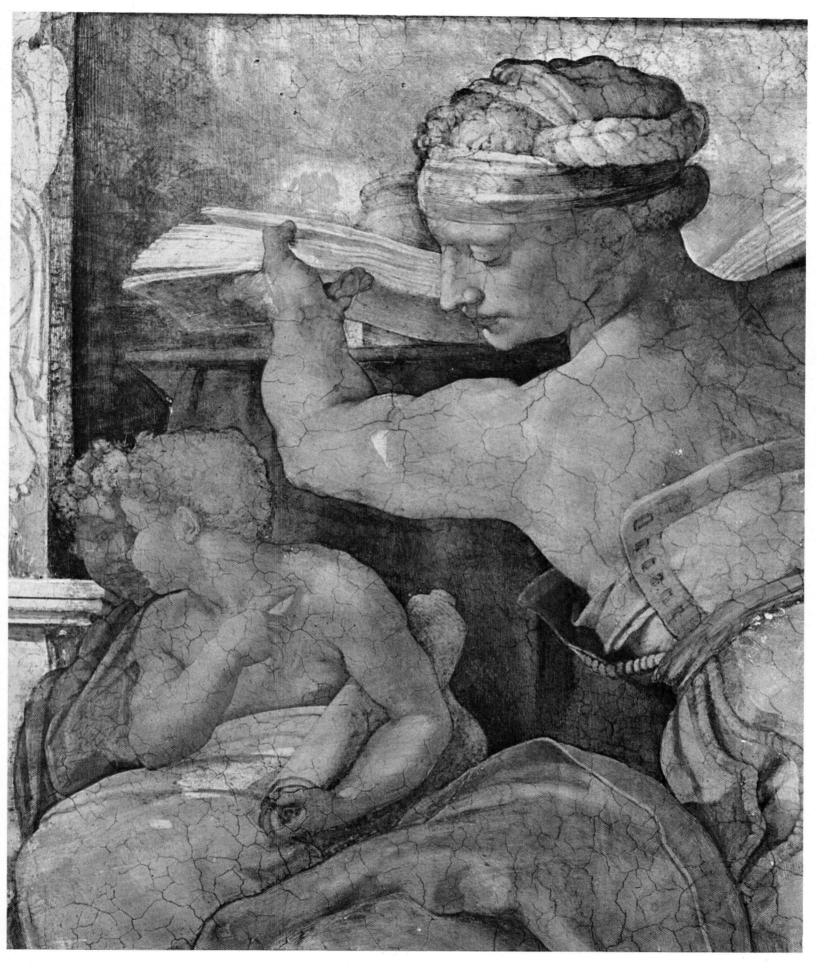

PLATE XXXI SISTINE CHAPEL CEILING Vatican [No. 42]
Detail of the Libyan Sibyl (181 cm.)

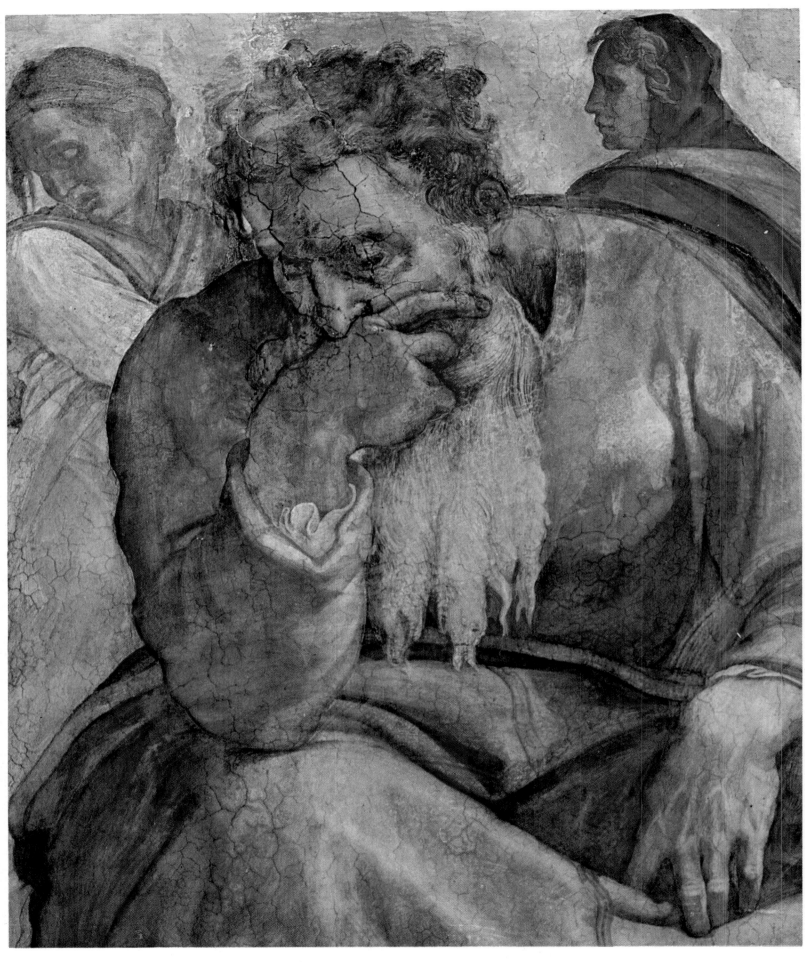

PLATE XXXII SISTINE CHAPEL CEILING Vatican [No. 43]
Detail of the Prophet Jeremiah (162 cm.)

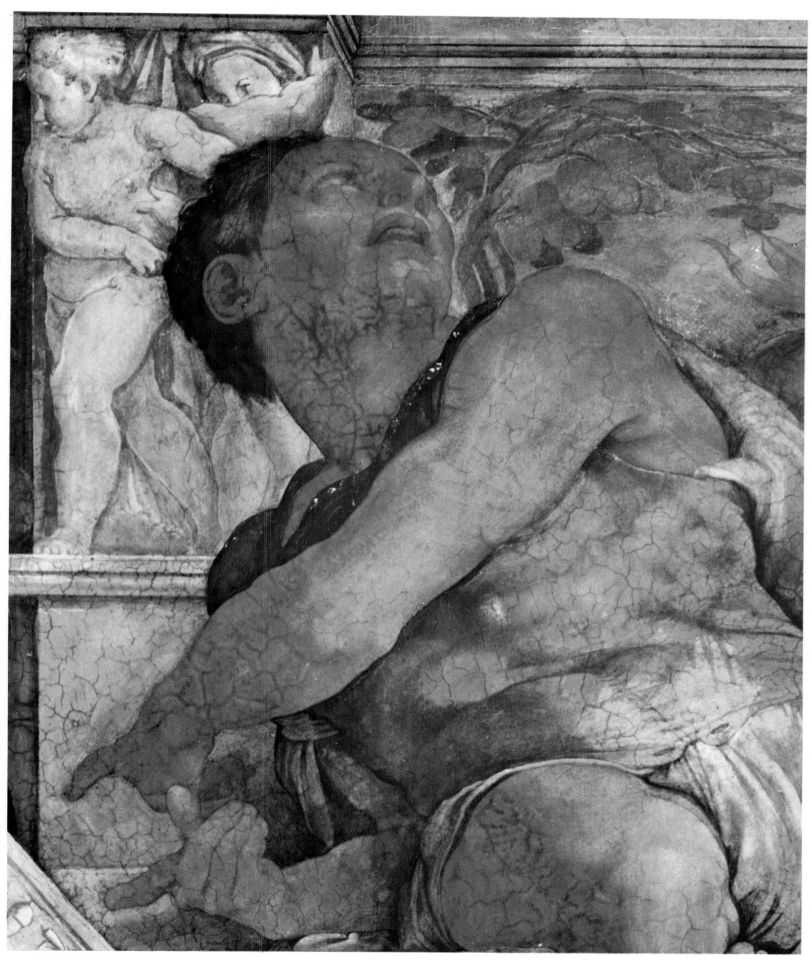

PLATE XXXIII SISTINE CHAPEL CEILING Vatican [No. 44]
Detail of the Prophet Jonah (173 cm.)

PLATE XXXIV SISTINE CHAPEL CEILING Vatican [No. 40]
Detail of inscription-bearing *putto* (68 cm.)

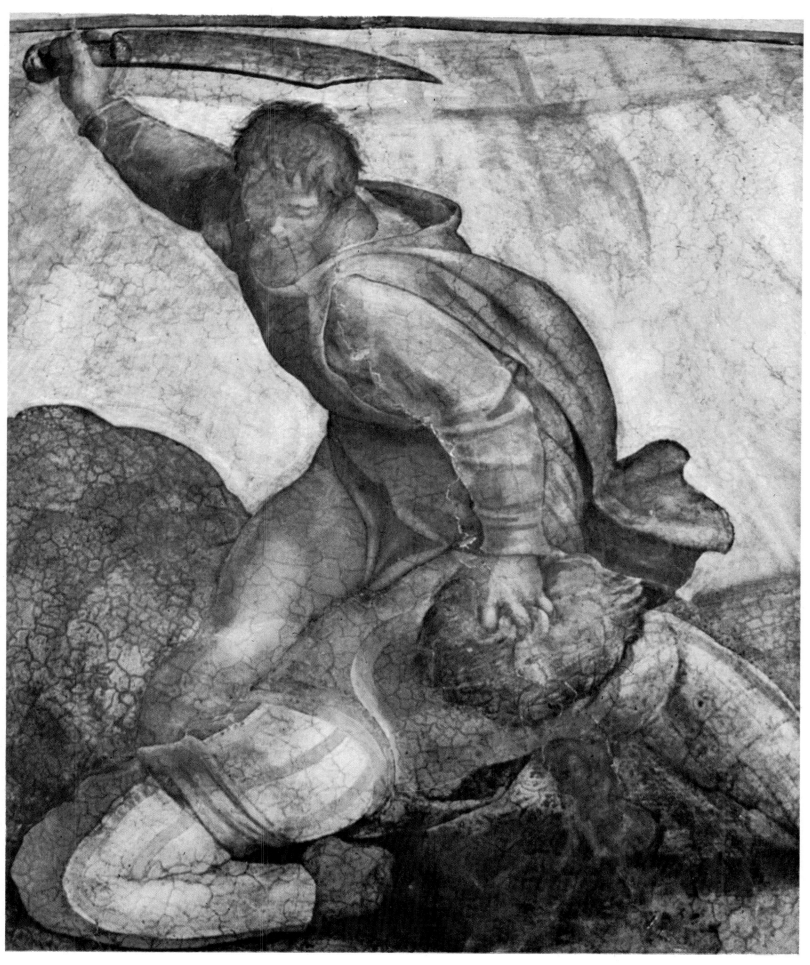

PLATE XXXV SISTINE CHAPEL CEILING Vatican [No. 46 A]
Detail of *David and Goliath* (243 cm.)

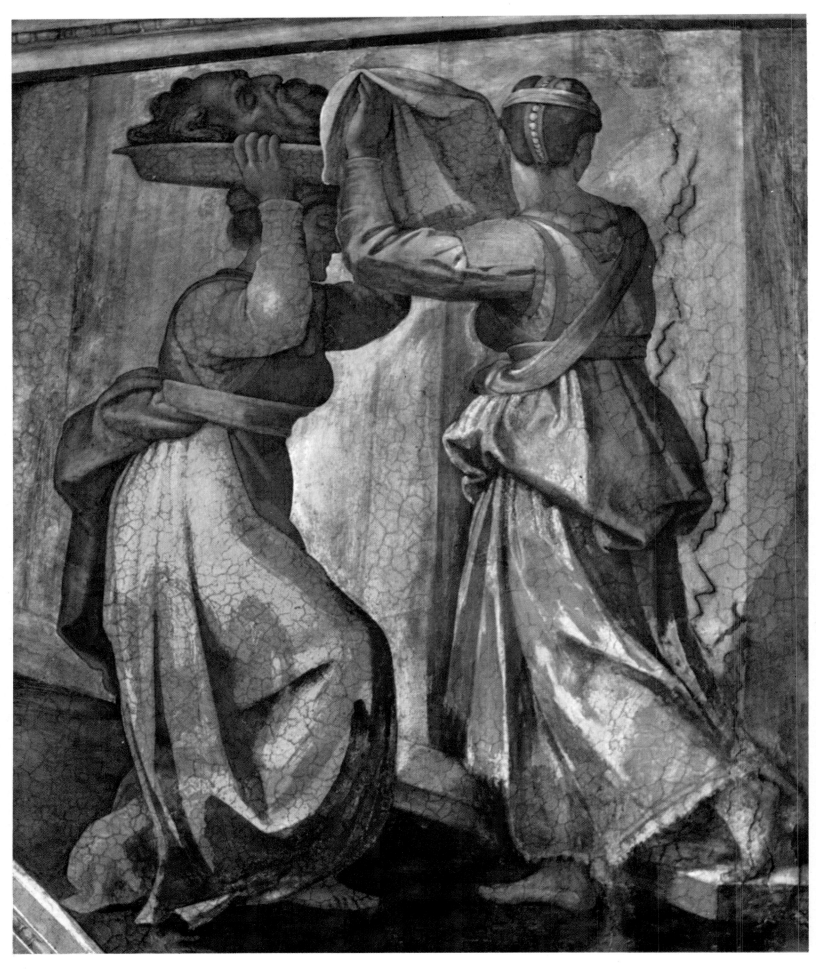

PLATE XXXVI SISTINE CHAPEL CEILING Vatican [No. 45 A]
Detail of *Judith and Holofernes* (259 cm.)

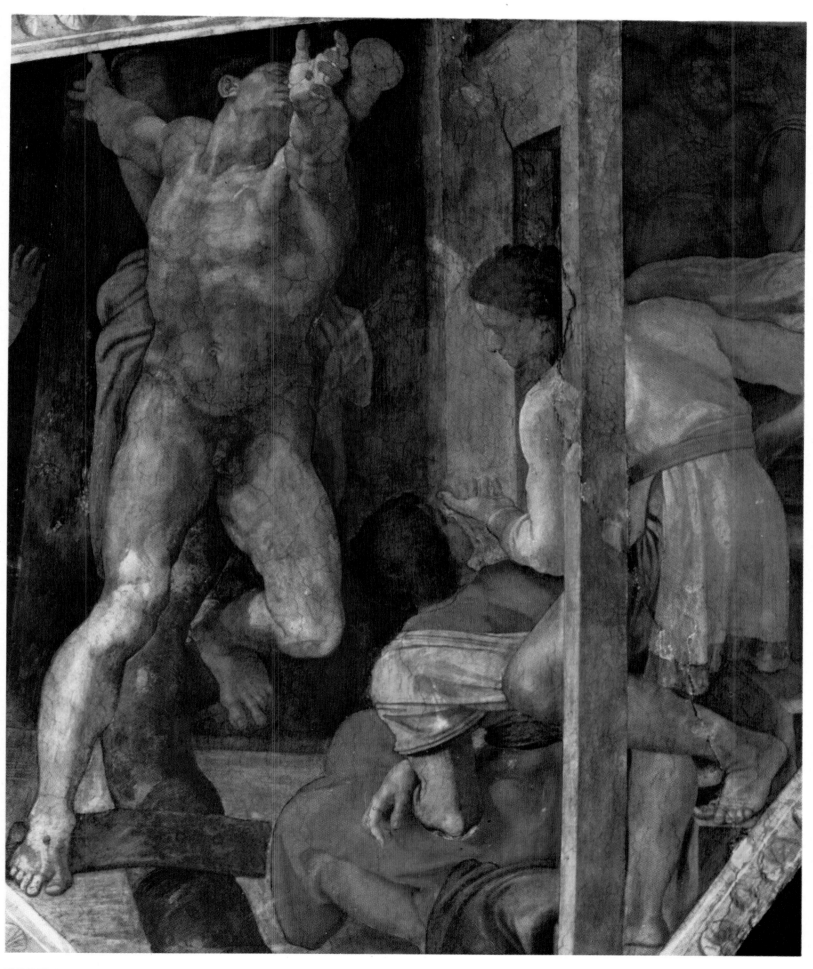

PLATE XXXVII SISTINE CHAPEL CEILING Vatican [No. 48 A]
Detail of the *Punishment of Haman* (324 cm.)

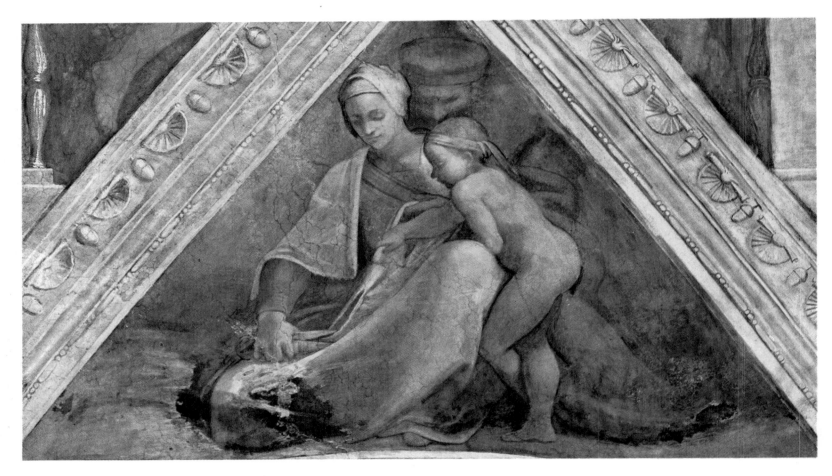

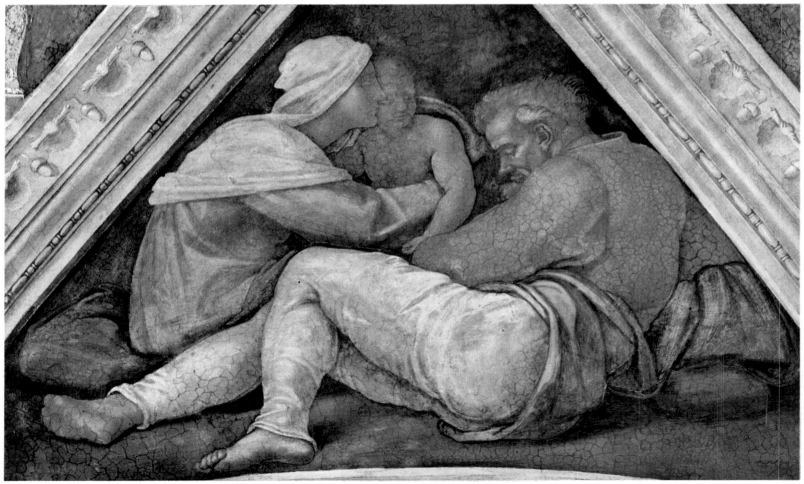

PLATE XXXVIII SISTINE CHAPEL CEILING Vatican [No. 56 A & 49 A]
Tympanum figures (304 cm. and 291 cm.)

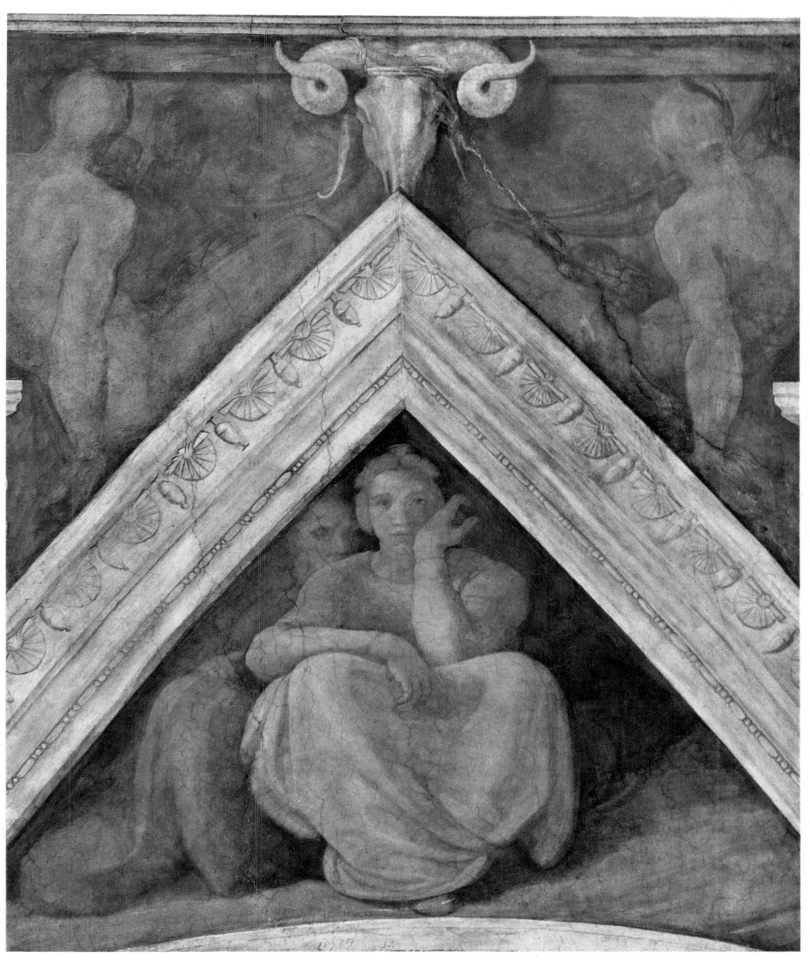

PLATE XXXIX SISTINE CHAPEL CEILING Vatican [No. 55 A & B]
Tympanum and bronze like nudes (308 cm.)

PLATE XL SISTINE CHAPEL CEILING Vatican [No. 67 & 61]
Lunettes (183 and 186 cm.)

PLATE XLI SISTINE CHAPEL CEILING Vatican [No. 65]
Detail of Lunette (99 cm.)

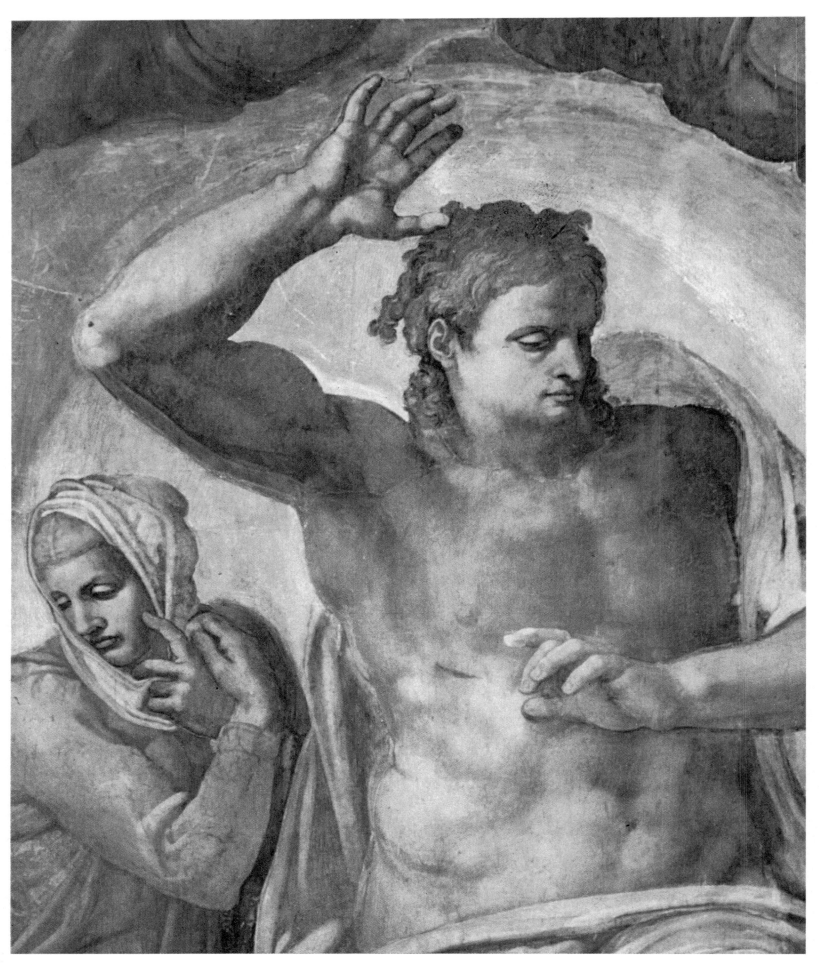

PLATE XLII THE LAST JUDGEMENT Vatican, Sistine Chapel [No. 73]
Detail of figures 13 and 14: Madonna and Christ (129 cm.)

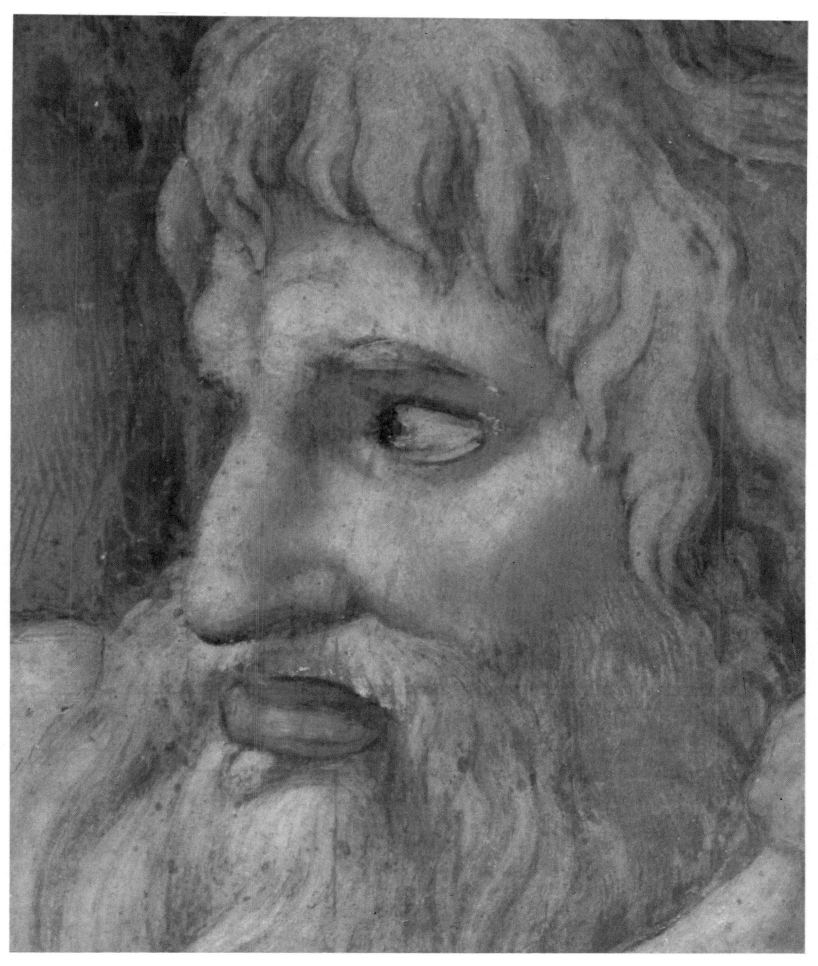

PLATE XLIII THE LAST JUDGEMENT Vatican, Sistine Chapel [No. 73]
Detail of figure 18: presumed Saint Paul (actual size)

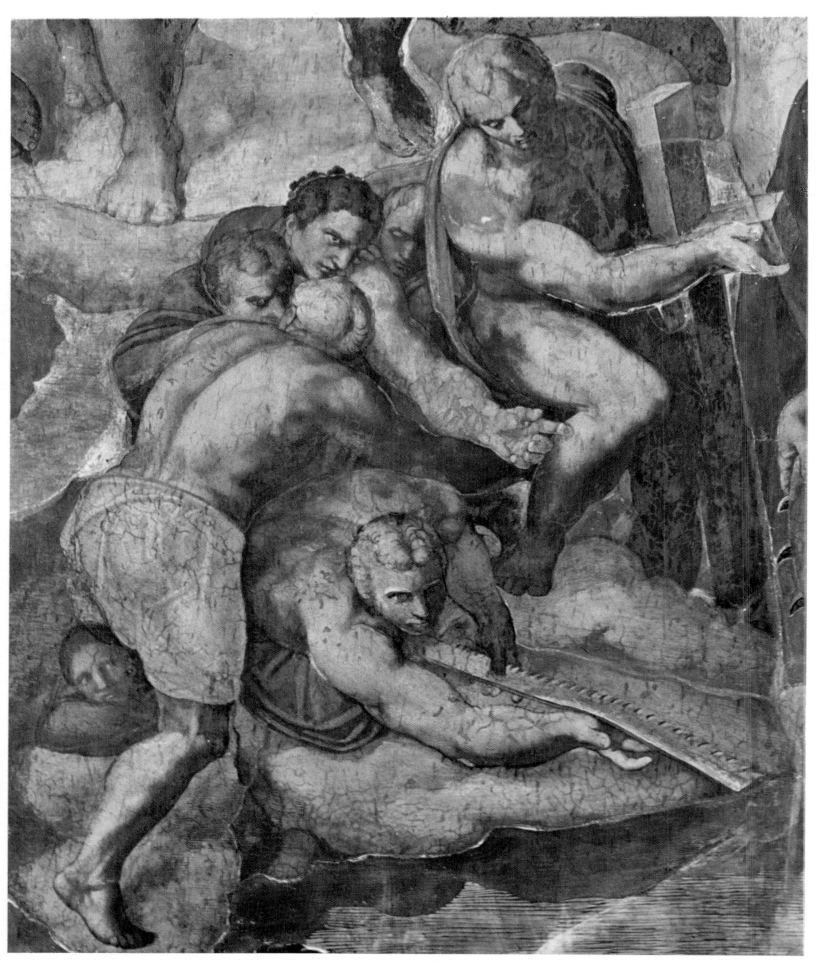

PLATE XLIV THE LAST JUDGEMENT Vatican, Sistine Chapel [No. 73]
Detail of figures 21, 22 and 23: presumed SS. Longinus, Simon the Zealot, and Philip or Dismas (174 cm.)

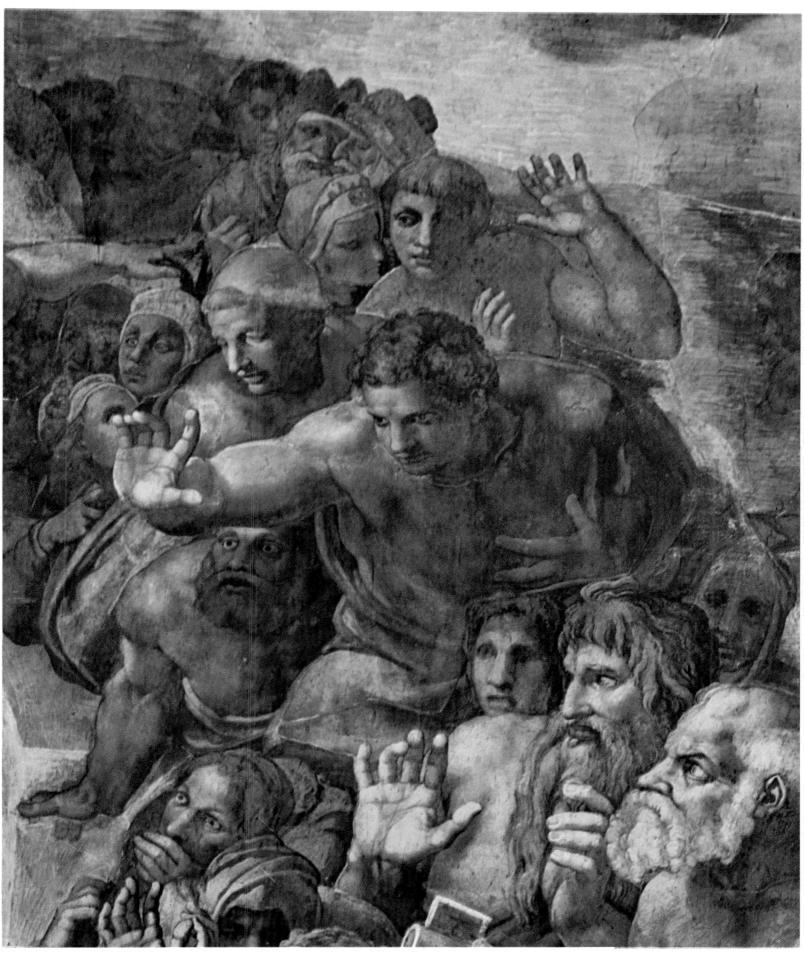

PLATE XLV THE LAST JUDGEMENT Vatican, Sistine Chapel [No. 73]
Figures of the blessed (173 cm.)

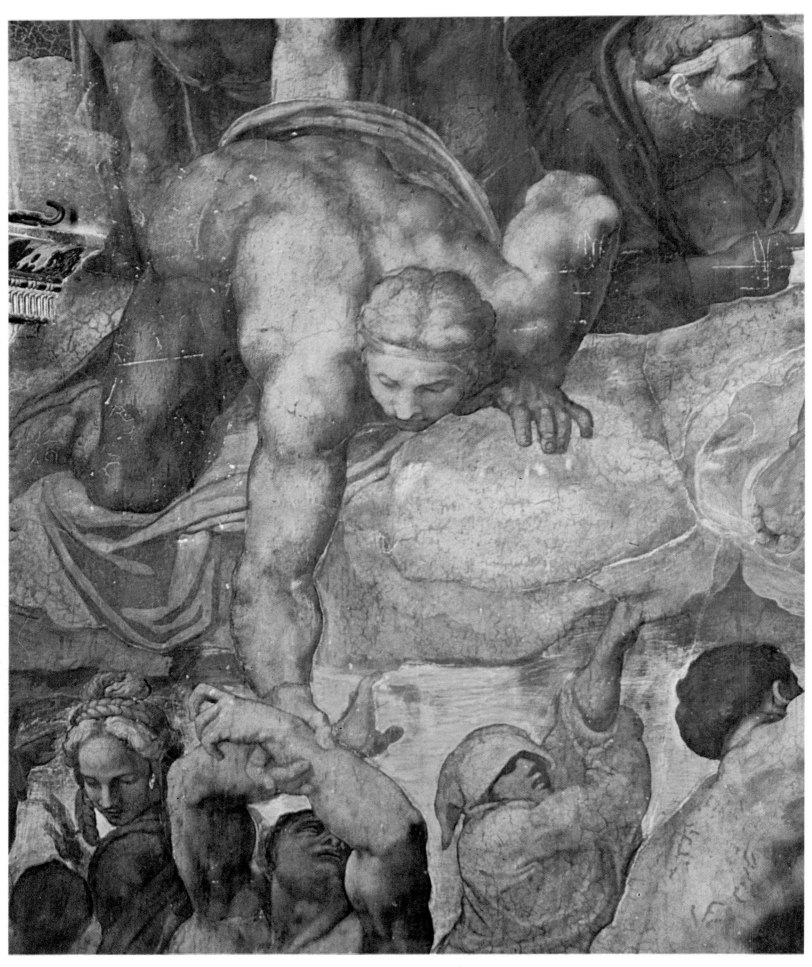

PLATE XLVI THE LAST JUDGEMENT Vatican, Sistine Chapel [No. 73]
The elect ascending to Heaven assisted by angels or the blessed (162 cm.)

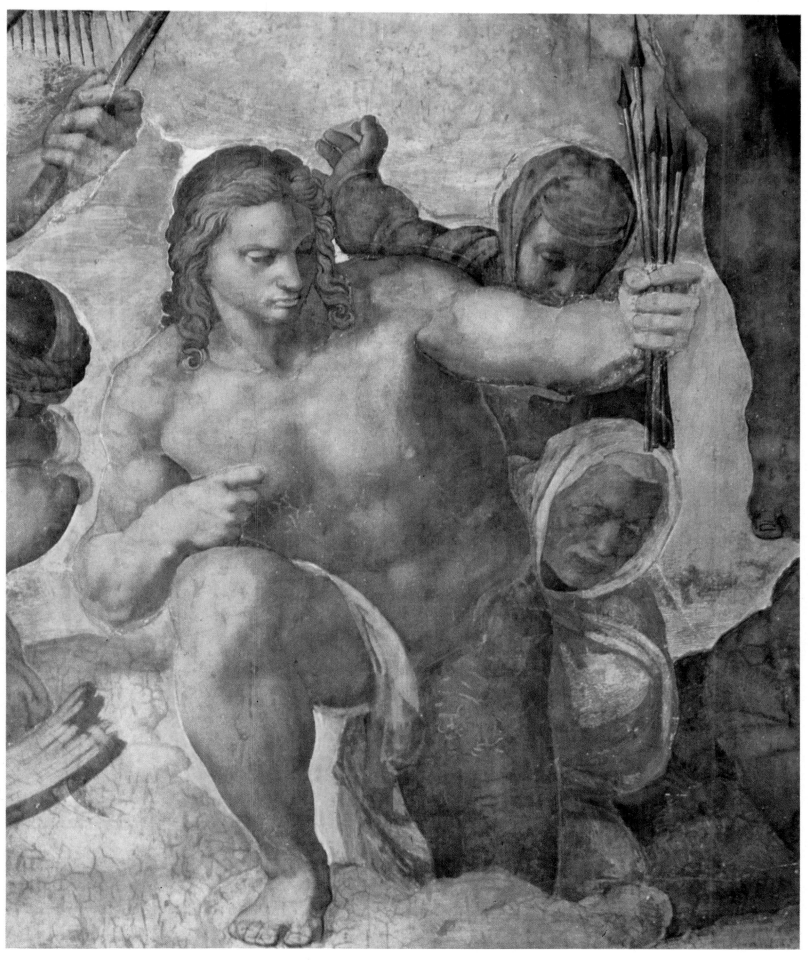

PLATE XLVII THE LAST JUDGEMENT Vatican, Sistine Chapel [No. 73]
Figure 28: Saint Sebastian (122 cm.)

PLATE XLVIII THE LAST JUDGEMENT Vatican, Sistine Chapel [No. 73]
Detail of one of the risen (actual size)

PLATE XLIX THE LAST JUDGEMENT Vatican, Sistine Chapel [No. 73]
Detail of one of the elect (actual size)

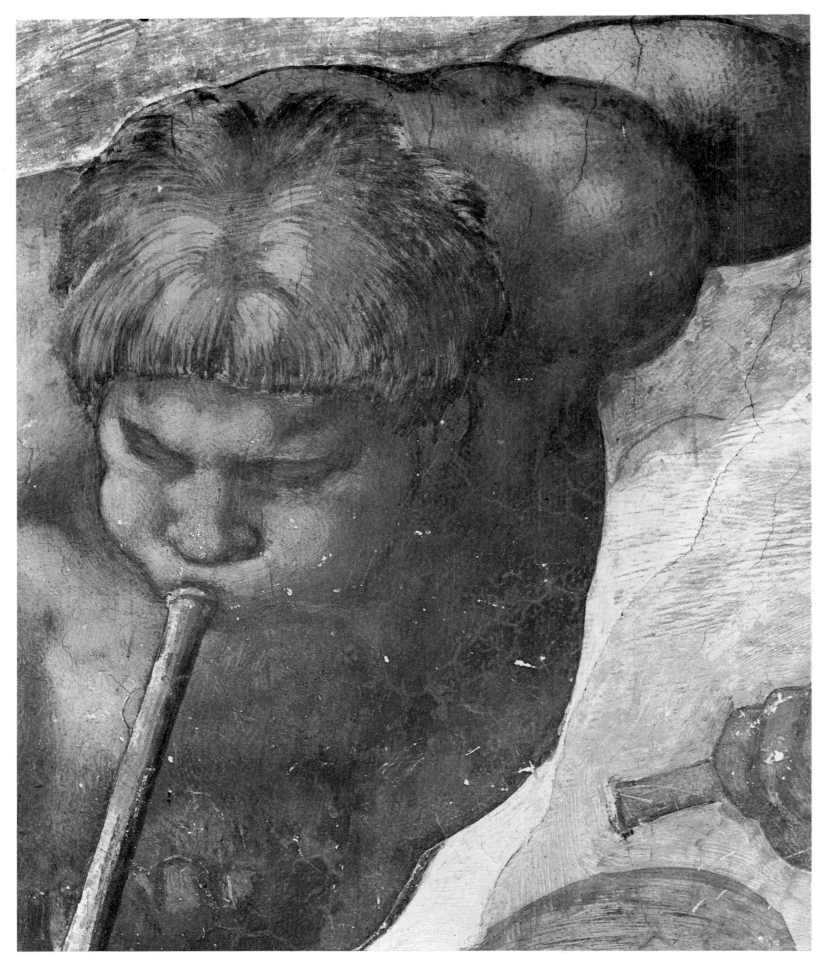

PLATE L THE LAST JUDGEMENT Vatican, Sistine Chapel [No. 73]
Detail of an angel (44 cm.)

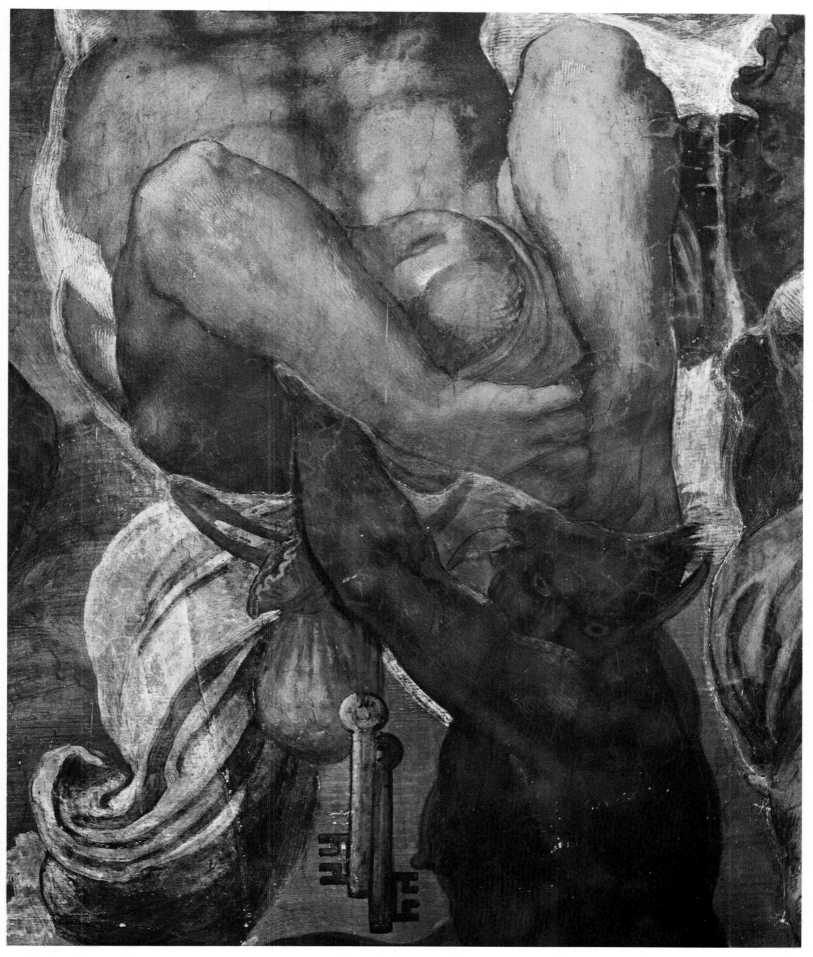

PLATE LI THE LAST JUDGEMENT Vatican, Sistine Chapel [No. 73]
Detail of figure 41: an avaricious man (78 cm.)

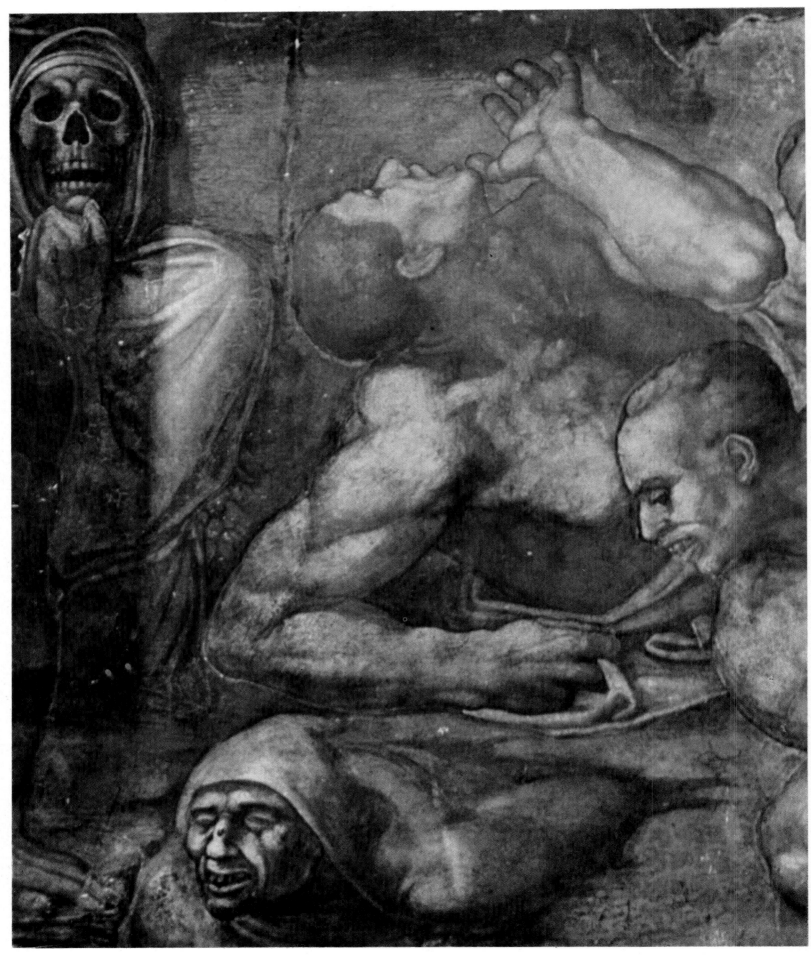

PLATE LII THE LAST JUDGEMENT Vatican, Sistine Chapel [No. 73]
Detail of the resurrection of the dead (235 cm.)

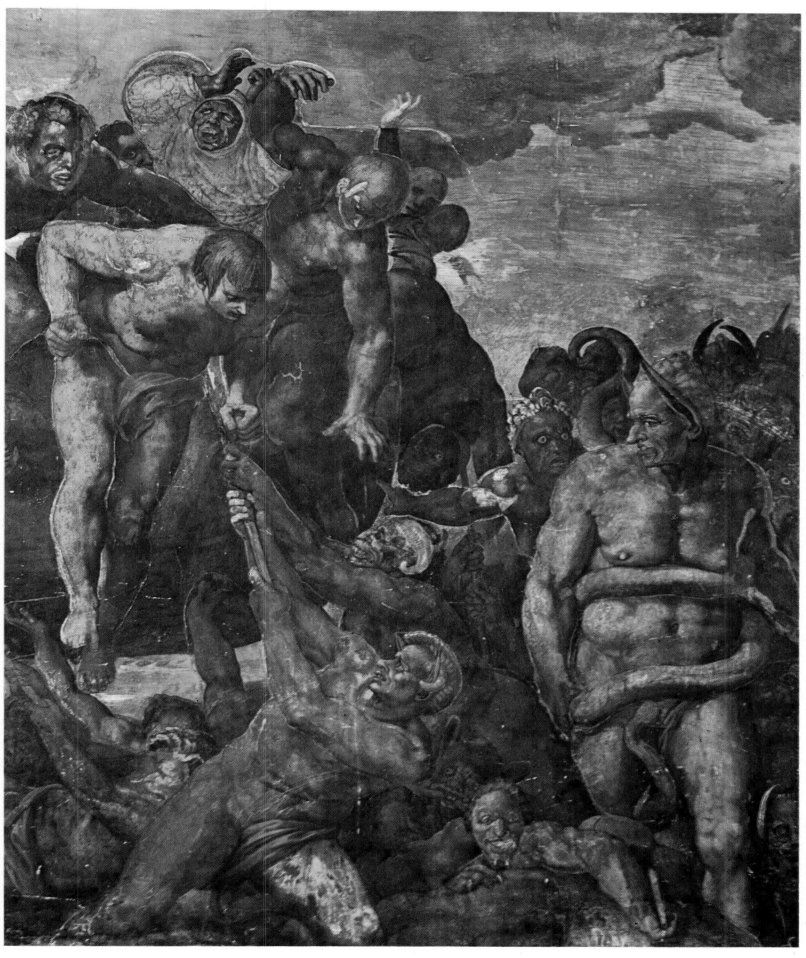

PLATE LIII THE LAST JUDGEMENT Vatican, Sistine Chapel [No. 73]
The damned with demons and Minos: figure 50 (202 cm.)

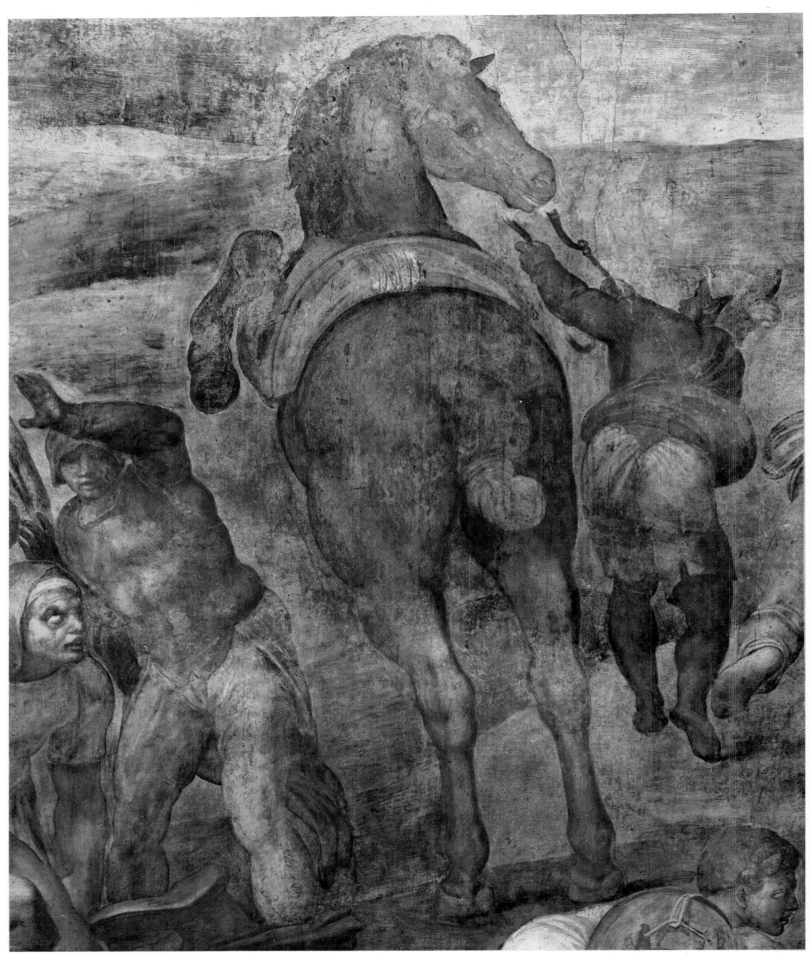

PLATE LIV THE CONVERSION OF SAINT PAUL Vatican, Pauline Chapel [No. 77]
Detail (202 cm.)

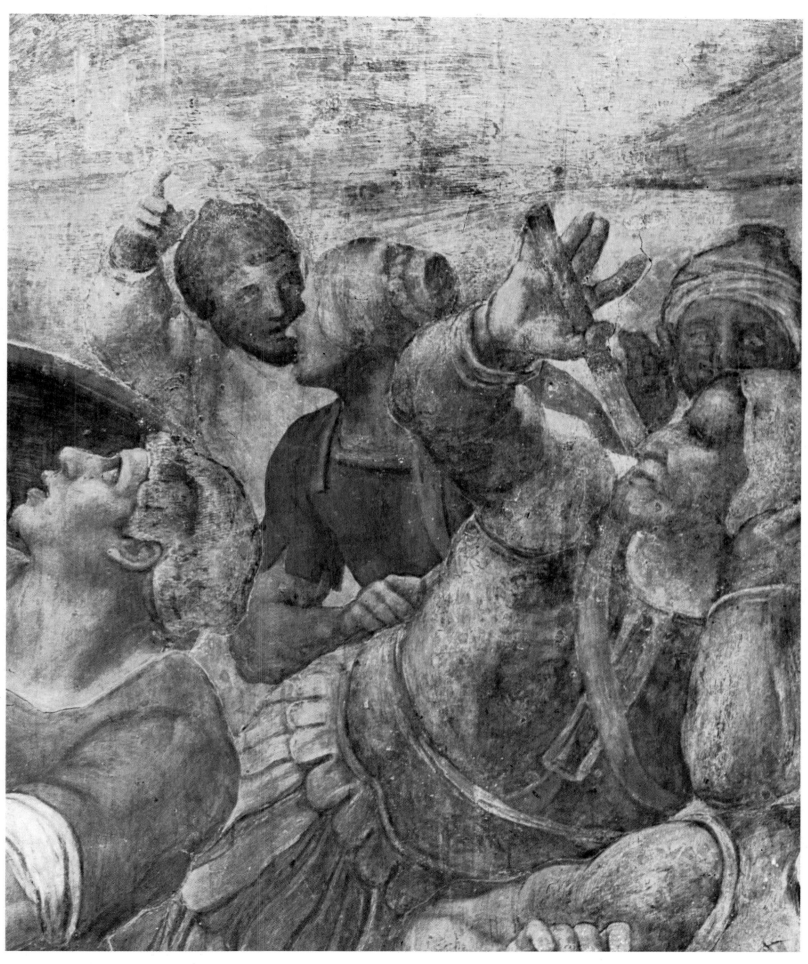

PLATE LV THE CONVERSION OF SAINT PAUL Vatican, Pauline Chapel [No. 77]
Detail (114 cm.)

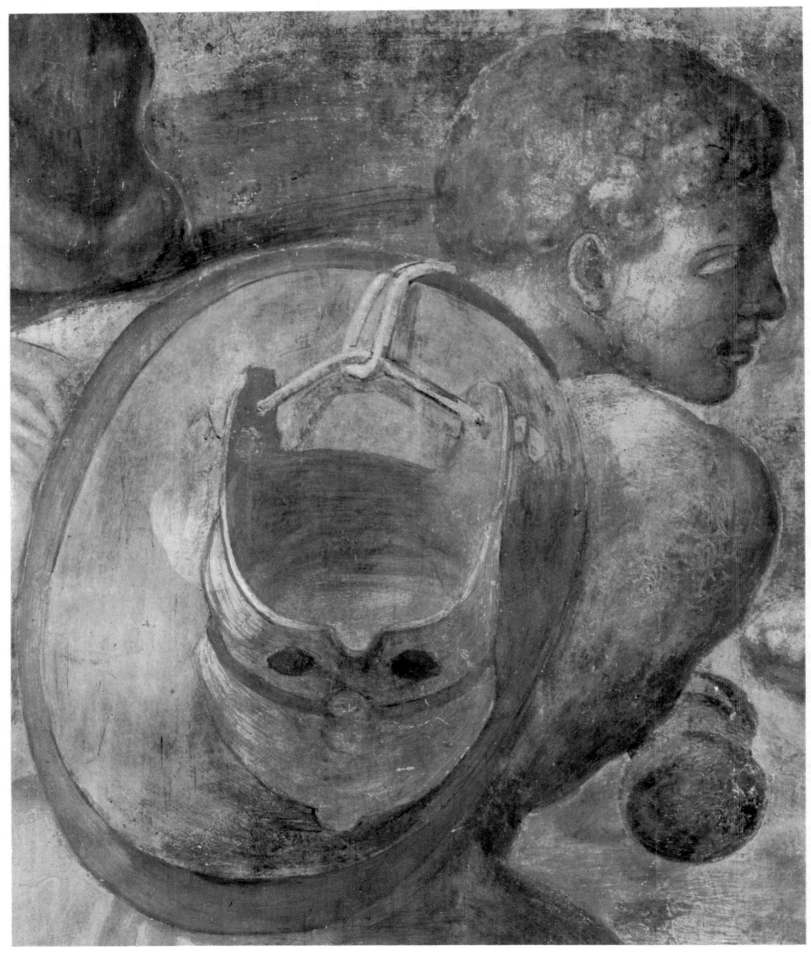

PLATE LVI THE CONVERSION OF SAINT PAUL Vatican, Pauline Chapel [No. 77]
Detail (63 cm.)

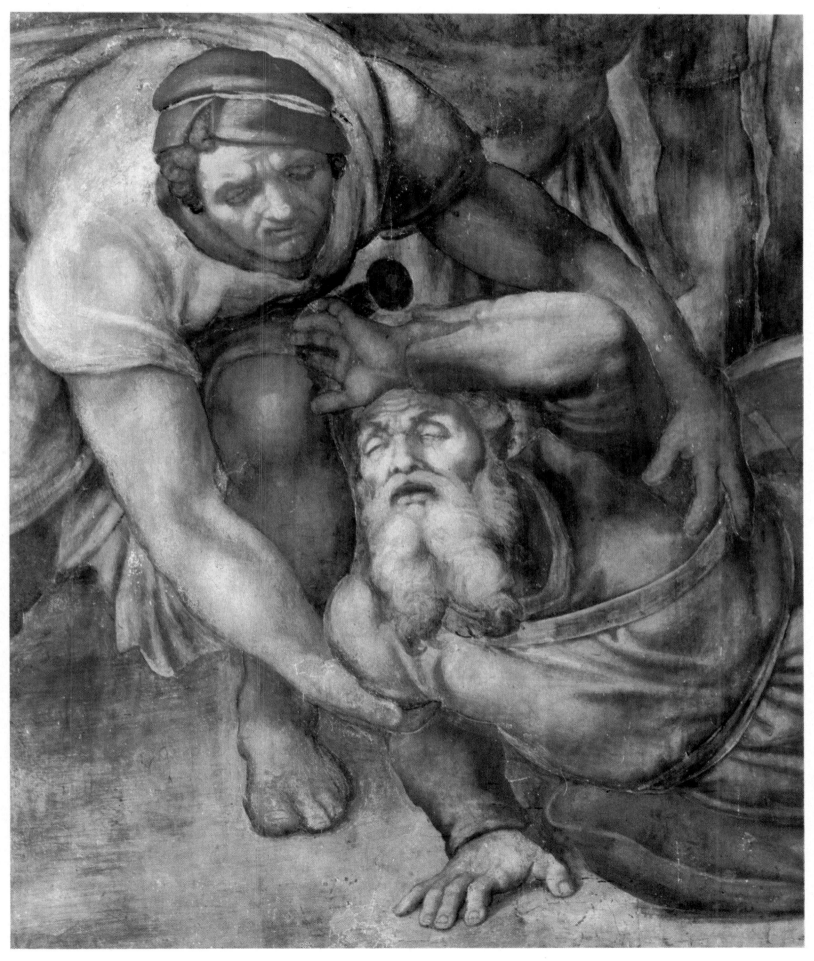

PLATE LVII THE CONVERSION OF SAINT PAUL Vatican, Pauline Chapel [No. 77]
Detail of Paul with a soldier 101 cm.)

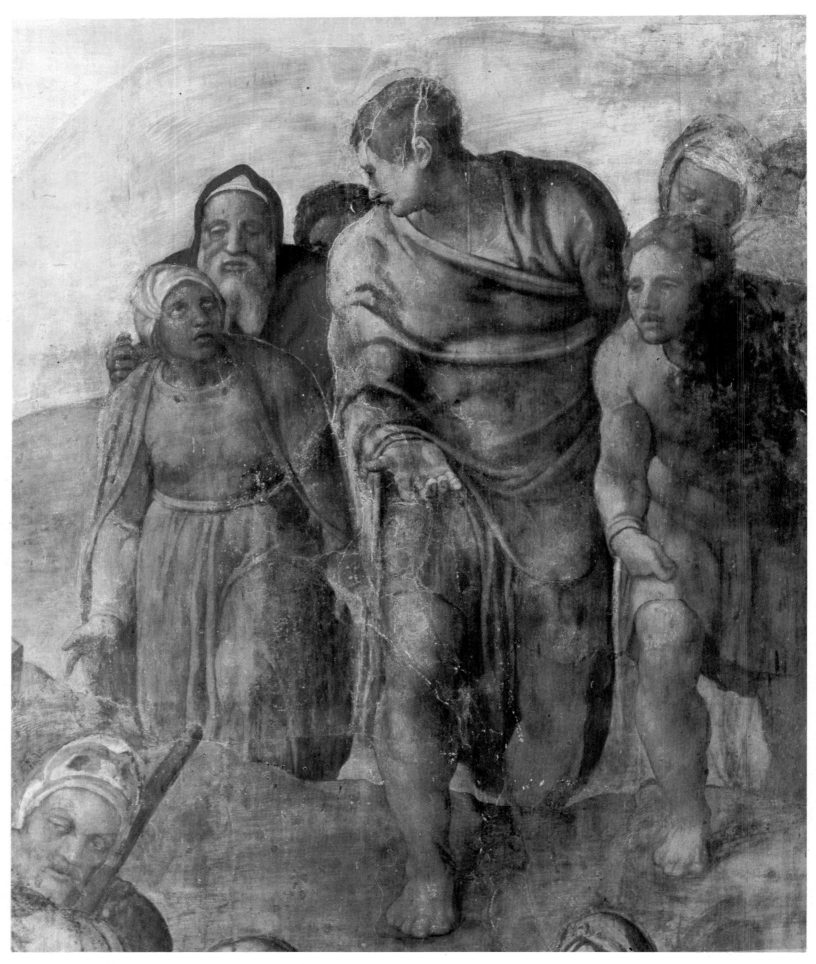

PLATE LVIII THE CRUCIFIXION OF SAINT PETER Vatican, Pauline Chapel [No. 78]
Detail (151 cm.)

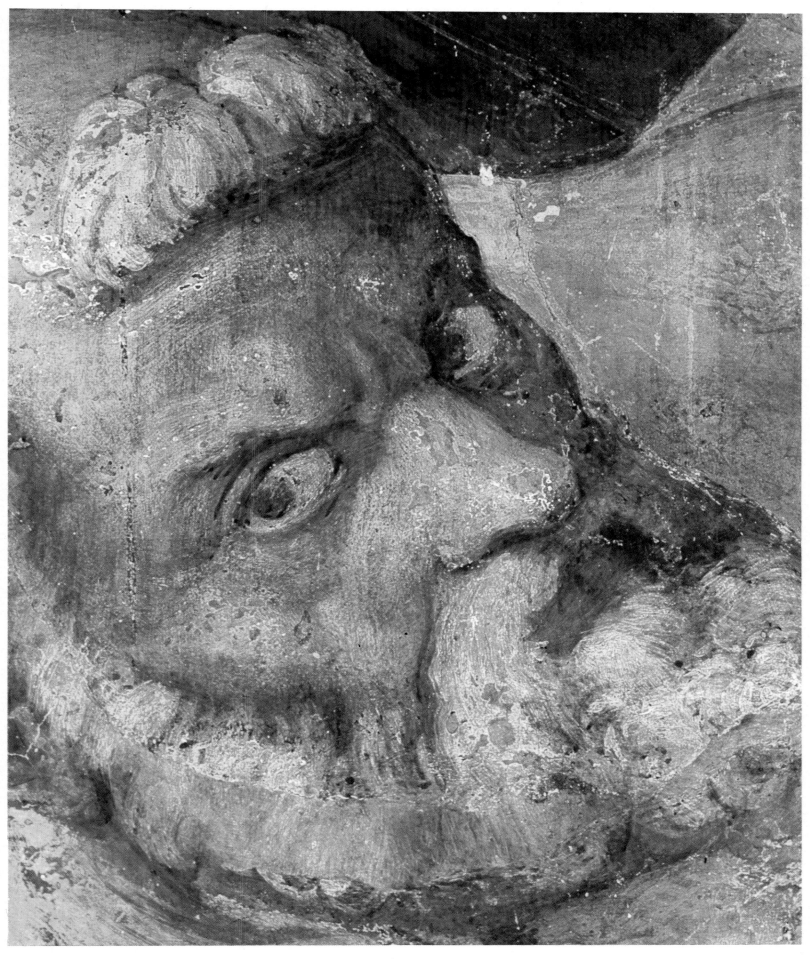

PLATE LIX THE CRUCIFIXION OF SAINT PETER Vatican, Pauline Chapel [No. 78]
Detail of Saint Peter (41 cm.)

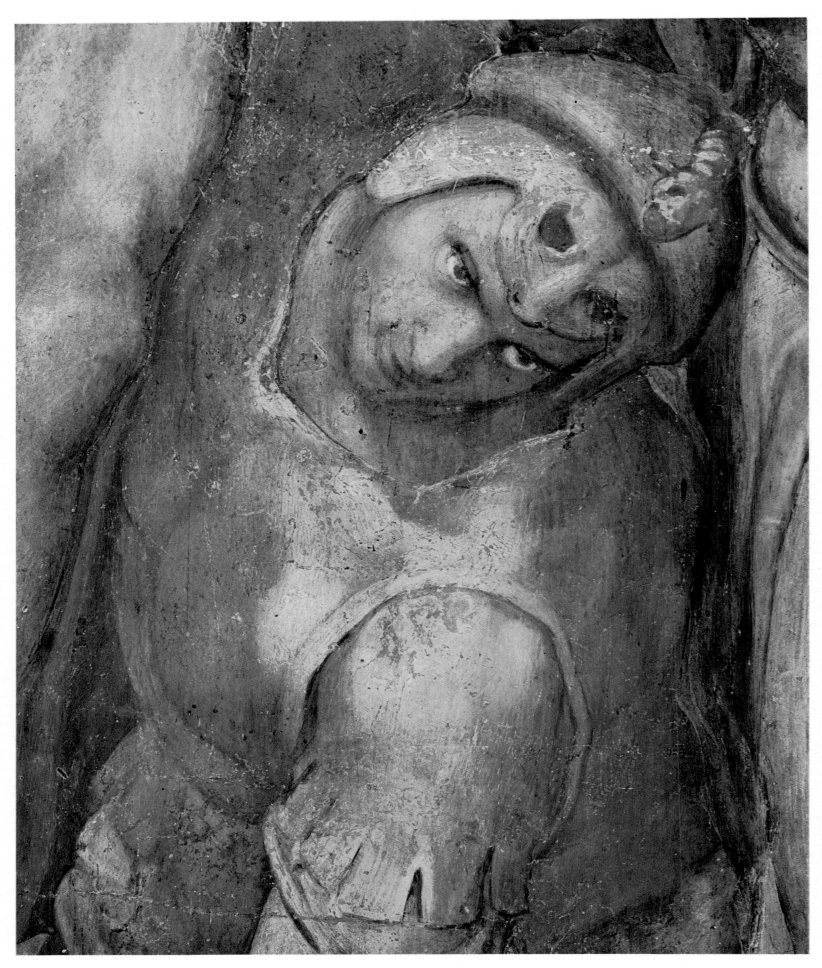

PLATE LX THE CRUCIFIXION OF SAINT PETER Vatican, Pauline Chapel [No. 78]
Detail (76 cm.)

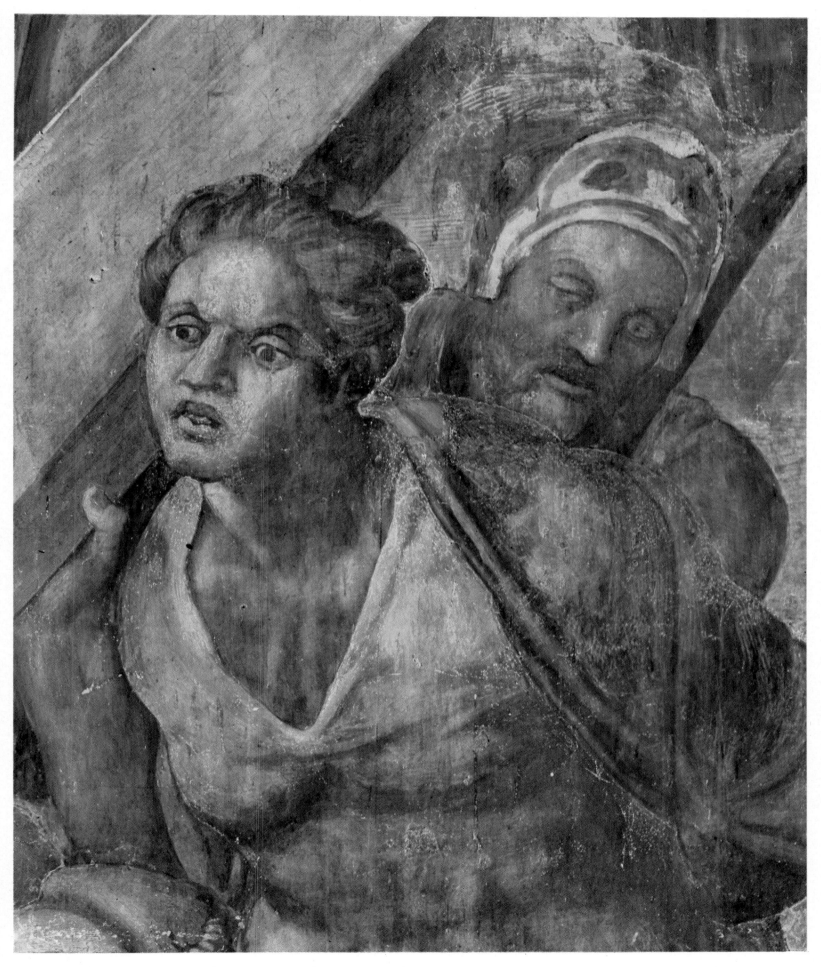

PLATE LXI THE CRUCIFIXION OF SAINT PETER Vatican, Pauline Chapel [No. 78]
Detail (74 cm.)

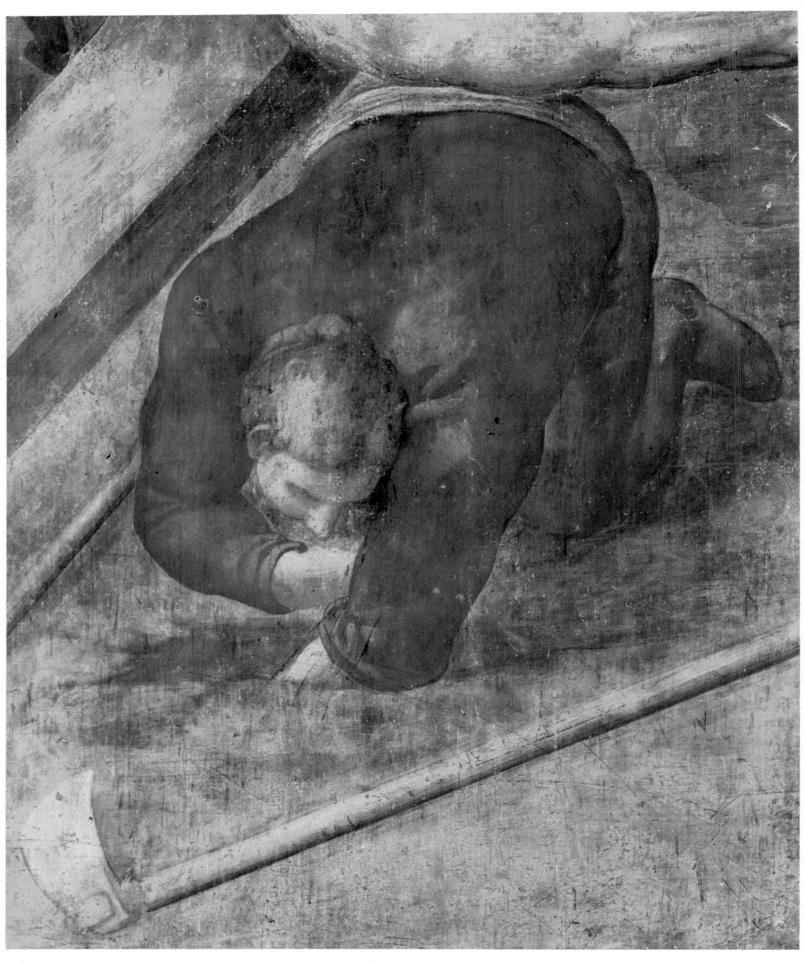

PLATE LXII THE CRUCIFIXION OF SAINT PETER Vatican, Pauline Chapel [No. 78]
Detail (95 cm.)

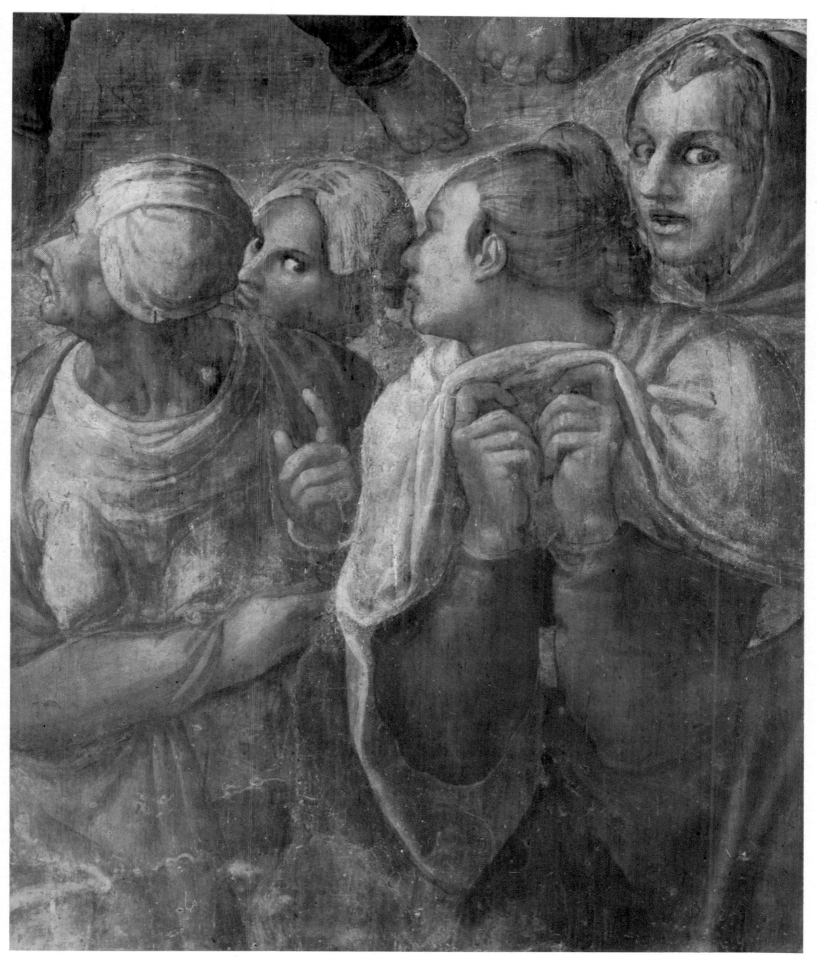

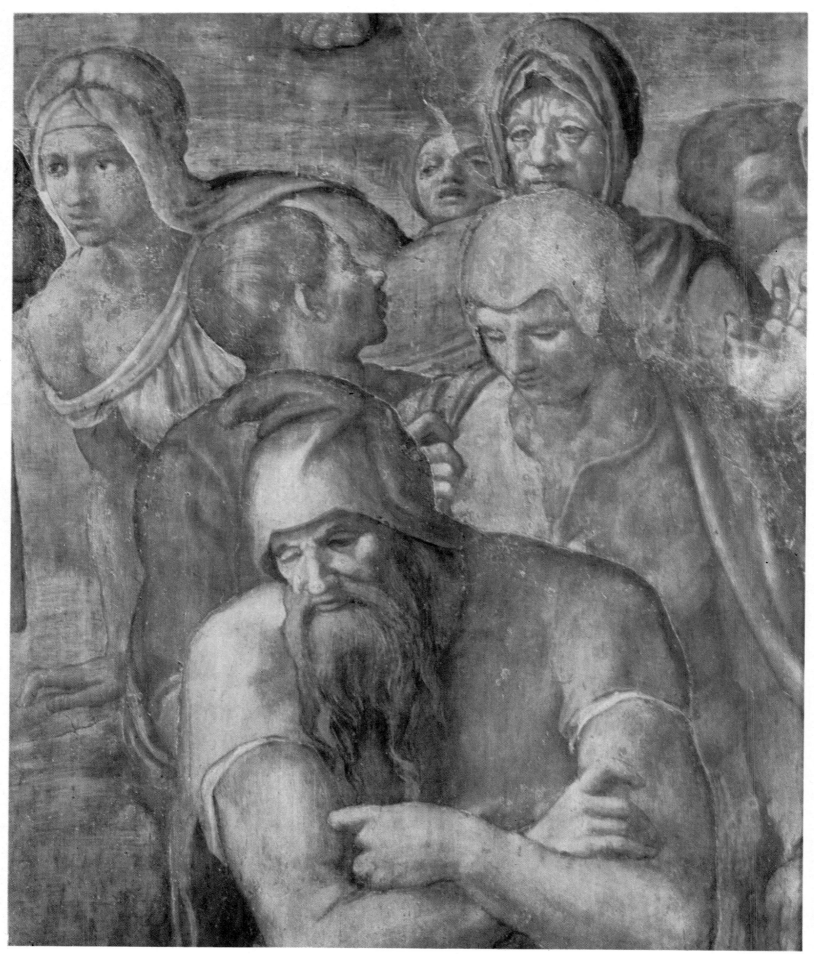

PLATE LXIV THE CRUCIFIXION OF SAINT PETER Vatican, Pauline Chapel [No. 78]
Detail (103 cm.)

The Works

In order to provide, in readily accessible form, a guide to the basic elements of each work, all items of the Catalogue are preceded by a number (which refers to the chronological position of the work in the painter's activity, and is used throughout this volume for purposes of identification), and by a series of symbols denoting the following: 1) execution of the work: i.e., to what extent it is the artist's own work; 2) medium; 3) base; 4) location; 5) other information such as: whether the work is signed or dated; whether it is now complete; whether it was originally finished. The remaining numerals denote respectively the size, in centimetres, of the painting (height x width) and the date. These figures are preceded or followed by an asterisk in all cases in which the information given is only approximate. All such data are based on the general consensus of opinion and any further relevant data are discussed in the text.

Basic Bibliography

The very extensive literature on Michelangelo up to 1926 was recorded in *Michelangelo Bibliographie* by E. STEINMANN and R. WITTKOWER (Leipzig, 1927), updated by H. W. SCHMIDT in an appendix to *Michelangelo im Spiegel seiner Zeit*, also by STEINMANN (Leipzig, 1930), and subsequently by P. CHERUBELLI in the collection of studies *Michelangelo Buonarroti nel quarto centenario del ... Giudizio* (Florence, 1942), by P. BAROCCHI in G. VASARI's *La vita di Michelangelo* (Naples, 1962), and finally by P. MELLER in the miscellany *Michelangelo, artista pensatore e scrittore* (Novara, 1965).

The main body of documents concerning the artist was compiled by G. MILANESI in *Lettere di Michelangelo ... coi ricordi ed i contratti artistici* (Florence, 1875), and a more complete one is published under the editorship of A. FORTUNA ('Il Vasari', 1957-66). Also fundamental are: B. VARCHI (*Due lezzioni*, Florence, 1549), G. VASARI (*Le vite*, Florence, 1550 and 1568) and A. CONDIVI (*Vi-*

ta di Michelagnolo Buonarroti, Rome, 1553).

Among modern studies worthy of mention are those by H. THODE (*Michelangelo und das Ende der Renaissance*, Berlin, 1902-13 and 1912-30; *Michelangelo*, Berlin 1908-13), A. BERTINI (*Michelangelo fino alla Sistina*, Turin, 1942), V. MARIANI (*Michelangelo*, Turin, 1942; *Michelangelo pittore*, Milan, 1964), E. CARLI (*Michelangelo*, Bergamo, 1942 and 1946; *Tutta la pittura di Michelangelo*, Milan, 1951 and 1964), C. DE TOLNAY (*Michelangelo* I-V, Princeton, 1943-60), H. VON EINEM (*Michelangelo*, Stuttgart, 1959), J. S. FREEDBERG (*Painting of the High Renaissance*, Cambridge, Mass., 1961), L. GOLDSCHEIDER (*Michelangelo*, Köln, 1964), R. SALVINI (in the above-mentioned miscellany published at Novara in 1965). Concerning the Sistine Chapel, see E. STEINMANN (*Die Sixtinische Kapel*, Munich, 1901-1905) and R. SALVINI, E. CAMESASCA and C. L. RAGGHIANTI (*La Cappella Sistina in Vaticano*, Milan, 1965); for the ceiling in particular, see

the works of H. WÖLFFLIN ('Die Sixtinische Decke Michelangelos", *Repertorium für Kunstwissenschaft*, 1890), E. WIND (*Gazette des Beaux-Arts*, 1944), F. HARTT (*The Art Bulletin*, 1950), J. WILDE (*The Decoration of the Sistine Chapel*, London, 1958); for the *Last Judgement*, see the works of D. REDIG DE CAMPOS and B. BIAGETTI (*Il Giudizio universale*, Rome, 1944); the former's contribution was brought up to date and republished, Milan, 1964); for the Pauline Chapel, the works of V. MARIANI (*Gli affreschi di Michelangelo nella Cappella Paolina*, Rome, 1932) and DE CAMPOS (*Affreschi della Cappella Paolina*, Milan, 1951). In addition, mention should be made of the contributions — concerning aesthetics and technique — by E. MONTÉGUT (1870), C. H. WILSON (1876), H. WÖLFFLIN (1899), H. VOSS (1920), E. PANOFSKY (1921), M. DVORAK (1927-29), A. VENTURI (1926 and 1936) and G. BRIGANTI (1945); regarding these, see the critical outline that is printed on pages 12-14 of this volume.

82

Execution

⊞ Autograph

⊞ With assistance

⊞ With collaboration

⊞ With extensive collaboration

⊞ From the workshop

⊞ Generally attributed

⊞ Generally not attributed

⊞ Traditionally attributed

⊞ Recently attributed

Technique

⊕ Oil

⊕ Fresco

⊕ Tempera

Base

⊕ Panel

⊕ Wall

⊕ Canvas

Location

⦂ Open to the public

Private collection

Whereabouts unknown

Lost work

Additional data

☰ Signed work

☰ Dated work

☰ Part or fragment

☰ Unfinished work

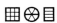
Information supplied in the text

Outline Biography

1475, 6 MARCH. Michelangelo Buonarroti, the second of five children, was born at Caprese in the Casentino region, to the Florentine Lodovico di Leonardo di Buonarroto Simoni (then the *podestà* of Caprese under the jurisdiction of Florence), and Francesca di Neri di Miniato del Sera. At the end of March, having completed his six-month term of office, the father took the family back to Settignano (near Florence) and entrusted his new-born son to a wet nurse, the daughter and wife of stonemasons: the artist considered this a determinant factor in his later development.

1481. Michelangelo's mother died. The boy studied grammar with the Humanist Francesco Galatea da Urbino. Later he became acquainted with the painter Francesco Granacci, his elder by six years, who encouraged him to draw, against Lodovico Buonarroti's wishes.

1488, 1 APRIL. Having finally resigned himself, Michelangelo's father placed him in the Florentine workshop of the painter brothers Domenico and Davide Ghirlandajo, stipulating — as was customary — a contract of apprenticeship for a period of three years. Through his 'spokesman' Condivi, the elderly Michelangelo was later to deny this apprenticeship, although it is documented by various accounts (Vasari, Varchi, etc.) and by some of his very work (see, in particular, the *Catalogue of Works*, page 85, 4). During the period in question, Michelangelo did copies of Giotto and Masaccio and of Schongauer's *Temptation of St. Anthony* (*Catalogue*, 1).

1489-92. Having left the Ghirlandajos' workshop one year before the expiration of his term — because of disagreement with Domenico Ghirlandajo. According to his first two biographers, Vasari and Condivi, Michelangelo then attended the 'school' in the Medici Garden at Piazza San Marco, where he studied the rich collection of works of art assembled by Lorenzo the Magnificent, under the guidance of Bertoldo di Giovanni, who could therefore be considered his immediate teacher, at least in sculpture. This fact is accepted unreservedly by most critics, including recent ones; nevertheless, the brevity of Condivi's mention of this period and the many uncertainties and contradictions in Vasari's writings, led some scholars to express a well-founded scepticism regarding the acceptability of the 'Garden' as an *ante litteram* academy, and it has finally been conjectured that Buonarroti's practical instruction in sculptural technique took place much more likely within the circle of Benedetto da Maiano [Lisner, 1963, 1964]. There is no doubt, at any rate, that during this period Michelangelo was welcomed almost as an adopted son by Lorenzo de' Medici, who was enchanted with his talent; in the Palazzo Medici he met Poliziano, Marsilio Ficino, Pico della Mirandola and other Humanists of the Medici circle. There he executed, among other things, the *Virgin of the Stairs* (Florence, Casa Buonarroti) and the *Battle of the Centaurs* (*ibid.*). After the death of Lorenzo de' Medici, Piero continued the hospitality to the artist.

1494, OCTOBER - **1495**, NOVEMBER. Shortly before Charles VIII of France made his entrance into Florence, Michelangelo fled to Venice; he then went on to Bologna, where he added to the sculpture of St. Dominic's tomb.

1495, NOVEMBER - **1496**, JUNE. Michelangelo returned to Florence, where he carved two statuettes (both lost) for Pierfrancesco de' Medici, a supporter of the popular government inspired by Fra' Savonarola, of whom Michelangelo was an admirer though not a close follower.

1496, JULY. Michelangelo went to Rome for the first time, as a guest of Cardinal Riario.

1497, NOVEMBER. After sculpturing his *Bacchus* (Florence, Bargello) and a *Cupid* (lost) for the banker Jacopo Galli, he was commissioned to carve the *Pietà* for St. Peter's and left for Carrara to select the marble.

1498, AUGUST - **1499**. Execution, in Rome, of the Vatican

Presumed self-portraits: in the Last Judgement *and in the Nicodemus of the* Pietà *in Florence Cathedral.*

Pietà. Around this time he presumably made a cartoon for *St. Francis Receiving the Stigmata* (lost), for the Church of S. Pietro in Montorio (*Catalogue*, 7).

1501. He returned to Florence, under the republican government. Beginning of the *Bruges Madonna* (Church of Notre-Dame); on 5 June he was commissioned to make some sculptures for the Piccolomini altar in Siena Cathedral, and on 16 August he was entrusted with the carving of the marble *David* for the Piazza della Signoria (Florence, Accademia).

1502, 12 AUGUST. The Signoria of Florence asked him to make a bronze *David* for Cardinal Pierre de Rohan; this was still unfinished in 1508 and later completed by Benedetto da Rovezzano.

1503, 24 APRIL. The Opera di S. Maria del Fiore commissioned him to carve twelve statues of *Apostles* for the interior of the Cathedral; he was to rough out only one of them (*St. Matthew*, Florence, Accademia).

1504. At this time he was probably engaged in carving the marble *Pitti Tondo* (Florence, Bargello) and the *Taddei Tondo* (London, Royal Academy), and about to begin painting the *Doni Tondo* (*Catalogue*, 8). In August he was commissioned to paint the *Battle of Càscina* (*Catalogue*, 9); on 8 September the marble *David* was set up in the Piazza della Signoria (a copy was put in its place in 1873).

1505, MARCH. Pope Julius II summoned the artist to Rome to execute his funerary monument; the design was approved before May, and Michelangelo moved to Carrara until December to supervise the quarrying of the marble.

1506. Back in Rome, he was denied audience by the Pope and confirmation of the commission for the tomb; on 18 April he returned indignantly to Florence. Thus began the 'tragedy of the tomb' — as Michelangelo himself was to call it — which was to distress the artist for forty years. In Florence, he took up again the cartoon for the *Battle of Càscina*, while the Pope addressed at least three messages to the Gonfaloniere of Florence requesting Buonarroti's return to Rome. Michelangelo finally joined him in Bologna on 21 November; there Julius commissioned a large bronze equestrian statue of himself, to be set up in front of S. Petronio. Michelangelo remained to execute it.

1508, 21 FEBRUARY. The monument of Julius II was unveiled. Michelangelo returned to Florence at once and Gonfaloniere Soderini commissioned *Hercules and Antaeus*.

1508, APRIL. Having returned to Rome, on 10 May he signed the agreement to fresco the

Self-caricature drawn during the execution of the Sistine Ceiling frescoes.

ceiling of the Sistine Chapel. The exhausting undertaking began soon afterwards, and was made heavier by Michelangelo's typical dissatisfaction with himself, by delays in payment and the constant requests for financial assistance which he received from his family.

1509, 27 JANUARY. He wrote to his father: '... for over a year now I have had not even one *grosso* from this pope, and I ask for none since my work does not progress in such a way as to make me feel I deserve it. And this is the difficulty of the work, in addition to painting not being my profession. And thus I waste my time without reward, may God help me.'

1509, FEBRUARY-MARCH. Again writing to his father, he confirmed: 'I am dissatisfied here and not particularly healthy, very weary, uncared for and without money.'

1510, JANUARY. In sending his father one hundred ducats for

the purchase of a shop for his brother 'Buonarroto and the others,' he wrote: 'I have no money. What I send I tear from my heart, and it does not seem right to ask for any.'

1511, 30 DECEMBER. The Commune of Bologna had the statue of Julius II destroyed and melted down.

1512, 11 OCTOBER. Completion of the Sistine Chapel frescoes (for other chronological data, see *Catalogue*, 14-72). In the meantime, the Medicis' return to Florence caused great apprehension to the artist and to his relatives, who were deprived of the small political offices and compensations granted them by the republican government.

1513, MARCH. After the death of Julius II, his Della Rovere heirs and Michelangelo stipulated a new contract for the tomb, and the forty statues initially planned were reduced to twenty-eight; of these, three were begun: the *Moses* (Rome, Church of S. Pietro in Vincoli) and two *Captives* (Paris, Louvre), the work being frequently interrupted by trips to the Carrara quarries.

1514, 15 JUNE. Michelangelo was commissioned to carve the *Resurrected Christ* for the Church of S. Maria sopra Minerva in Rome.

1516. Another contract (8 July) for the tomb of Julius II further

in the New Sacristy, but the number was reduced to two.

1521, MARCH. Beginning of the work on the Medici tombs. In August the *Resurrected Christ* for S. Maria sopra Minerva arrived in Rome.

1523. The heirs of Julius II, supported by the new pope, Hadrian VI, demanded Michelangelo's fulfillment of the contract for the tombs. The Genoese Senate commissioned a statue of Andrea Doria.

1524. Work was begun on the Laurenziana Library in Florence, and on the figures for the tomb of Lorenzo de' Medici in the New Sacristy, including the statues of *Dusk* and *Dawn*.

1526. A new, simpler design for the tomb, put forward by Michelangelo, was rejected by the heirs of Julius II. The artist began work on the tomb of Giuliano de' Medici for S. Lorenzo, with the statues of *Night* and *Day*.

1527. The Medici were expelled from Florence, and work on the Medici Chapel in S. Lorenzo consequently interrupted.

1528, 22 AUGUST. Michelangelo put himself at the disposal of the republican government; his commission for *Hercules and Antaeus* was confirmed, but the artist transformed the subject into *Samson with two Philistines*.

1530. While Florence was under siege, Michelangelo paint-

ues. Michelangelo met Tommaso de' Cavalieri, a brilliant young Roman nobleman of extraordinary beauty, for whom he was to develop a passionate friendship, dedicating to him drawings and poems.

1533, 22 SEPTEMBER. At San Miniato al Tedesco, Michelangelo met Clement VII, while the latter was on his way to France: it has been suggested that the painting of the *Last Judgement* in the Sistine Chapel was agreed upon on this occasion.

1534, SEPTEMBER. Interrupting the sculptures for the Medici tombs in S. Lorenzo, the artist settled in Rome. A few days later Clement VII died; Michelangelo left the *Last Judgement* and resumed work on the tomb of Julius II.

1535. The new pope, Paul III Farnese, confirmed the commission for the *Last Judgement* and appointed Michelangelo (1 September) painter, sculptor and architect of the Vatican Palace.

1537 ca. Michelangelo became acquainted with Vittoria Colonna, the widow of Ferrante d'Avalos, a sensitive poetess full of religious fervour; the artist was to dedicate to her verse and representational works as a mark of devoted friendship.

1538. Michelangelo supervised the setting up of the equestrian statue of Marcus Aurelius on the Roman Capitol.

work was begun for the new arrangement of the Capitol. At the end of the year, completion of the architectural part of the tomb of Julius II in S. Pietro in Vincoli.

1545. Perhaps in February, the statues for the tomb of Julius II were set up. Certainly during that month he painted a *Crucifixion* for Vittoria Colonna (*Catalogue*, 79); within the year he completed the *Conversion of St. Paul* in the Pauline Chapel.

1546. Beginning of the *Crucifixion of St. Peter* in the Pauline Chapel. In October, after the death of Antonio da Sangallo the Younger, Michelangelo was appointed to replace him as works supervisor of the Vatican Basilica. According to Vasari, he won the competition announced by Paul III for the completion of the Farnese Palace.

1547, 25 FEBRUARY. Death of Vittoria Colonna, a bitter loss to Michelangelo.

1549. Benedetto Varchi published his *Due lezzioni* (two lectures), held at Florence to illustrate a sonnet by Michelangelo.

1550. Probable completion of the Pauline frescoes. Giorgio Vasari published the first edition of the well-known *Vite*, a literary monument to Michelangelo's fame.

1552. End of the work for the

1556, SEPTEMBER. The approach of the Spanish army induced Michelangelo to abandon Rome, bound for Loreto; he stopped in Spoleto, where on 31 October he received the pope's request to return.

1557. The artist executed a model for St. Peter's dome.

1559. Designs were made for the Church of S. Giovanni de' Fiorentini and for the Sforza Chapel in S. Maria Maggiore. Michelangelo sent to Florence the model for the staircase of the Laurenziana Library. It is probable that he may already have been working on the Rondanini *Pietà* (Milan, Castello Sforzesco).

1560. He designed for Catherine de' Medici a monument in honour of Henri II of France; designed the tomb of Giangia-

Michelangelo, St. Matthew (1503-1505; det.; probably a self-portrait), Florence, Accademia.

como de' Medici for Milan Cathedral, executed by Leone Leoni; and designed Porta Pia in Rome.

1561. He designed the Church of S. Maria degli Angeli in Rome.

1563, 31 JANUARY. Foundation of the *Accademia del Disegno* in Florence (the first art academy in history); Michelangelo was appointed head together with Cosimo I de' Medici.

1564, 21 JANUARY. The Congregation of the Council of Trent decided that any part of the *Last Judgement* that might be 'obscene' should be 'covered', and the 'moralizing' repairs began immediately.

1564, 18 FEBRUARY. Almost ninety, Michelangelo died at dusk in his house at Macel de' Corvi in Rome, in the presence of a few friends, including Tommaso de' Cavalieri, who had attended him during his brief illness.

1564, 11 MARCH. In order to comply with Michelangelo's wish to be buried in Florence, his nephew Leonardo had his body secretly transferred to that city, where it was buried (12 March) in the Church of S. Croce.

1564, 14 JULY. Michelangelo's solemn funeral took place in the Church of S. Lorenzo (Florence); it was arranged by the Accademia, and Benedetto Varchi pronounced the official oration.

Iacopino del Conte (attr.) and Giuliano Bugiardini, Portraits of Michelangelo (det.), Florence, Casa Buonarroti; *Lorenzo Lotto*, Portrait of a Man (Michelangelo?; det.), Nancy, Musée des Beaux-Arts; *Giambologna*, Michelangelo (bronze bust; det.), Florence, Accademia.

reduced its size and importance. The new Medici pope, Leo X, commissioned the artist to design the façade of the Medici Church of S. Lorenzo in Florence.

1518. New designs and new visits to the quarries for the façade of S. Lorenzo.

1519, 20 OCTOBER. Michelangelo suggested to the Pope the execution of a tomb for Dante in Florence; he was instead entrusted with the construction of the New Sacristy in the Church of S. Lorenzo, to contain six Medici tombs.

1520, 10 MARCH. For unexplained reasons, Leo X changed his mind about the façade of S. Lorenzo and cancelled the contract, thus provoking great resentment in the artist. In November, Michelangelo executed the models for the Medici tombs

ed a *Leda* for the Duke of Ferrara (*Catalogue*, 74) and carved an *Apollo* (Florence, Bargello) for Baccio Valori. On 12 August the Florentine Republic capitulated, and the artist took refuge in the cloisters of S. Lorenzo, barely escaping the hired assassins of Alessandro de' Medici. Soon afterwards, pardoned by Clement VII, he resumed work on the Laurenziana Library and on the New Sacristy.

1531. In April he made the cartoon for the *Noli me tangere* (*Catalogue*, 75) and, while continuing his activity in the New Sacristy (completing *Dawn* and *Night*) and the Library, he designed the *Tribuna delle reliquie*, also for S. Lorenzo.

1532, APRIL. In Rome, negotiations were entered into by the Pope and the heirs of Julius II, resulting in yet another contract for the tomb, with only six stat-

1539. He may have begun to carve the *Brutus* (Florence, Bargello) for Cardinal Niccolò Ridolfi.

1541, 31 OCTOBER. Unveiling of the *Last Judgement* (for other data, see *Catalogue*, 73).

1542, 20 AUGUST. Last contract for the tomb, with the condition that Michelangelo complete a single statue, the *Moses*, while two others — *Leah* and *Rachel* (in place of the *Captives*) — were to be finished by Raffaello da Montelupo. Shortly afterwards Michelangelo began the frescoes of the Pauline Chapel (*Catalogue*, 77-78).

1544. In January he designed the tomb of Francesco Bracci, the nephew of Luigi del Riccio; in the latter's house he was assisted during the serious illness which struck him in June. After designs by Michelangelo,

Capitol's flight of steps. Michelangelo designed the flight of stairs of the Belvedere courtyard in the Vatican.

1553. Work on the *Pietà*, now in Florence Cathedral. His follower Ascanio Condivi published the *Vita di Michelangelo Buonarroti*.

1555. The election of Marcellus II to the papacy jeopardized Michelangelo's position as supervisor in the building of St. Peter's but this pope was soon succeeded by Paul IV, who confirmed the artist's appointment, employing him in the construction of the basilica's dome. Death of Michelangelo's brother Gismondo and of Francesco Amadori, known as 'l'Urbino', who had been Buonarroti's faithful servant and assistant for twenty-six years. Probable beginning of the *Pietà* of Palestrina (Florence, Accademia).

Catalogue of Works

Chronological and iconographical inventory of all the paintings of Michelangelo Buonarroti and of works attributed to him.

1 ▦ ✪ 47×35 1487* ▤ ○○

TEMPTATION OF ST. ANTHONY

Condivi, Vasari and Varchi all mention a copy of Martin Schongauer's engraving representing the *Temptation of St. Anthony*, executed by the young Michelangelo at Granacci's prompting. The first biographer records that it was diligently painted on a 'wooden panel'; and Varchi specifies that it was Buonarroti's 'first thing.' G. Bianconi [in Gualandi, 1840] identified as Michelangelo's a painting of this subject, which, after having met with some acceptance, was eventually rejected as a later work [Milanesi, 1881, VII]. Another painting — reproduced here; transferred (1837) from the Scorzi collection in Pisa to that of Baron Triqueti; then (1886) to the Lee-Child collection; finally (ca. 1905) to Sir Paul Harwey, who put it up for sale (1960 at Sotheby's in London) — was made known by Clément [1861]; his view of its authenticity was shared by others [Montaiglon, 1875, etc.], but disputed by Mantz [1876]; on the occasion of its last reappearance, it gave rise to doubtful verbal opinions which, at any rate, did not deny the unquestionable mark of the Ghirlandajos evident in the painting (especially in the head of the saint, to be compared with that of St. Joseph in the *Doni Tondo*) and in the exquisite freshness of the colours: so that it could at least be considered as a good copy of Michelangelo.

2 ▦ ✪ 100×71 1490* ▤ ：

THE HOLY FAMILY WITH THE INFANT ST. JOHN. Dublin, National Gallery of Ireland.

Regarded at the time as a work of Ghirlandajo, it passed in 1866 from the de Choiseul collection to its present home, in the most recent catalogue of which it bears the name of Buonarroti. The attribution to Michelangelo's very early period, in contact with Granacci, was put forward by Fiocco [1930, etc.] and accepted by Gamba [1932] and others; but it was rejected in favour of Granacci by Toesca [1934], Longhi [1941], Bertini [1942], Tolnay [1943-60], Zeri [1953] and various others.

3 ▦ ✪ 1488-90 ▤ ：

DORMITIO VIRGINIS (detail). Florence, Church of S. Maria Novella, Cappella Maggiore.

It is part of the mural series executed by Ghirlandajo for Giovanni Tornabuoni in 1485-90, with ample recourse to the workshop. Since the contract which bound the fourteen-year-old Michelangelo as apprentice specified that the boy was not only to learn but also to paint, and since the date of the document coincides with the execution of the cycle in question, Fineschi [1836] suggested that the hand of the apprentice could be perceived in the small figures on the terrace in the *Meeting of Mary and Elizabeth* (the *Visitation*), while Holroyd [1903] drew attention to the seated nude in the *Virgin in the Temple*. More recently [1953] Marchini pointed out the three figures on the right in the group reproduced here, and drew considerable agreement especially as regards the figure viewed from the rear, marked by a vigorous and imposing simplicity [Salvini, 1965]. (See also 4).

4 ▦ ✪ 1488-90 ▤ ：

BAPTISM OF CHRIST (detail). Florence, S. Maria Novella, Cappella Maggiore.

As in the case of 3 (q.v.) the hypothesis of a connection between these figures and the young Michelangelo was formulated by Marchini, and met with general agreement (though Longhi [1958] disputed both figures), especially in the restrained, very intense solidity of the kneeling figure about to be baptized [Salvini, 1965].

The early biographers, Vasari in particular, in attempting to create a myth of Michelangelo — and perhaps following suggestions by Michelangelo himself — ended by placing even his artistic beginnings on a plane of supreme, almost abstract divinity: Michelangelo, the pupil of the Masters of Antiquity by way of the works set in the Medici Garden and student under the uncertain guidance of a decrepit Bertoldo di Giovanni. Almost the direct pupil of the Ancients; what could have been more fitting for the 'divine artist' of the Renaissance? Even setting aside Chastel's [1950] legitimate doubts of the credibility of the Garden as an *ante litteram* academy (albeit sustained by Vasari, the passionate supporter of a real academy, such as the one that was to be formed in 1563, in Florence), and even without knowing anything abourt the apprenticeship in the Ghirlandajo workshop, the critics woud have been forced sooner or later to seek out a flesh and blood teacher for the young Buonarroti, unless they were prepared to continue accepting a supposition contrary to the artistic usage of the 15th century. The imprint of the *Manchester Madonna* (see 10) so obviously pervaded by the Ghirlandajos' style, suffices to prove the correctness of the reference.

5 ▦ ✪ *1490-92* ▤ ○○

ST. JOHN THE EVANGELIST. Basel, private collection.

Mentioned by Goldscheider [1952] as a work by the Manchester Master (see 10) after Longhi, Fiocco, Nicodemi and Magugliani had attributed it to Buonarroti. Longhi [1958] insisted on — and won agreement from others [e.g., Salvini, 1965] — the reference to Michelangelo at the time 'of his apprenticeship with Granacci, in the Ghirlandajo workshop.' Longhi identified the painting as a fragment of a large altar frontal

Lamentation (modern copy) in the Church of S. Cristoforo at Canonica (near Florence).

representing a *Lamentation*, formerly in the small Church of S. Cristoforo at Canonica (near Florence), where a recent copy, reproduced here, has since been placed.

6 ▦ ✪ diam. 66 1495* ▤ ：

MADONNA AND CHILD WITH THE INFANT ST. JOHN (Madonna of the Loggia), Vienna, Akademie der bildenden Künste.

It had already been attributed to Michelangelo in the year 1651, when it was in the Meniconi collection, Perugia. Re-

cently, it was related to Buonarroti's stay in Bologna (1494-95) — when he presumably studied the work of the Ferrarese artists Cossa, de' Roberti and Costa — on the basis of a hypothesis formulated by A. Venturi, accepted by Fiocco [1937], later rejected by Longhi [1942],

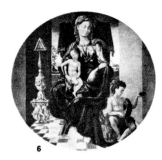

6

Bertini [1942], Tolnay [1943-60, I] and others, among them Zeri [1953], who ascribed it to the Master of the Manchester Madonna (see 10).

7 ▦ ✪ — 1500* ▤ ∘∘

ST. FRANCIS RECEIVING THE STIGMATA.

The Anonimo Magliabechiano [1537-42] mentioned a 'not very large altar panel' in the Church of S. Pietro in Montorio, Rome, with this subject interpreted 'in tempera, drawn and perhaps also coloured by the hand of Michelangelo'; Vasari, who first [1550] confirmed the attribution to Buonarroti, also for the execution of the actual painting, later [1568] limited the artist's contribution to the cartoon, while the rest is said to have been handled by a 'barbiere' (a bloodletter) in the service of Cardinal Riario, Michelangelo's host. Titi [1763] identified the painting with a work by Giovanni de' Vecchi in the same church: chronological reasons make this impossible [Baglione, 1642; Bottari, 1759-60, III]; the conclusion was therefore reached [Marchese, Pini, Milanesi, 1856] that de' Vecchi's painting was totally independent of Buonarroti or merely vaguely influenced by the latter [Tolnay, 1943-60, I], while it is absolutely out of the question [Thode, 1908-13] that it might have been painted over the Michelangelo original, as has also been conjectured.

8 ▦ ✪ diam. 120 *1504-06* ▤ ∶

THE HOLY FAMILY WITH THE INFANT ST. JOHN (Doni Tondo). Florence, Uffizi.

This work was interpreted in a pietistic key until the 17th century; then in a naturalistic-domestic key (Joseph hands the Child to Mary after she has finished reading) still supported by some scholars [Tolnay, 1943-60, I; Mariani, 1947, etc.]. Others credited it with the most varied allegorical meanings: such as the Virgin as a symbol of the Church and the nudes in the background as prophetic figures [Corsi, 1815]; the nudes as the 'fauns of a Dionysiac orgy' and symbols of paganism, in contrast with the figures in the foreground, who epitomize Christianity [Pater, 1871; Tolnay; etc.]; the various ages of men, with the nudes as pagan

youths, also in contrast with the principal figures [Thode, 1902-03; Justi, 1907; etc.]; an allusion to the family name of the first owners, with Mary asking Joseph to 'give' her (in Italian: donare, doni) her son [Brockhaus, 1909]; the nudes as a reference to primeval life [Toesca, 1934], or allusive to baptism [Mariani; ec.] or identified as angels; finally, the nudes as a symbol of humanity *ante Legem*, Mary and Joseph of humanity *sub Legem*, Jesus of humanity *sub Gratia*. The work was already mentioned as being in the Doni house by the Anonimo Magliabechiano [1537-42] and by A. F. Doni [1549]; a 1643 inventory records that it was by then in the Tribuna of the Uffizi. At first Vasari [1550] maintained that it was painted before the *Bacchus* of the Bargello, then [1568] he stated it to be a later work; according to Grimm [1863], it was painted in 1503; Poggi [1907], having discovered the coat of arms of the Strozzi family on the frame, which is original, assumed it was a present for the wedding of Maddalena Strozzi and Agnolo Doni, which took place between the end of 1503 and the beginning of 1504, within which period the scholar dated the painting; however, without discarding the hypothesis of the painting as a wedding present, somewhat later datings were also suggested: the time of the cartoon for the *Battle of Càscina* or shortly afterwards [Tolnay, 1943-60, I], 1506 [Wilde, 1953]; contemporaneously with the Sistine Ceiling [Baumgart, 1934-35; Bottari, 1941]. The most frequent analogical reference is to a tondo by Signorelli, now in the Uffizi (ca. 1490); but Leonardesque peculiarities were also pointed out [Einem, 1959] and, in the figure of the Virgin, a virile type of beauty quite similar to the Sibyls of the Sistine Chapel frescoes [Tolnay].

Granted that Michelangelo had recourse in sculpture to means regarded as prevalently pictorial (influenced by the tradition of Donatello), the tendency is to insist that, when painting, he was still intent on sculpture. Apart from the coarseness of such a judgement, which is applicable to most of the Tuscan artists (pre-eminently Botticelli), it takes no account of factors which demonstrate in Buonarroti a profound consciousness of the resources inherent in the pictorial means of expression, a consciousness which is evident even in the very conception of his paintings. Proof of this is in the very genesis of the *Doni Tondo*, according to the theses put forward by Ragghianti in his film on Michelangelo (1964). The structure of the work reveals that the exedra, where the background nudes sit, lies on a different perspective surface and has a lower vanishing point than the ground plane of the principal figures, and the low balustrade under Joseph is intended to conceal the difference. It is quite probable that the artifice was suggested by the position planned for the panel; and the strictness with which it is well known that works of art were placed in Florentine houses confirms this possibility. The intent of the two vanishing points is sug-

8 [PLS. I-V]

gested, for the lower one, by the progression of the shadow projected by the exedra; for the upper, connected with the principal figures, by the direction of the small cross on the shoulder of the little St. John. This last establishes by itself a link between the trio in the foreground — usually considered in strict isolation, as though it were a group carved out of a marble block — and another element of the composition. Nor is it the only link: note those between the visible shoulder of St. Joseph and the humerus of the nude standing behind him, between Mary's raised forearm and the arm of the nude on the left, and so on. It is precisely through the amazing articulation of the perspective space even more than through the spi-

ral composition of the Virgin's figure — that the *Doni Tondo* can truly be considered as a starting point of Mannerism. Moreover, the 'luminous, sharp colour follows and stresses the plastic articulation of the masses and scans their broad and solemn movement'; this is also why, 'despite the intensity of its plastic values, this cannot be considered as the mere translation into painting of a sculptural relief'; besides, the 'translation' theory is contradicted by the very 'creation of an image of universal space', fully realized here, yet absent in both the *Pitti Madonna* of the Bargello in Florence and the *Taddei Madonna* of the London Academy (see *Appendix*), that is, in Michelangelo's marble tondi [Salvini, 1955].

9 ▦ ✪ 1505-06 ▤ ∘∘

THE BATTLE OF CASCINA.

The subject comes from Villani's *Cronica*: on 29 July 1364 Galeotto Malatesta, *condottiero* of the Florentines bound for an attack on Pisa, set up his camp six miles from the city, and precisely 'in the outskirts of Càscina'; the heat induced the greater part of the soldiers to disarm in order to bathe in the river Arno, while the captain lay down in his own tent; Mario Donati, realizing that an attack was about to be launched by the Pisans, gave a timely warning, and the action ended in favour of the Florentines. The relevant contract is not extant, but documents record that in the second half of 1504 Michelangelo was commissioned by

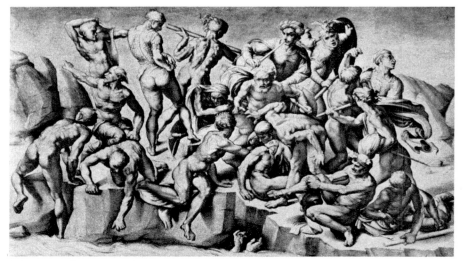

Aristotile da Sangallo (attr.), copy of the cartoon for the Battle of Càscina *(1542?), Holkham Hall (Norfolk), Leicester Collection.*

Gonfaloniere Soderini to fresco this 'history' in the Council Chamber of Palazzo Vecchio at Florence, after Leonardo had already been entrusted with the painting of the *Battle of Anghiari* on another wall of the same chamber. In a letter of 1524 Michelangelo recalled that he had drawn the cartoon for the painting in March 1505, while Vasari and Condivi date its execution a few months later; but the cartoon may have been completed in November 1506 [Thode, 1908-1913; Wilde, 1953; Einem, 1959; Tolnay, 1963]. It is documented that the cartoon was executed in a room of the Hospital of the Dyers (Ospedale dei Tintori) at S. Onofrio, transferred from there to the Council Chamber before 1508, then (1512?) to the

approximately 7×17.5 m; the one on the right was to be occupied by Leonardo's painting, the other by Michelangelo's. On the basis of the Leicester copy, various ideal reconstructions of Buonarroti's composition have been attempted: Köhler [1907] thought the central figure to be the soldier who is putting on his breeches, with the composition completed on the left by a group of horsemen whose presence is documented by drawings now in London and Oxford (partly reproduced here, together with others related to the cartoon); according to Thode [1908-13], who agreed with the position of the central figure and of the horsemen, the missing portions are the lateral ones and represented soldiers

Studies for the Battle of Càscina: *Ignudi (pencil and silver point, 235×356 mm.; Florence, Uffizi); uncertain attribution.*

Foot soldier and horseman *(pen and charcoal, 270×185 mm.; Oxford, Ashmolean);* Ignudo *(charcoal and white lead, 272×199 mm.; Vienna, Albertina): controversial attribution.*

Ignudo *(pen and pencil, 408× 284 mm.; Florence, Casa Buonarroti). The attribution to Michelangelo is unanimous, but its connection with the Battle of Càscina controversial.*

Church of S. Maria Novella, and finally (before 1515) to Palazzo Medici; around 1550 it had already been divided into fragments, later dispersed between various owners and ultimately destroyed. Some partial copies are extant, of which the best-known and most important is the one reproduced here, in the collection of the Earl of Leicester, at Holkham Hall (Norfolk), attributed to Aristotile da Sangallo and mentioned for the first time by Passavant [1833]. Wilde concluded that the only spaces available in the Council Chamber were those on the east wall and consisted of two surfaces, each

running and about to mount; Tolnay considers later work only the group of horsemen in the distant background, and even this much without certainty. Wilde also assumed that the Leicester group had other figures behind it, while the horsemen might have been placed on the right; Grohn [1963], having confirmed the large dimensions attributed to the painting (according to him, 5 or 6×18 m.), suggested a great number of additions, more in keeping with other sketches identified as related to this cartoon (to be seen in Florence [Uffizi and Casa Buonarroti] and in Paris and Vienna).

10 〔⌗〕 ⊛ 102×76 / 1510* 〔目〕 ⦂

MADONNA AND CHILD, WITH THE INFANT ST. JOHN AND FOUR ANGELS (Manchester Madonna). London, National Gallery.

The title originates from the fact that the first exhibition of this canvas as a work by Michelangelo occurred in Manchester (1857), while it had previously been ascribed to Ghirlandajo. It came originally from the Borghese collection in Rome. The attribution to Michelangelo was rejected, in favour of a follower, by F. Reiset [1877] and by Wölfflin [1891], as well as by Robinson [1881; who suggested Bandinelli], Berenson [1903; who ascribed it to Bugiardini], Popp [1925; to Mini], A. Venturi [1932; to Jacopino del Conte], Antal [1932; to B. Franco], and various others, including Zeri [1953], who attributed it to the Manchester Master, 'a mediocre painter, but of such affinity to Michelangelo that he could work from the latter's drawings and notes': in the present case, around 1510, he might have benefited from Michelangelo's sketches as well as from some direct assistance from Michelangelo. On the other hand, the attribution to Michelangelo (as a work executed around 1500 or earlier), made by Toesca [1934], has not been without recent support [Bottari, 1941; Bertini, 1942; Arslan, 1943-44; Carli, 1964; etc.].

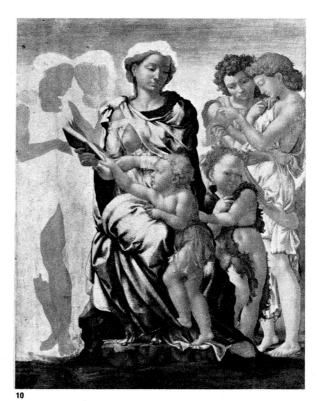

10

11 〔⌗〕 ⊛ 159×149 / 1511* 〔目〕 ⦂

DEPOSITION IN THE SEPULCHRE. London, National Gallery.

It has been suggested that the composition is more or less based on a conception by Mantegna. The painting appears to have been extensively worked in oils during the original execution. It may have belonged first to the Farnese family, then to other Roman collectors; its present location dates to 1868. The attribution to Michelangelo was put forward (1846) by Cornelius and Overbeck, and accepted by many others, though with contrasting opinions as to dating: between the *Doni Tondo* and the Sistine Ceiling, or contemporary with the latter [Berenson, 1896, etc.; A. Venturi, 1925, IX I; up to Carli, 1942, etc.; Mariani, 1942; Grassi, 1955; etc.]; or prior to the *Doni Tondo* [Bertini, 1942] and precisely in the period 1496-1501 [Gamba, 1945]. It is at present more usually ascribed to a follower, variously identified as a certain Carlo [Reiset, 1877], as B. Franco [Antal, 1932], or as the Master of the Manchester Madonna [Zeri, 1953], though it is observed in this connection that Michelangelo's direct assistance must have been more considerable than in the London *Madonna* (10), which gives the work its title [Salvini, 1965].

12 〔⌗〕 ⊛ 64×54 / 1510* 〔目〕 ⦂

MADONNA AND CHILD. Baden (Zurich), private collection.

Fiocco [1937, etc.] attributed it to Michelangelo's apprenticeship with Ghirlandajo; but the attribution was rejected by Longhi [1942], Bertini [1942], Tolnay [1943-60, I] and others.

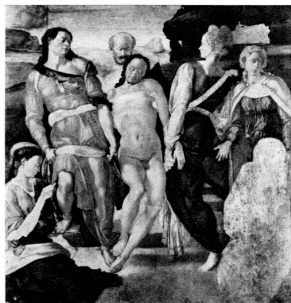

11

12

13

13 〔⌗〕 ⊛ 64×54 / 1510* 〔目〕 ⦂

MADONNA AND CHILD WITH THE INFANT ST. JOHN. New York, private collection.

Formerly in London, then in Florence as part of the Contini collection. Ascribed to Michelangelo by Fiocco [1950]; then, with greater acceptance, attributed by Zeri [1953] to the Master of the Manchester Madonna.

87

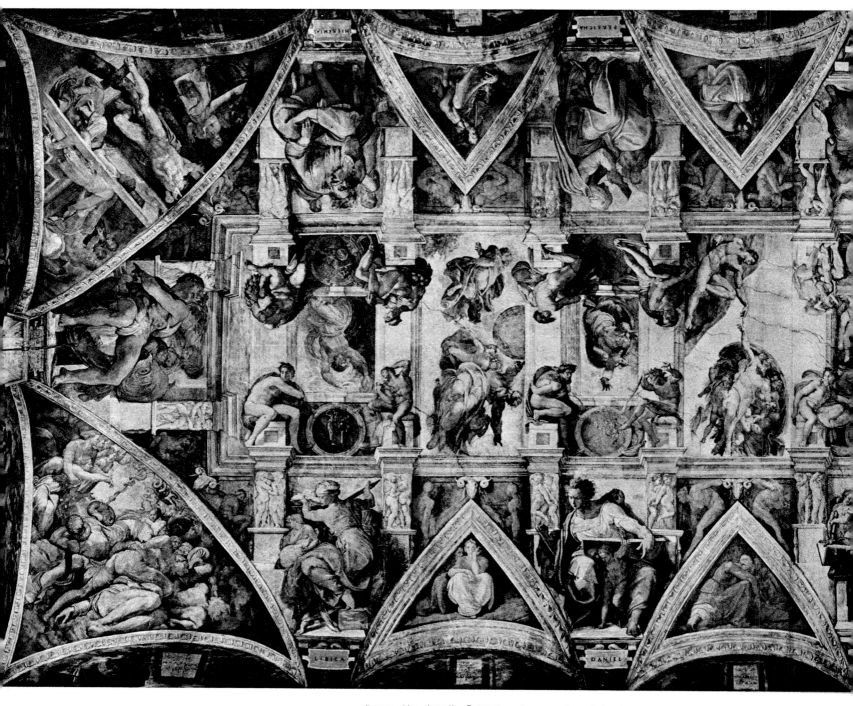

Ceiling
of the Sistine Chapel

The Sistine Chapel, which is located within the Vatican Palace in Rome, was built for Pope Sixtus IV, and dedicated to Our Lady of the Assumption: an *Assumption* was indeed frescoed on the west wall (the altar end) by Perugino (where Michelangelo's *Last Judgement* was later to be painted) as part of the original pictorial decoration of the chapel (also engaged in this undertaking were Botticelli, Ghirlandajo, Rosselli, Signorelli and others), which included the ceiling painted by Piermatteo d'Amelia, conceived to represent a starry sky. This last part was

destroyed to make room for the frescoes commissioned from Michelangelo. The new decoration, comprising some three hundred figures and spreading over more than, 1,000 sq.m. (plan: 13×36 m.), consists of three distinct superimposed zones: the bottom zone of the lunettes (which in fact constitute the upper part of the walls); then the tympana of the arches and, on the short sides, the corner spandrels, which, with the thrones of the Seers (Prophets and Sibyls), form the intermediate zone; at the centre, the biblical scene linked to the intermediate zone by the nude

figures (the *Ignudi*). Between the lunettes stand *putti* bearing inscriptions. At the top of each tympanum and above the corner spandrels are the bronze-like nudes; on the plinths at either side of the thrones, the *putti* caryatids; between the pairs of *Ignudi* are roundels with biblical episodes.

In a document of 10 May 1508, Michelangelo noted that he had obtained five hundred ducats 'on account' for this undertaking, 'for which I begin work today': it is obvious that he alluded to work on the preliminary drawings, since the assistants called from Florence — essential for such a task — were not due to join him before the autumn. The assistants were his old friends Granacci, Giuliano Bugiardini, Aristotile da Sangallo and others. On the basis of Vasari and Condivi, art historiography has unanimously denied their participation in

the execution of the frescoes. Dissatisfied with their initial efforts, Michelangelo apparently discharged them almost immediately, continuing the work alone. Nevertheless, even some scholars who are inclined to accept this version never fail to point out signs of collaboration in various zones. Biagetti [1937] is to be credited with the discovery of elements which, confirmed by stylistic evidence [Camesasca, 1965], eventually proved that the *garzoni* (the assistant labourers) were with Buonarroti until around January 1511, after which time they actually did leave, though he kept with him a few collaborators, perhaps of less than mediocre talent, but perhaps not assigned merely menial tasks. In accordance with the original plans of the commissioning pope, Julius II Della Rovere, Michelangelo prepared a design comprising only

the figures of the twelve Apostles, to be distributed on the corbels, with the central space of the ceiling to be covered with geometric decoration. But the artist was soon given free rein, and the present composition was eventually carried out. At first, the painting proceeded slowly, because of the artist's dissatisfaction with himself and with his assistants, and because of technical setbacks, such as the formation of a layer of mould, mentioned by Vasari and confirmed by recent research. The actual beginning of the painting has been placed around the end of 1508 [Holroyd, 1903; etc.], certainly not later than the beginning of 1509, and specifically in January [Symonds, 1892; Tolnay, 1943-60, II; Einem, 1959; etc.]. Letters written by Michelangelo between 1509 and 1510 indicate that the partial unveiling of the cycle was about to take place or

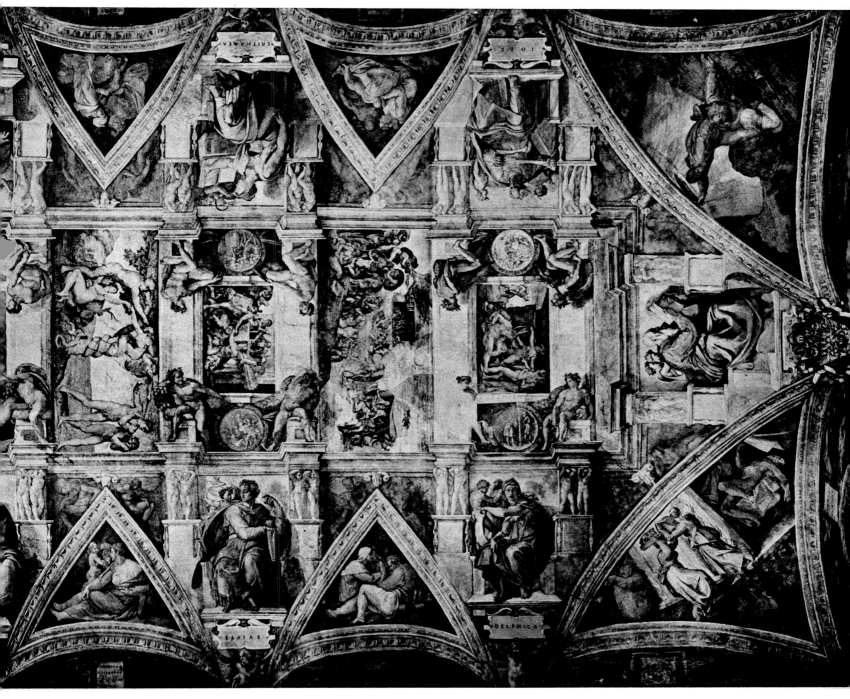

had just occurred, involving the section 'from the door up to the middle of the Vault' [Condivi], or a little less. The Diary of *Cerimoniere* De Grassis records that on 14 or 15 August 1511 Julius II went to the Sistine Chapel 'to see the recently unveiled paintings.' It appears that in January 1511 the painter had already carried out the cartoons for zones that can be identified as the lunettes. Again from De Grassis we learn that on 31 October 1512, the work being finished, the Chapel was re-opened. These facts gave rise to various suppositions as to the timing of the cycle; however, they are all based on the assumption that the painting progressed from the entrance end towards the altar, in transverse sections comprising one or more central 'histories', the corresponding *Ignudi* and Seers and tympana below; while, as regards the lunettes, they are almost unanimously held to have been painted after the completion of the ceiling proper. Tolnay found widespread agreement when he maintained that the execution must have proceeded in four stages: the first (comprising the three stories of Noah, eight *Ignudi*, five Seers, two tympana and two corner spandrels) completed by 15 September 1509; the second (the next two biblical stories, four *Ignudi*, two Seers and two tympana), finished in August 1510; the third (including the four remaining stories, the respective *Ignudi*, five Seers, four tympana and two corner spandrels), completed between January and August 1511; the fourth (all the lunettes), carried out between October 1511 and October 1512. The most appreciable variants to this chronology were advanced by Ragghianti [1965], according to whom the corner spandrel depicting *David and Goliath* and the two tympana closest to it belong not to the first, but rather to the fourth stage.

Recent criticism has endeavoured to reveal hidden meanings in the Ceiling frescoes. While Vasari ascribed their 'invention' exclusively to Michelangelo, later scholars suggested, in addition to the Bible, Plato [Hettner, 1879; up to Tolnay] or theological texts (to be regarded as actual 'programmes' imposed on Michelangelo) by an unknown author [Einem, 1959], by the Savonarola-inspired Sante Pagnini [Wind, 1944],

Plan of the Sistine Ceiling; the numbers are those used in this Catalogue.

14

15 [PLS. VI-VII]

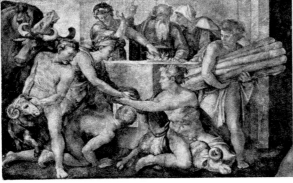

16

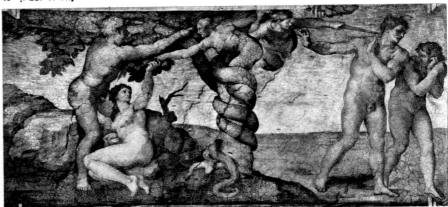

17 [PLS. VIII-IX]

by the Franciscan Marco Vigerio — in particular his *Decachordum* published in 1507 — [Hartt, 1950]. Among those who thought the Bible to have been the only source of inspiration, some drew attention to a metaphorical interpretation of the texts, related to the destiny of mankind [Montégut, 1870; Steinmann, 1905; Thode, 1908-13; etc., up to Bertini, 1942]; others [Henke, 1871 and 1886; etc.] saw in the cycle the representation of the essential phases of the spiritual vicissitudes experienced by mankind, symbolizing therefore the state prior to the Revelation (lunettes, tympana, corner spandrels), the state of Knowledge (Seers and *Ignudi*), and that of the direct relationship with heaven (biblical stories); this was further elaborated by Tolnay, who reached the conclusion that in the Ceiling there is a double ascent: from the bottom towards the top through the three zones symbolizing the three stages of existence, and in the succession from the stories of Noah to those of the Creation; moreover, a theological aim has been perceived in the very division of the Ceiling in relation to the original floor of the Chapel (before the screen was moved in the second half of the 16th century), pointing out that, accordingly, the frescoes where God the Father appears were above the presbytery, while the zone reserved for the laity was covered by the biblical stories relating 'human misfortunes'. Finally, the cycle was read as a complex representation of the Tree of Jesse — identified with the Della Rovere (It., *rovere* = oak) emblem of the commissioning pope — and the entire decoration of the Chapel thus

referred to humanity *ante Legem* (the Ceiling), *sub Lege* (the wall frescoes with episodes from the life of Moses) and *sub Gratia* (the facing frescoes representing episodes from the life of Christ), establishing a very intricate play of correspondences [Hart; Wind; etc.].

An official 'cleaner' of the 'Ceiling and of the walls' of the Sistine Chapel was appointed as early as 1543; and in 1565, after some pieces of plaster became detached, the first restorations were carried out by Carnevale, followed by others in 1625, around 1710, in 1903-05, and in 1935-36. In the course of one such restoration (almost certainly the 18th-century one), the cycle was seriously tarnished by the spreading of a glue-based varnish; moreover, it suffered considerable damage from water infiltration, candle smoke and other causes, which are mentioned below in the treatment of the single parts. The various elements of the cycle are examined starting from the east wall (the entrance side) and proceeding towards the altar-end wall, and from left to right as seen by the visitor whose back is to the main entrance of the Chapel. Although this order is reversed in the succession of the biblical stories, it is closest to the chronology of the cycle's execution.

The absolute novelty of the Ceiling, the original naturalness with which Michelangelo represented the human figure, his masterly use of persepective (even if considered mere formal virtuosity), the spiritual intensity of the drawing, the skilful elegance of the execution, were already noted by Vasari. The acknowledgement of Michelangelo as a 'great colourist'

only goes back to Montégut [1870], and it never enjoyed as general a consensus as Vasari's comments. For in its present state, the Ceiling is dimmed by the dirt that covers it. Nevertheless there is such a wealth of tones and so varied and free an orchestration, that we should reject the criticisms on the alleged 'marble-like' monotony of Michelangelo 'the sculptor'. On the contrary, the treatment of colour sets him alongside the most vigorous Mannerists, those who were most inclined to cover crystalline figures with joyous and at the same time acidulous colours, giving off daring iridescences, reflections from a yet unseen aurora borealis, lovely glows and transfiguring, even abstract vividness. Despite all the admiration he deserves, Rosso Fiorentino has nothing new to say about colour to those who have perceived the true colour of the *Jonah*; Beccafumi at his most incandescent and extravagant, perhaps the greatest visionary of Mannerism, adds nothing to the colouristic wonders of the Cumean Sibyl or of the Persian Sibyl. Furthermore, Montégut should be credited with the first scrutiny of Vasari's statement on the 'perfection of the foreshortening,' when applied to Michelangelo. This praiseworthy scholar pinpointed its dynamics in the unbroken succession of formal impulses, the cause of an incessant concatenation between the various component elements of the Ceiling: thus explaining its coherence, which one might term 'external', since it does not implicate the deeper motives of art. In fact, this coherence cannot explain the startling drama, the feeling of dismay and

creative power which grips the visitor to the Sistine Chapel. It seems that a valuable clarification was provided by Ragghianti [1965] in his study of the general lay-out of the cycle, which he would view as real architecture, even though it was painted and not built. The first fact to emerge is that, thanks to the 'architectural' method of the framework, the cohesive dynamics between the elements of the structure represented is so concrete as to amount to a geometric system. Moreover, by carrying out an ideal projection of the painted architecture, Ragghianti has pointed out that its framework projects enormously with respect to the 15th-century floor decoration below (wholly aimed at 'breaking through' the walls): an immense weight loaded on the slender pilasters and on the 'recessed' walls of the Chapel. Therefore,

it is already clear why the lower sections of the Sistine Chapel appear to be held back in a quiet distance, while the Ceiling weighs down on the onlooker or, rather, welcomes him among its structures, making him a direct participant in the events that take place in it. The insertion of the colossal figures only increases the weight, in concert with other factors: the curvature of the vault, made to appear more marked than it actually is; the apparent absence of any support for so great an architectural mass; no support other than the frames of the tympana, whose supporting function is emphasized not only by their considerable thickness but also by the projection in respect of the foreparts of the thrones, and enhanced by the evident sense of repose of the whole composition on the ram skulls.

Working days of 15 (solid line for the certain ones; dotted for the doubtful ones), collaborations (distinguished by letters and numbers: the latter concern the succession of the days ascribable to each of three different hands identified in the painting, of which Michelangelo's is marked with M, Bugiardini's with B, Granacci's with G), missing pieces (dashes), and grips to hold the plaster (black segments).

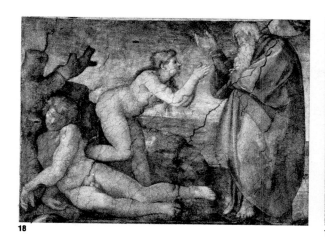

18

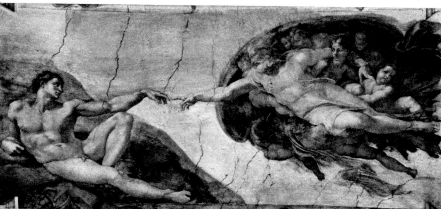

19 [PLS. X-XI]

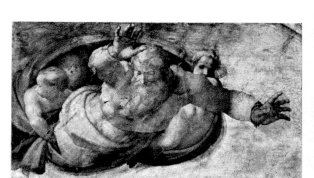

20 [PL. XII]

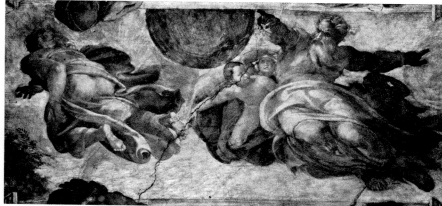

21 [PL. XIII]

The Biblical Stories

There are nine in all. The five smaller ones are each set between two pairs of *Ignudi*; the four larger ones spread over the whole space between the friezes above the thrones of the Seers. It has been emphasized that these are not pedestrian illustrations, but rather a 'profound plastic interpretation of the spirit of the Old Testament' [Mariani, 1964]. From the point of view of subjects, the comparison most frequently made is to Ghiberti's second door for the Baptistery in Florence.

14 *170×260* 1509
THE DRUNKENNESS OF NOAH.

The most plausible interpretation is the following: Noah sleeps next to the vat and jug of his drunkenness. In the foreground, his son Ham derides him; another son, perhaps Japheth, covers him, while the third, Shem, reprimands the derider (*Gen.* 9:20 ff.). In the left background the patriarch himself is planting the vine. This was probably the second painting of the cycle to be executed, after the *Flood*; some contribution from assistants was pointed out in a few draperies and in Shem's hair [Camesasca].

15 *280×570* 1508-09
THE FLOOD.

The various elements of this story (*Gen.* 7) have long been noted by scholars — the ark, the overcrowded craft, the people sheltering under the tent on top of the mountain which emerges

from the water, the 'tormented' crowd on the rise in the foreground — singling out episodes of love, fear, pity and selfishness. The detail of the unleashing of the divine wrath — in the form of a thunderbolt striking the tent on the right — described by Condivi, is no longer visible owing to the collapse of part of the plaster, following an explosion in Castel Sant'Angela (1797); but it appears in a 16th-century copy, now in the Louvre. That this was the first biblical story to be frescoed emerges, not only from the statements of the first biographers, but also from the following facts: traces of mould were ascertained [Vasari; etc.], which formed at the beginning of the painting; the disorderly and irrational succession of the *giornate* (working days) in the fresco reveals scanty familiarity with mural technique, which is not the case in other zones; the presence of different 'hands', ascribable to the assistants' contribution, partly acknowledged by the early biographers. In this connection other styles were recognized around the centre of the composition: Bugiardini's, especially in the figures near the sides, and Granacci's, particularly in the foreground figures on the left [Camesasca; see plan p. 90].

16 *170×260* 1509
THE SACRIFICE OF NOAH.

A theme of doubtful interpretation, some thought it to be Noah's thanks-giving to God for having been saved from the Flood (*Gen.* 8:20) although, if such were the case, it should occupy the compartment on the opposite side of the *Flood* itself. It was said to represent the

22

sacrifice of Cain and Abel, 'the former agreeable to God, the latter loathesome' [Condivi]; or Abraham about to offer up the ram in exchange for the unconsummated sacrifice of Isaac [Müntz]; a rite of the idolater Lamech [S. Meller], to which, however, the biblical texts make no precise allusion; etc. According to D'Ancona [1964], most of the actual painting was carried out by assistants, but it would seem more plausible to consider it almost totally authentic [Camesasca]. The collapse of a vast portion of the plaster resulted in a restoration by Carnevale, as early as the second half of the 16th century.

17 *280×570* 1509-10
THE FALL.

The Temptation of Eve and the Expulsion from Eden are represented with a modernity and coherence unknown before

Michelangelo; they have provided an opportunity for innumerable 'readings' in a conceptual key. At the same time, Eve's comeliness was extolled, mention made of the ageing of the expelled progenitors (as well as the absence of the traditional fig leaf), and attention drawn to the simultaneous rising from the tree, in the centre, of the 'two forces of Evil and of Vengeance' [A. Venturi, 1926]. The *Expulsion* reveals 'second thoughts' in Eve's left shoulder and in Adam's legs; the fresco appears to have been completed in eight or nine 'giornate'; it is much blackened by the 18th-century varnishing, except in a triangular portion of Eve's face in the *Temptation*.

18 *170×260* 1509-10
THE CREATION OF EVE.

The theme is drawn from *Genesis* (2:21). Early criticism em-

phasized the contrast between the dynamic Eve — highly praised for her physical grace — and the torpid Adam, and the 'fearsome' authority of God the Father. The compartment is crossed by a large crack.

19 *280×570* 1510
THE CREATION OF ADAM.

The theme is drawn from *Genesis* (1:26). The creating gesture has practically polarized the attention of the critics; Condivi perceived in it normative intents on the part of God the Father; and the painter Füseli [1801] went so far as to compare the approaching fingers to a life-generating electrical contact. The eleven angels supporting the Creator were also the object of esoteric identifications: in particular, the one under God's left arm, conjectured to be female and recognized as Eve [Richter, 1875; etc.], or the 'idea' of her [Tolnay], Wisdom [Sanday, 1875], the Virgin [Higgins, 1875], the human soul [Hettner, 1879], Dante's Beatrice [Spahn, 1907]. Long, deep fissures streak through the painting, in which the glue-based varnish dims a rectangle of sky.

20 *155×270* 1511
GOD SEPARATING THE WATERS FROM THE EARTH.

The theme of this compartment is quite controversial: Vasari's reference to the third day of Creation ('Left the waters ... be gathered together ... and let the dry land appear' [*Gen.* 1:9]), met with general consensus. But some have supported Condivi, who, referring to a different biblical passage (*Gen.*

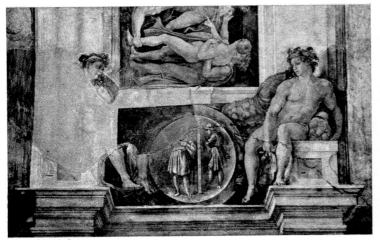

23 A, B and C

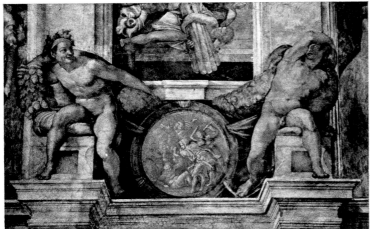

25 A, B and C [PL. XV]



24 A, B and C [PL. XIV]

26 A, B and C [PL. XVI]

1:20), described it as the creation of aquatic animals; others interpreted it as the creation of all the other 'living creatures' [Chattard, 1766, up to Carli, 1964]; and yet others, as the separation of the firmament from the waters [Lange, 1910; up to Tolnay]. Traces of the transfer from the cartoon are particularly visible here, especially in the face of God the Father, whose right hand appears to have been repainted, perhaps by Carnevale (1655-72).

21 ⊞ ⊕ *280 × 570* 1511 ▤ ⋮

THE CREATION OF THE SUN AND THE MOON.

Most modern scholars agree with Condivi, according to whom the double presence of God results from the combination of two 'Creation' days, the third and the fourth: the facing God creates the sun with his right hand and the moon with his left; the other figure, foreshortened in a rear view, deals with the creation of plant life. However, the latter figure was also identified as Chaos in flight, Night, and so on. Various esoteric interpretations were also suggested for the *putti* supporting the first of the two figures; the second has drawn considerable praise for its perspective.

22 ⊞ ⊕ *180 × 260* 1511 ▤ ⋮

THE DIVISION OF THE LIGHT FROM THE DARKNESS.

The reference to the first day of Creation (*Gen.* 1:4), already

made by Vasari, is the most widely accepted. Visible cracks and restorations.

The Ignudi

The heights vary between 150 and 180 cm. Disposed in pairs, their evident role is to support plant festoons and — by means of ribbons — the bronze-like roundels, while sitting on cubes above the thrones of the Seers. There are twenty of them, since two are lacking for the two prophets on the short sides of the Ceiling. In the pairs at the sides of the *Drunkenness of Noah*, the repetition of the poses reveals that a single cartoon was used twice, front and back, for each pair. Then the

Anonymous artist (perhaps Florentine) before 1535, copy of 23 A in original condition (Windsor Castle).

poses gradually become more diversified. The *Ignudi* have been interpreted as caryatids, though they support nothing, or as slaves or captives, though they are not in chains; Vasari believed them to be symbols of the 'golden age' created in Italy by Julius II; modern scholars tend to see in them references to the ideas of Savonarola [Klaczko, 1898], the neo-Platonists [Tolnay], or 16th-century theologians [Hartt]. The origins of these figures are mainly to be sought in the *Laocoön* [Steinmann, 1905; etc.] and in the Belvedere *Torso*. In supplying, here below, further details on the elements of the series, the components of each pair are indicated by the same number with the letter A for the figure to the left of the Seer below them and C for the other one, the letter B applying to the central medallion (p. 93).

23 ⊞ ⊕ *190 × 385* 1509 ▤ ⋮

PAIR ABOVE THE DELPHIC SIBYL.

A. The 1797 explosion destroyed this figure almost completely, and its appearance can be reconstructed only through some poor 16th-century copies.

C. Early scholars were particularly attracted by his melancholy expression.

24 ⊞ ⊕ *190 × 385* 1509 ▤ ⋮

PAIR ABOVE THE PROPHET JOEL.

A. Early interpreters noted his virile pensiveness.

C. Attention has been drawn to the fact that he resembles a famous nude figure painted by Signorelli in the *Death of Moses*, also in the Sistine Chapel [Jacobsen and Ferri, 1905].

25 ⊞ ⊕ *190 × 395* 1509 ▤ ⋮

PAIR ABOVE THE PROPHET ISAIAH.

A. Admired by early scholars for his smiling, cheerful demeanour. Considerably disfigured by the 'glue' varnishing.

C. According to early interpreters, it is the effort of pulling on the garland which causes his face to express weary vexation. There are several cracks.

26 ⊞ ⊕ *190 × 390* 1509 ▤ ⋮

PAIR ABOVE THE ERITREAN SIBYL.

A. The pose was related to that of Diomedes in an antique jewel copied by Donatello's school for a tondo in the courtyard of Palazzo Medici, Florence [Wickhoff, 1882]. The figure is spoiled by 18th-century varnishing.

C. In this case, too, a comparison to Diomedes was put forward; fairly good condition.

27 ⊞ ⊕ *195 × 385* 1509-10 ▤ ⋮

PAIR ABOVE THE CUMEAN SIBYL.

A. This figure attracted limited interest among early critics; within the mystically oriented interpretation of the Ceiling, he was considered to be turned

with 'tranquil amazement' toward the *Creation of Adam* as a preconization of the Incarnation [Hartt].

C. Shows deep cracks.

28 ⊞ ⊕ *195 × 385* 1509-10 ▤ ⋮

PAIR ABOVE THE PROPHET EZEKIEL.

A. Attention has been called to the almost feminine figure. Crossed by deep cracks.

C. Fairly good state of preservation.

29 ⊞ ⊕ *195 × 385* 1511 ▤ ⋮

PAIR ABOVE THE PROPHET DANIEL.

A. He was thought to be a 'sort of negro' [Geoffrey, no date] and connected with the *Heroic Captive* of the Louvre [Steinmann].

C. Much attention has been drawn to his appearance as an unrestrained dancing satyr. Damaged by a crack along the left thigh.

30 ⊞ ⊕ *200 × 395* 1511 ▤ ⋮

PAIR ABOVE THE PERSIAN SIBYL.

A. His proud immobility was taken to be the result of the marked *contrapposto* of the figure [Freedberg, 1961]. Damaged by cracks.

C. He is perhaps the most highly admired of the series for the 'howling' dynamics of his attitude. A long crack cuts through his bent leg.

31

⊞ ⊕ *195×385* 📄 ⋮
1511

PAIR ABOVE THE LIBYAN SIBYL.

A. Fairly good state of preservation.

C. The posture might derive from that of a classical Hercules bearing the young Bacchus [Steinmann; etc.]; there are noticeable connections with the classical sculpture of the *Laocoön* and with Michelangelo's *Dying Captive* of the Louvre [Clark, 1956].

32

⊞ ⊕ *200×395* 📄 ⋮
1511

PAIR ABOVE THE PROPHET JEREMIAH.

A. Particularly extolled for his physical beauty. Deeply cracked and distressingly uneven in parts, due to the varnishing.

C. The origin of his pose in the Belvedere torso is unanimously accepted. Very uneven glue-based varnishing.

The Medallions

Different diameters: from 130 to 140 cm. Varyingly connected with the subjects of the biblical stories, with the scenes represented in the first circle of Dante's Purgatory, with the episodes painted on the Chapel's walls or with the special reverence of Julius II for the Host. The subjects are reported here according to Steinmann's interpretation, which seems most convincing; Tolnay is the source of the technical comments. As regards the numbering, see the *Ignudi* (p. 92).

23 B. Joab, David's nephew, kills Abner (II *Sam.* 3:27). The conception is undoubtedly Michelangelo's, but at least the figure of Joab reveals the brush of an assistant.

24 B. The corpse of King Joram is thrown from the chariot by Bidkar (II *Kings* 9:21 ff.). Both the composition and the actual painting are probably by Michelangelo, except the figure of Joram.

25 B. Death of Uriah, Bathsheba's husband (II *Samuel* 11:24); the kneeling figure on the left (added *a secco*) is perhaps that of the repentant King David. It has been conjectured [Camesasca] that the *a fresco* painting was carried out by Bugiardini.

26 B. Jehu has the image of Baal destroyed (II *Kings* 10:25 ff.). The two figures on the right, which are not gilded, were added *a secco*, perhaps by Aristotile da Sangallo, like all the similar ones of the series; the *a fresco* part reveals the same hand as the preceding medallion.

27 B. David kneels before the prophet Nathan (II *Samuel* 12:1 ff.). The warrior on the left was added *a secco*; the frescoed part might also be ascribed to Aristotile da Sangallo, who may have made additions to other sections.

28 B. Destruction of the tribe of Ahab (II *Kings* 10:17). The fresco painting, perhaps by Sangallo, includes only the two horsemen and the two foot soldiers in the foreground; the rest was added *a secco*.

29 B. Death of Absalom (II *Samuel* 18:9 ff.). Perhaps both the design and the painting should be ascribed to Aristotile da Sangallo.

30 B. Unpainted.

31 B. Sacrifice of Abraham (*Gen.* 22:9 ff.).

32 B. Elijah ascends to heaven (II *Kings* 2:11). The horses were added *a secco*.

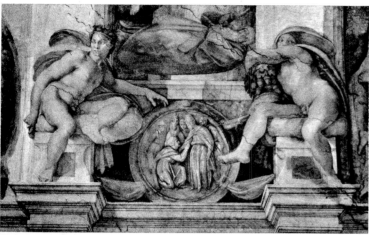

27 A, B and C

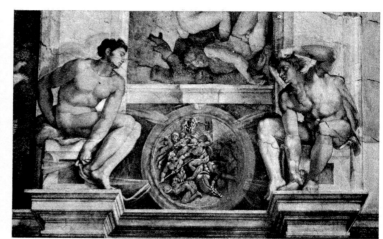

28 A, B and C [PL. XVII]

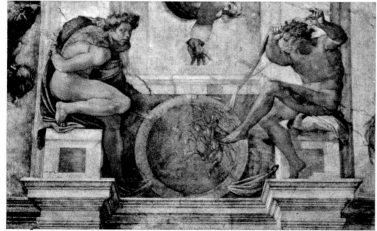

29 A, B and C

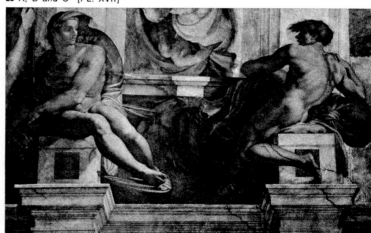

30 A, B and C [PLS. XVIII-XIX]

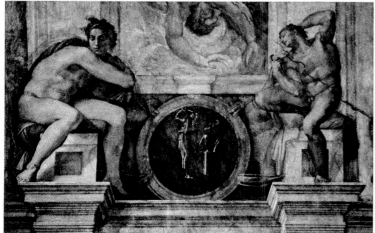

31 A. B and C

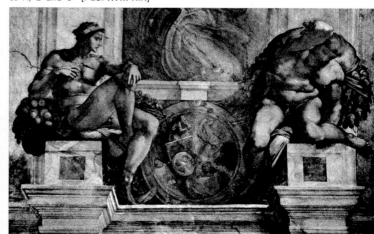

32 A, B and C [PLS. XX-XXI]

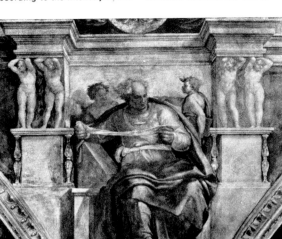

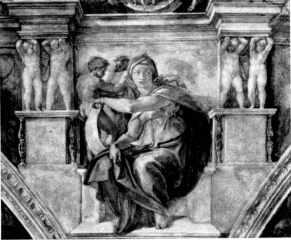

33 A, B and C [PL. XXII]

The Seers
Prophets and Sibyls

Heights varying between 260 and 298 cm. The prophets are seven, inspired by the Hebrew tradition; the Sibyls five, drawn from the Greek tradition; each is accompanied by two assistants. It was assumed that they might follow an ideal chronology or that they might be scaled according to the intensity of the prophetic enlightenment [Dvořák, 1927-29; Thode, 1908-13] or related to political events of the early 16th century [Justi], to the feasts celebrated in the Chapel [Steinmann], or to adjoining biblical stories [Tolnay]. Consequently there are many clashing opinions on possible literary sources and the meaning of the assistants. Wölfflin [1890] is credited with the first mention of the Seers' gradually increasing proportions (when the series is viewed from the entrance towards the altar), especially in the last five figures, which bring about a varied lowering of the supports on which rest the inscription-bearing *putti*. Among the various explanations, the most convincing concerns the artist's wish to correct the perspective diminution apparent to whoever looks at the Ceiling from the Chapel's main entrance. A few elements of fundamental importance still seem to elude the critics. In the detailed description which follows, each Seer bears a number accompanied by the letter *B*; the same number with the letters *A* and *C* apply to the corresponding pairs of *putti* caryatids, to the left and right respectively (see p. 95), and with the letter *D* to the inscription-bearing *putto* below (see pp. 96-97).

33 ⊞ ✪ *360×390* 1509 ⊟ ⦙
ZACHARIAH.
B. Vasari described him as intent upon looking in his book for 'a thing he could not find,' giving rise to numerous theories as to what the thing might be. He was also considered a symbol of the papacy, of prayer, of the law, of the building undertakings of Julius II, etc. The outline of his clothes, executed *a secco*, has almost disappeared as a result of dampness.

34 ⊞ ✪ *350×380* 1509 ⊟ ⦙
DELPHIC SIBYL.
B. The most admired of the series for her physical beauty. Interpreted as an allusion to Cassandra, to Greek culture, etc. It has been related, from the point of view of style, to Michelangelo's early *Madonnas*.

35 ⊞ ✪ *355×380* 1509 ⊟ ⦙
JOEL.
B. Vasari described him as satisfied with his reading, thus provoking a large number of naturalistic interpretations; his face was assumed to be a portrait of Bramante.

36 ⊞ ✪ *365×380* 1509 ⊟ ⦙
ISAIAH.
B. According to Vasari, he is answering the call of an assistant, usually interpreted as a divine messenger, bearing good or bad news. The colours have visibly faded in the tunic.

37 ⊞ ✪ *360×380* 1509 ⊟ ⦙
ERITREAN SIBYL.
B. She was described as grave, defiant and aggressive (and her 'boxer-like' arms were much criticized; Bérence, 1947), while she turns a page where only a letter Q is legible. It has been suggested [Camesasca] that she might be connected with Ezekiel, towards whom she turns and who seems to be addressing her. The assistant lighting the lamp was considered a symbol of divination; and he was assumed to be suntanned [Mariani, 1964], though this is probably the result of the 18th-century varnishing. Some small restorations are noticeable.

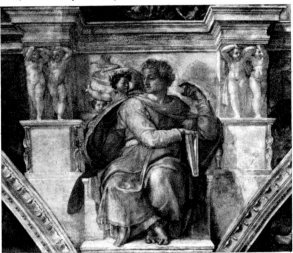

34 A, B and C [PL. XXIII]

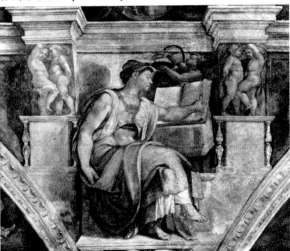

35 A, B and C [PL. XXVIII]

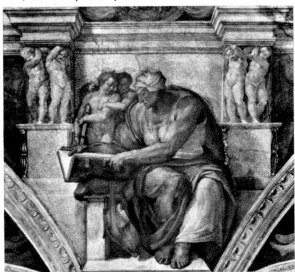

36 A, B and C [PL. XXV]

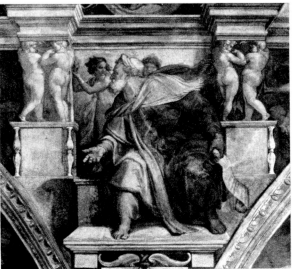

37 A, B and C [PL. XXVI]

38 A, B and C [PL. XXVII]

39 A, B and C [PL. XXIV]

38 *375×380* 1510

CUMEAN SIBYL.

B. Her decrepit appearance gave rise to countless interpretations (*virago plebea*, marked by a touch of 'something Etruscan', etc.); and she was generally described as dismayed or terrified, to the point of moving the assistants. Shows small restorations.

39 *355×380* 1510

EZEKIEL.

B. Described as prey to excitement or anger, cursing with 'southern gesticulations' decked out in the Syrian fashion, etc. Of the assistants, the one who points was thought by some to be a giri; but it is usually interpreted as an angel. For this last figure Bertini [1942] claimed a possible Leonardesque origin, discarded by others [Clemens, 1964], but recently confirmed and extended also to the prophet [Camesasca]. Various damaged points in the clothes.

40 *395×380* 1511

DANIEL.

B. Generally described as occupied in comparing two texts in connection with the Last Judgement, to which the assistants would also refer. Seriously discoloured by dampness.

41 *400×380* 1511

PERSIAN SIBYL.

B. Vasari noted her 'old age' and short-sightedness, to which others added her hump. The presence of clothes on the assistants appeared as an exceptional fact [Michelet, 1876; etc.]; it is repeated in the *Jeremiah*. Slight restorations in the lower part.

42 *395×380* 1511

LIBYAN SIBYL.

B. Vasari's interpretation — according to which the Sibyl, having just finished writing, is about to put down her book with a 'womanly gesture' — was widely accepted; modern scholars maintain, instead, that she is taking up the volume. Retouching, abrasion, oxidation, uneven varnishing disfigure this painting.

43 *390×380* 1511

JEREMIAH.

B. The 'bitterness' observed by Vasari was dramatized by subsequent interpreters and related to the state of mind of the painter himself, whose more or less symbolic self-portrait this was taken to be. The scroll at the foot of the throne bears the inscription 'Alef V' followed by an 'M', variously explained by seekers of allegorical meanings. The two assistants were generally described as female figures alluding to the Church, to Zion, to Rachel, etc. The figurative motif might originate in Ghiberti's *St. John* on the first door of the Florence Baptistry. Cracks and discolouring.

44 *400×380* 1511

JONAH.

B. The prophet's attitude was related to practically all of the numerous episodes which studded his history, though with some preference for the episode of the whale. Of the two assistants, generally described as participating in the prophet's trials, the one in front was believed to be a girl symbolizing the Church, Compassion or Nineveh, etc. Various cracks and restorations are visible.

The Putti caryatids

They were painted to simulate marble and placed in pairs at either side of the Seers' thrones with the task of supporting the 'cornice which encompasses the work on every side' [Condivi]. In painting the pairs flanking the same throne recourse was constantly made to a single cartoon, front and back. Each pair is formed by a male and female, to whom various symbolic meanings were attributed. Thode pointed out that they were executed with considerable assistance from a *garzone*; in fact, more than one assistant may have contributed [Camesasca]. For the numbering, see *The Seers* (p. 94).

ZACHARIAH.

33 A. The group was traced to previous conceptions by Michelangelo [Wölfflin, 1891] and to a classical gem representing *Eros and Psyche* which was at the time part of the Medici collections [Tolnay]. Very probably painted by an assistant.

33 C. Almost certainly painted by Michelangelo.

DELPHIC SIBYL.

34 A. The quality of the painting, somewhat diminished by the damage suffered, appears inferior to that of the other pair.

34 C. Could be authentic.

JOEL.

35 A. Authentic, according to Thode.

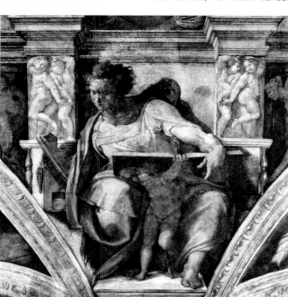

40 A, B and C [PL. XXIX]

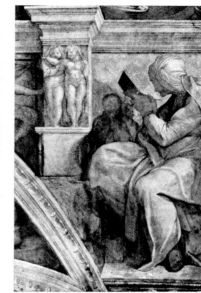

41 A, B and C [PL. XXX]

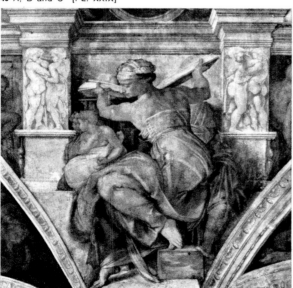

42 A, B and C [PL. XXXI]

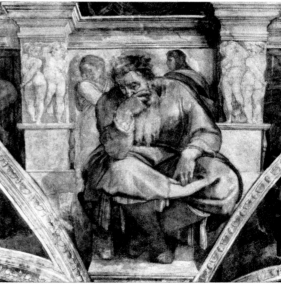

43 A, B and C [PL. XXXII]

Working days of 34 (solid lines; note the one concerning the foot, presumably painted by Michelangelo dissatisfied with the one previously executed by an assistant), partitions (broken lines; observe those relating to the face, engraved in the wet wall to assure symmetry) and traces of the nails used to hang up the sections of the cartoon during the process of transferring the drawing into the fresh plaster of the wall (crosses).

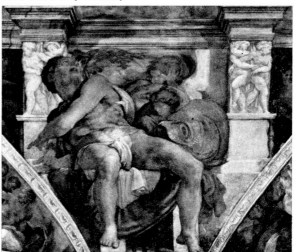

44 A, B and C [PL. XXXIII]

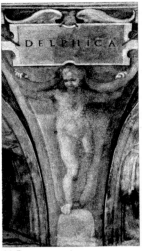

34 D

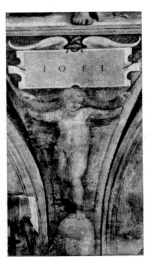

35 D

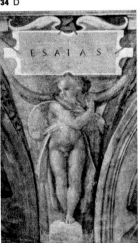

36 D

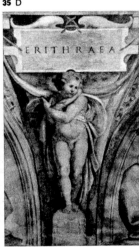

37 D

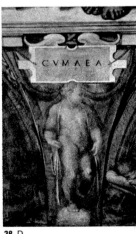

38 D

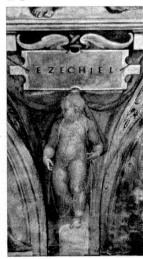

39 D

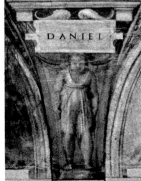

40 D [PL. XXXIV]

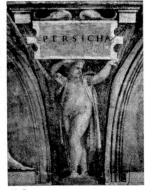

41 D

35 C. Painted by a *garzone*, again according to Thode; nevertheless, its execution displays a quality superior to that of the other pair [Camesasca].

ISAIAH.

36 A. The execution was justly considered superior to that of the other pair [Tolnay]; even so, it is not such as to be attributed to Michelangelo.

36 C. The preceding comment applies to the quality of this one.

ERITREAN SIBYL.

37 A. Compared with the other pair, this one is of better quality [Thode]; still, it might be by an assistant.

37 C. Undoubtedly painted by an assistant.

CUMEAN SIBYL.

38 A. The execution, inferior to that of the other pair [Camesasca], should clearly be ascribed to an assistant.

38 C. Despite the higher quality, it appears to be by a collaborator.

EZEKIEL.

39 A. It has been pointed out that the two *putti* appear to be moving away from each other, as though quarrelling [Michelet; etc.]. The quality is superior to that of the other pair, and might be by Michelangelo.

39 C. Almost certainly by an assistant. Heavily restored.

DANIEL.

40 A. Ascribed to an assistant.

40 C. The quality is slightly superior to that of the other pair [Camesasca].

PERSIAN SIBYL.

41 A. Probably attributable to an assistant [Thode].

41 C. Although superior to the other pair, it is probably the work of a collaborator.

LIBYAN SIBYL.

42 A. The execution is inferior to that of the other pair, but the damage suffered precludes a reliable appraisal.

42 C. A collaboration has been suggested, with good reason [Tolnay], despite the possibility that the execution may be better than in the other pair.

JEREMIAH.

43 A. Although superior to the other pair, its execution is not such as to be ascribed to Michelangelo.

43 C. Contributions by assistants have been pointed out [Thode].

JONAH.

44 A. Both pairs might be by a collaborator [Thode; Tolnay], tentatively identified as Bugiardini [Camesasca].

44 C. See preceding comment.

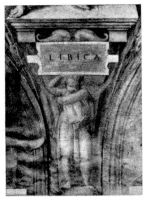

42 D

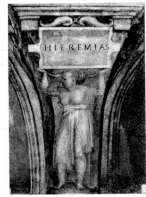

43 D

The Putti bearing inscriptions

The names written on the simulated marble tablets identify the prophets and sibyls represented. In the first three pairs (each formed by two *putti* facing each other from the opposite walls); the same cartoon was used, front and back. The progressive reduction in size (and particularly in that of the bases on which they rest), moving from the entrance of the Chapel towards the altar end, results from the increasing size of the respective Seers. These *putti* are absent under the tablets bearing the names of the prophets on the short walls (ZACHERIAS and IONAS). For the numbering, see *The Seers* (p. 94).

34 D. The inscription on the tablet is DELPHICA. The execution may be attributable to an assistant, but the damage caused by dampness prevents a precise appraisal [Camesasca].

35 D. IOEL. The damage, as serious as in the preceding *putto*, was partly restored.

36 D. ESAIAS. The right arm has been repainted; the rest appears oxidized.

37 D. ERITHRAEA. Considerably repainted.

38 D. CUMAEA. Perhaps by a collaborator, but so heavily damaged as to make an appraisal impossible.

45 B

46 B

47 B

48 B

39 D. EZECHIEL. Very much spoiled by cracks and by the varnish.

40 D. DANIEL. The first of the group (excluding 41 D) which early scholars regarded as stamped with physical horridness. This particular *putto* was described as an angry little dwarf, although it could be a female dwarf. Heavily damaged and restored.

41 D. PERSICHA. Very much damaged and restored.

42 D. LIBICA. The execution is ascribed to an assistant. Heavily damaged.

43 D. HIEREMIAS. Michelet dedicated a highly coloured description to the monstruosity of this 'pregnant dwarf'; however, after some acceptance of his interpretation by other critics, it was pointed out [Camesasca] that Michelet's impression was probably caused by a photographic reproduction heavily distorted by the curvature of the wall area of this painting.

The Bronze-like Nudes

They are paired, at either side of the ram skulls, above the corner spandrels and at the vertex of the tympana. The execution, in a bronze-like monochrome, was perhaps origi-

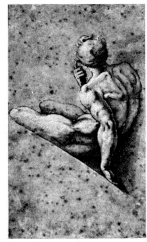

Anonymous 16th-century artist, copy of the Bronze-like Nude *on the right in pair 55 B (Cambridge, Fogg Art Museum).*

nally enriched with gold highlights. The figures are interpreted as statues, living figures, atlases or chained devils (although they are chainless), allusive to primeval mankind, etc. Each pair results from the double use of a single cartoon; in the first pairs there is an accentuated reference to classical examples — particularly to sculptural representations of river gods (Steinmann; although references to Donatello have also been made, e.g. Holroyd). Later, the figures were related to some of Michelangelo's early designs. Collaboration in the execution was acknowledged by Tolnay, but it remains hard to appraise because of the damage

[Camesasca]. In the detailed treatment below, each pair bears the same number (distinguished by the letter B) as the respective corner spandrel or tympanum (where the number is instead followed by the letter A). As regards the reproductions of numbers 49 B to 56 B, see the illustrations of the corresponding tympana.

45 B. They stand out against a bare background; damaged and badly restored.

46 B. The preceding comment applies.

47 B. Particularly poor state of preservation.

48 B. Heavily damaged, especially the nude on the right.

49 B. From here up to No. 51 B a classical acorn motif has been added in the background.

50 B. Heavily oxidized.

51 B. The head of the nude on the right reveals Leonardesque influence [Camesasca].

52 B. From here to the end of the series, the acorn motif disappears. Very heavily damaged.

53 B. The plaster is lifting.

54 B. A deep crack in addition to the usual damage.

55 B. Clumsy restorations are clearly visible.

56 B. The figure on the left is particularly damaged.

The Corner Spandrels

Though dealt with here as an independent series, they correspond to the tympana in the structural arrangement of the Ceiling. Their collective title is *Miraculous Salvations of Israel.* Wölfflin was the first [1890] to observe that the two corner spandrels of the entrance end display less expanded figures and less crowded compositions than the other two. As regards the numbering adopted in the single descriptions, see *The Bronze-like Nudes* (above).

45 ⊞ ⊕ *570×970* 1509 ▤ ⦂

JUDITH AND HOLOFERNES.

A. This represents the well-known biblical episode (*Judith* 13) of the beheading of Holofernes by a widow from Bethulia; it was also interpreted as an embodiment of liberty (not devoid of polemic intentions, on the artist's part, against the commissioning pope), of divine justice, of the Church triumphant, etc. Holofernes' head was identified by various scholars as Michelangelo's self-portrait. A deep crack at the centre was badly stopped with wax.

46 ⊞ ⊕ *570×970* 1509 ▤ ⦂

DAVID AND GOLIATH.

A. The well-known biblical episode (I *Samuel* 17) is depict-

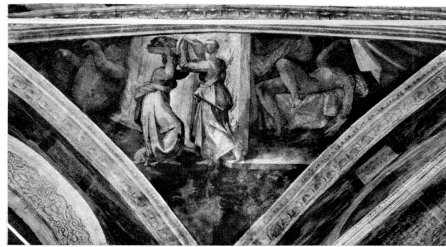

45 A [PL. XXXVI]

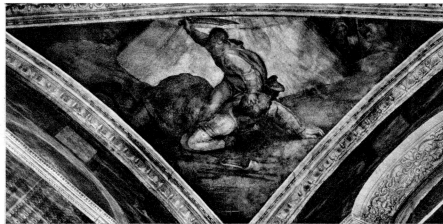

46 A [PL. XXXV]

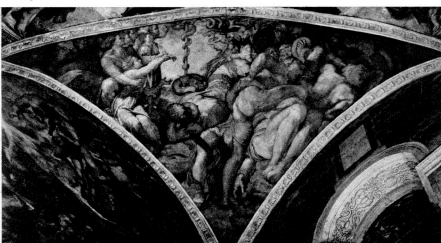

47 A

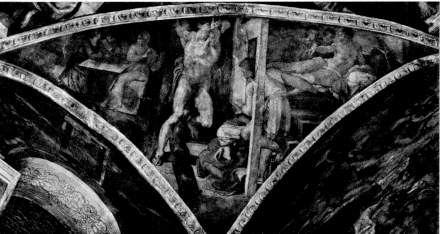

48 A [PL. XXXVII]

ed in its last stage, when David is about to behead Goliath, in the presence of the soldiers around the camp, whose heads are barely visible in the shadow. At the lower point of the spandrel, part of the grooving has remained without plaster.

47 *585×985* 1511

THE BRAZEN SERPENT.

A. Discouraged during the journey to Transjordan, the people of Israel 'spake against God and against Moses'; and the Lord sent serpents with a lethal bite; having repented, and inspired by God, they made a serpent of brass and put it on a pole, and whoever was bitten and looked at it was saved and lived (*Numbers* 21:4 ff.). Vasari identified Moses as the youth holding up a woman; others, as the old man on the right with upraised hands; Tolnay denied his presence. Attention was drawn to possible symbolic meanings connected with the struggle of humanity against fate, with the thaumaturgic power of the Church, etc. Agreement is unanimous as concerns a reference to the *Laocoön*, just discovered at the time. There are various slight abrasions and there have been restorations.

48 *585×985* 1511

THE PUNISHMENT OF HAMAN.

A. Vasari referred to the biblical text (*Esther* 3): Esther, the Jewish slave, niece of Mordecai and wife of King Ahasuerus, on the occasion of a quarrel between her uncle and the vizier Haman (accused by them of being involved in a conspiracy), obtains the reversal of a decree of slaughter against the Jews, issued by the vizier, and the condemnation of Haman himself. Through the walls of the royal palace, three episodes are represented simultaneously: on the right, Ahasuerus commands that Mordecaï be called in to be rewarded; on the left, the council held by the king to condemn Haman; the latter appears at the center nailed to a cross (although the Bible mentions hanging). Apart from this generally accepted version, variants of many kinds were suggested: for instance, the alleged council was taken to represent Esther's banquet (or a 'love scene' between her and Ahasuerus), etc. The seekers of hidden meanings pointed to Haman as the false Christ [Levi, 1883] or as a prefiguration of the Redeemer [Spahn, 1907], whom others identified with Mordecaï or Ahasuerus [Hartt], while Esther was said to anticipate the Virgin [Parroni, 1934] or the Church [Hartt]; etc. The *Laocoön* was usually mentioned as the figurative source; however, reference has also been made to classical sarcophagi representing the legend of Orestes [Tolnay], and to Giotto's paintings in the Church of S. Croce at Florence [Wilde, 1932]. In addition to small abrasions and discolourations, there is a fairly large restoration towards the left, which involved the renewal of the plaster.

The Tympana

Condivi noted the development, in the tympana and in the lunettes, of the single theme of Christ's regal ancestors, generally accepted by subsequent critics. On the other hand, Thode recognized the ancestors only in the lunettes, while he claimed the tympana to represent pagan families (described by others as Hebrew families awaiting the Messiah, e.g., Zola, 1890). The divergence in interpretation results from the different meaning attributed to the inscriptions in the lunettes, that is to say, whether the top name is referred to the tympanum above (this being the most widespread opinion), or the reference limited to the lunettes themselves. The value attributed to the works gave rise to opposed judgements. It was judged very great according to Vasari and Romantic scholars (albeit with the assumption of naturalistic aims on the author's part); it was considered lower by purists. Present-day criticism regards it as a culminating point of expressive freedom. For the numbering adopted, see *The Bronze-like Nudes* (p. 97).

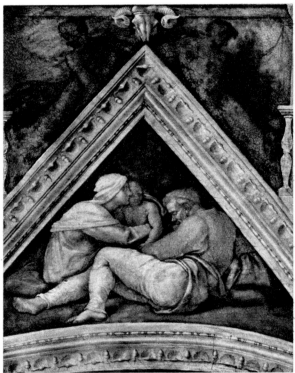

49 A-B [PL. XXXVIII B]

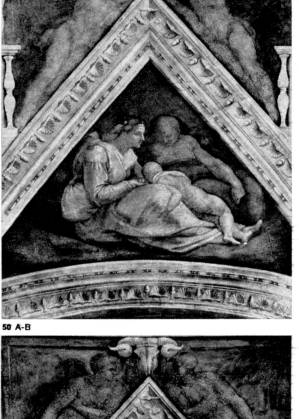

50 A-B

49 *245×340* 1509

A. On the basis of the top name in the lunette, this depicts the young Josiah, a future king, with his mother and his father, the wicked Amon, who is taken to symbolize evil [Tolnay]. Some damage produced by dampness.

50 *245×340* 1509

A. The future king Zorobabel with his father, Salathiel, and his mother. The scene might be connected with the *Flood* (15) both by its structure and by the meaning of Zorobabel, 'Lord of Babylon', the city that symbolized the world of the idolators, from which only those who trusted in God were saved [Hartt].

51 *245×340* 1510

A. The future king Hezekiah, just suckled by his mother, is watchful, in contrast to his dozing father, Ahaz, with obvious symbolic meanings [Tolnay].

52 *245×340* 1510

A. The future king Ahaziah, whose virtue, displayed on the throne of Judah, might be prefigured by the mother; behind them, the 'indolent' Joram with another son. State of preservation like 49.

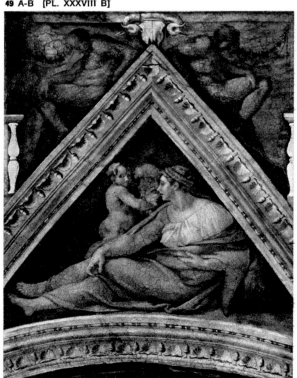

51 A-B

52 A-B

53 ⊞ ⊕ *240×340* 1511 ▤ ⫶

A. The future king Asa, a great destroyer of idols, represented as the consoler of his father, while his mother, an idolater, appears to sleep [Tolnay]. State of preservation like the preceding one.

54 ⊞ ⊕ *240×340* 1511 ▤ ⫶

A. The woman, mother of the future king Rehoboam, might prefigure the moral laxity which the Bible (I *Kings* 12:18; etc.) documents in her adult son; the male figure at the back might be that of the great Solomon.

More widespread damage than in the preceding ones.

55 ⊞ ⊕ *245×340* 1511 ▤ ⫶

A. The child, almost hidden in the shadows on the right, might be the future king Jesse, with his parents.

56 ⊞ ⊕ *245×340* 1511 ▤ ⫶

A. Thode was the first to point out that the woman is cutting a garment which is also held up by her son; the latter might be the future king Solomon, and his gesture would allude to the captivity in Babylon [Tolnay].

The Lunettes

The inscriptions at the centre are derived from the *Gospel According to St. Matthew*, which enumerates Christ's royal ancestors back to Abraham. Steinmann was the first to observe that, with regard to the Gospel text, the names appear in the tablets in a zigzag order, which had already been adopted by the Sistine Chapel's 15th-century decorators for the series of the Popes; the gaps in respect of the evangelic enumeration might be correlated to the deportation of the Jews to Babylon or to the prophecies of the adjoining Seers. See also the tympana (p. 98). It is probable that the upper part of the frames and the tablets was the last of the work done by the assistants and that the execution of all the rest is ascribable to Michelangelo alone [Camesasca] (see outline on p. 101).

57 ⊞ ⊕ *215×430* 1511-12 ▤ ⫶

The inscription on the tablet reads: ELEAZAR // MATHAN. The youth on the right was identified as Eleazar; for his companion, usually described as very ugly, no identification was put forward; the child seems to imitate the pose of the infant St. John in the *Pitti Tondo* of the Bargello in Florence. In the other group, Mathan, St. Joseph's grandfather, appears indifferent in comparison with his wife, the keeper of the family's savings (in the bag hanging on her side), who is playfully encouraging the infant Jacob to dance [Tolnay]. Widespread damage.

58 ⊞ ⊕ *215×430* 1511-12 ▤ ⫶

IACOB // IOSEPH. On the left, the old man might be Cacciaguida Alighieri with the infant Dante [Borinski, 1908], or St. Joseph [Steinmann], or his father Jacob. The group on the right is usually interpreted as the Holy Family with the infant St. John. This lunette would therefore conclude the series of the generations, begun with 72. Very poor state of preservation.

59 ⊞ ⊕ *215×430* 1511-12 ▤ ⫶

AZOR // SADOCH. The lack of information on Azor and Sadoc in the biblical sources has prevented any investigation of the Ancestors; it has, instead, been suggested that Michelangelo himself should be identified with the 'philosopher' on the right [Michelet; etc.].

60 ⊞ ⊕ *215×430* 1511-12 ▤ ⫶

ACHIM // ELIVD. The scarcity of biblical information on Achim and Eliud — conjectured at any rate to be the figures on the left — has prevented the usual comments on the antecedents of Christ; on the right, the mother of the young Eliud appears to be offering food (fish, according to Tolnay) to a younger son. There is serious damage, which has been caused by dampness, especially on the left-hand side of the scene.

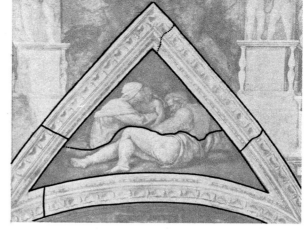

Working days of 49 (solid line for the certain ones, dotted for the doubtful ones); the order of the pieces frescoed is similar in the other tympana.

53 A-B

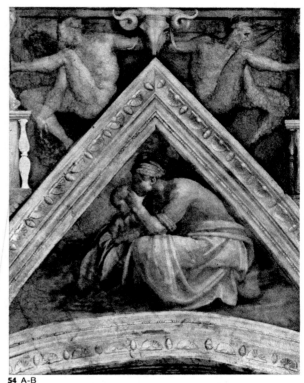

54 A-B

55 A-B [PL. XXXIX]

56 A-B [PL. XXXVIII A]

Copies of 71 and 72, engraved under the direction of W. Y. Ottley (ca. 1800) after 16th-century drawn copies, later lost.

children with their mother on the right, Joram might be the one who embraces her with the greatest violence, in view of the aggressive temperament displayed as an adult. Preservation as in 64.

66 ⊞ ⊕ *215×430* 1511-12 ▤ ⦂

ROBOAM // ABIAS. The zone on the left led to the conjecture of an allusive connection between the woman, usually described as an expectant mother, and the forty-odd sons fathered by Abia, who might be the child barely visible behind her [Tolnay]. It is not clear whether the figure on the right represents a sleeping man [Henke, 1871; etc.] or a woman [Ollivier, 1892; etc.]; it is, at any rate, someone overwhelmed by sorrow or weariness. State of preservation as in 64.

67 ⊞ ⊕ *215×430* 1511-12 ▤ ⦂

IESSE // DAVID // SALOMON. The man on the left, dressed like an Arab, is believed to be the elderly David, described in the Bible as very susceptible to the cold; the child, Solomon. The figure on the other side might be that of Bathsheba, whom David had by then forsaken [Tolnay]. State of preservation as in 64.

68 ⊞ ⊕ *215×430* 1511-12 ▤ ⦂

SALOMON // BOOZ // OBETH. The figure on the right, with a grotesquely shaped canehead, was even thought to be a caricature of the commissioning pope, Julius II [Hartt, 1964]; it might instead be King Boaz, whose old age was comforted by his son Obed, on the left with his mother Ruth: hence the contrast between Obed's child-like bloom and the father's decay [Tolnay]. The discoloura-

tion appears even more marked than in the preceding frescoes of the series.

69 ⊞ ⊕ *215×430* 1511-12 ▤ ⦂

NAASON. The young prince Nahshon and, perhaps, his future wife, with no particular meaning [Tolnay]; or a student and Inspiration [Holroyd, 1903].

70 ⊞ ⊕ *215×430* 1511-12 ▤ ⦂

AMINADAB. This might be Aminadab, prince of the Levites, next to a girl combing her hair, with no hidden meanings beyond the melancholy which was almost constantly noted by scholars in the figures of the lunettes.

71 ⊞ ⊕ *215×430* 1511-12 ▤ ⦾

PHARES // ESROM // ARAM. One of the two lunettes executed on the altar end wall and subsequently caused to be destroyed by Michelangelo himself (1535-36), who used the space for the upper part of the Last Judgement. Of the known copies, we reproduce the engraved one, executed under the guidance of W. Y. Ottley after 16th-century drawings. The figure on the left was identified as Phares, sound asleep, with his wife and his small son Esrom behind him; on the right, Aram is represented as a pilgrim uncertain of his journey [Tolnay].

72 ⊞ ⊕ *215×430* 1511-12 ▤ ⦾

ABRAAM // ISAAC // IACOB // IVDAS. This is the other lost lunette (see 71). The youth on the left might be Jacob reading the genealogy of Christ [Justi; etc.]; the boy next to him, Judah, with his mother. In the other zone, Abraham and his son Isaac with the wood for the sacrifice.

The Last Judgement

73 ⊞ ⊕ 1370×1220 1537-41 ▤ ⦂

Nothing certain can be said about the date of the initial negotiations for the work to be painted in the Sistine Chapel; but Michelangelo agreed to undertake it in March 1534, after there had been talk — since the middle of 1533 — of his being commissioned to paint a *Resurrection* on the same wall or on the one opposite. The death of Clement VII, in September 1534, must have made the artist feel that the project would be given up, so he turned his attention away from it. Soon afterwards the new pope, Paul III, renewed the commission for the *Last Judgement*, and it is recorded that on 16 April 1535 the construction of the necessary scaffolding was begun. In January 1537 the actual painting was certainly in progress; the official unveiling

took place on 31 October 1541.

The nearly four hundred figures in the painting (whose heights vary between 250 cm. and over for those of the upper part, and 155 for those of the lower one) are distributed as follows: more than the upper half of the wall is taken up by the heavenly world, with Christ the Judge at the centre next to the Virgin, and at the sides saints, patriarchs, apostles, who form a first circle beyond which is a second, consisting of martyrs, Confessors of the Church, virgins, and the other blessed; immediately below Christ, two martyrs — St. Lawrence and St. Bartholomew — occupy a prominent position, perhaps due to the fact that the Sistine Chapel was to have been dedicated to them as well as to the Assumption Virgin. In the two lunettes above, groups of angels bear the symbols of the

First idea for the Last Judgement *(pencil, 418×288 mm.; Florence, Casa Buonarroti).*

Study (det.) for 73 (pencil, 345×291 mm.; Bayonne, Musée Bonnat); controversial attribution and chronology.

Passion of Christ. The space below them, on the left, is filled with those already judged and rising to Heaven and, on the right, with the damned falling to Hell; the centre is taken up by the trumpet-blowing angels arousing the dead, whose resurrection is depicted in the lower left-hand corner; on the right, Charon ferries the damned toward Minos, the infernal judge; in the centre is the cave identified by some as the mouth of hell (others describe it as the entrance to Limbo, e.g., Tolnay, 1943-60, V; etc.). It was inevitable — except for the figures always depicted in the Last Judgement and for very few others — that the identifications put forward at various times should be quite controversial, as shown also by the following list (referring to the diagram reproduced on p. 104). The few almost unanimously accepted identifications are given in italics: *1* - Archangel Gabriel; *2* - the Pharaoh's daughter who found Moses, or Sarah, or Eve; *3* and *4* - Niobe and a daughter, or Eve and a daughter, the personification of maternity, the merciful Church and a believer; *5* - Abel, or Eve; *6* - Abraham, or St. Bernard, or Pope Julius II; *7* - St. John the Baptist, or Adam; *8* - Rachel, or Dante's Beatrice; *9* - Noah, or Enoch, or Paul III; *10* - St. Andrew, or St. John the Baptist, or Dismas; *11* - St. Martha, or St. Anne, or Vittoria Colonna; *12* - *St. Lawrence*; *13* - *the Virgin*; *14* - *Christ the Judge*; *15* - Solomon's wife, or Dante Alighieri; *16* - Francesco Amadori known as Urbino, or Tommaso de' Cavalieri; *17* - *St. Bartholomew* as a portrait of Pietro Aretino; *17A* - *the flayed skin of St. Bartholomew as Michelangelo's self-portrait*; *18* - *St. Paul*; *19* - *St. Peter*; *20* - *St. Mark*, or Pope Clement VII; *21* - St. Longinus; *22* - Simon the Zealot; *23* - St. Philip, or Dismas; *24* - Job, or Adam, or Abraham; *25* - Job's wife, or Eve, Pope Hadrian VI; *26* - St. Blaise; *27* - St. Catherine of Alexandria; *28* - St. Sebastian; *29* - Dismas, or St. Francis of Assisi, St. Andrew, Simon the Cyrenian, the corporal representation of Justice, the symbol of man with his sorrows; *30* - Moses, or Adam; *31, 32* and *33* - one of the blessed (or an angel) pulling up two negroes; *34* - the Archangel Michael holding the book of the elect; *35* - a proud man, or an embezzler; *36* - a proud man, or a man damned for his despair (as opposed to theological Hope); *37* - a devil; *38* - a proud man, or a slothful one; *39* and *40* - Paolo and Francesca; *41* - an avaricious man, or Pope Nicholas III; *42* - a wrathful man, or a proud man; *43* - a lustful man 'dragged down by his genitals'; *44* - Michelangelo; *45* - Michelangelo, or Pope Julius II, Virgil, St. Stephen, Plato (or Wisdom), a charitable monk, an angel, Martin Luther; *46* - Dante; *47* - Savonarola; *48* - *Charon* or Satan, as a portrait of the High Constable of Bourbon; *49* - Cesare Borgia; *50* - *Minos*, as a portrait of Biagio da Cesena; *51* and *52* - Count Ugolino and Archbishop Ruggeri. With reference to the same diagram, it must be pointed out, furthermore, that: regarding the alleged Niobe (3) a resemblance was

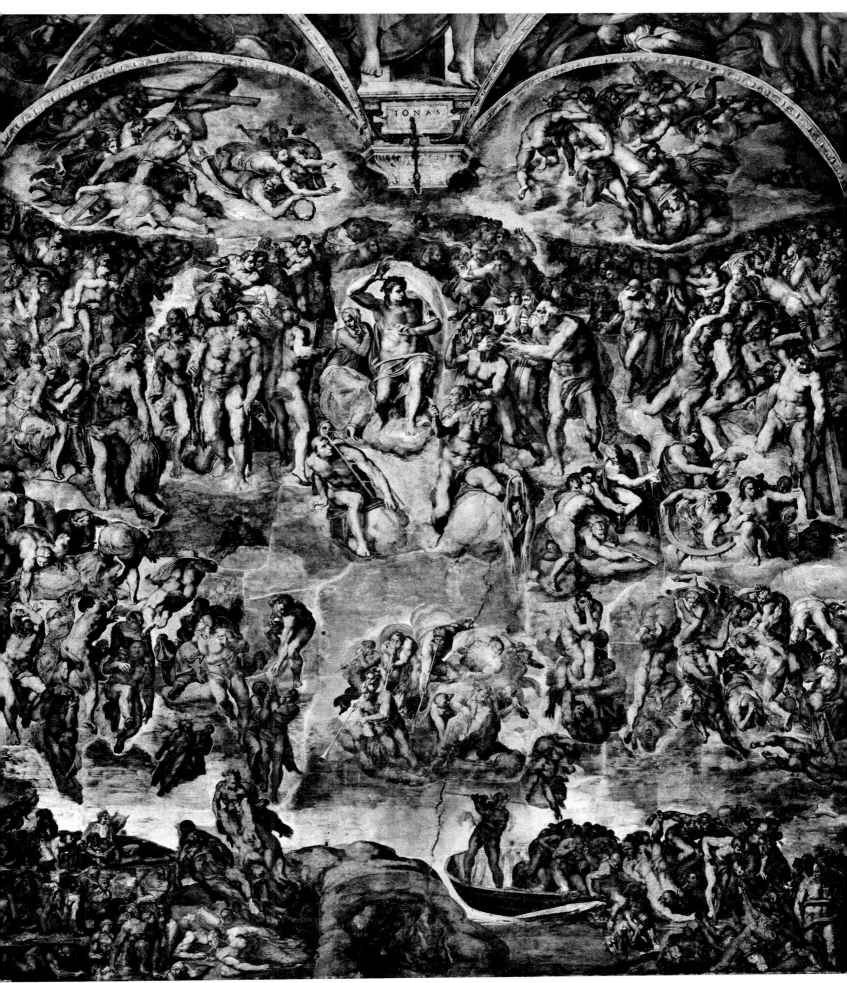

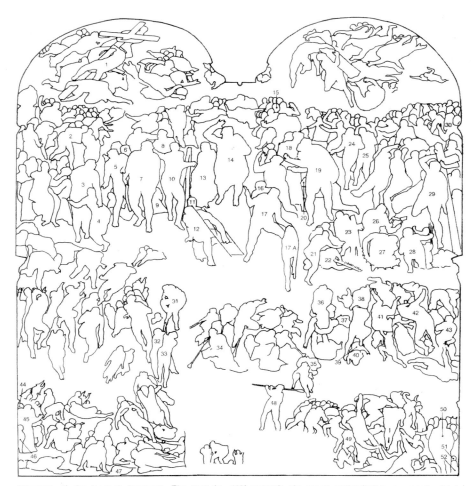

Diagram of the *Last Judgement. The text (p. 102) records the most authoritative or most widely accepted hypotheses on the location of the figures in the fresco, many of which, however, are still unidentified.*

Study for the blessed to the left of Christ (pencil, 179×239 mm.; Bayonne, Musée Bonnat).

claimed to the classical marble sculpture of this subject now in the Uffizi in Florence; the Virgin (*13*) was said to be a portrait of Vittoria Colonna [Bellonci, 1929; etc.], or a synthesis of the traditional representation of the Virgin and the classical portrayal of Aphrodite [Tolnay], and her gesture derived (with an allusive meaning) from that of Eve in the Ceiling fresco representing the *Expulsion from Eden* [Hart, 1950]; the nudity of Christ (*14*) (see below) was the most severely criticized for a long time [until Keppler, 1913], his type said to recall the classical ones of Jupiter the Thunderer [Justi, 1900; etc.] and more particularly of Phoebus [Gregorovius, 1859-79; up to Tolnay; etc.]; the figure required ten *giornate* (working days) of painting, that is to say, more than any of the others, but it bears signs of various 'second thoughts'; some are also noticeable in the skin of St. Bartholomew (*8*), where the identification of Michelangelo's self-portrait is by now unanimously accepted and was related to the Bacchic mysteries which the artist may have cultivated in his youth [Wind, 1958 and 1960]. For the creatures rising to judgement (in the intermediate zone on the left, up to *33*), references were advanced: to the nudes in the cartoon for the *Battle of Càscina* [Steinmann, 1905; etc.], to Signorelli's frescoes in Orvieto Cathedral and to other 15th-century sources, including Bosch; the group representing one of the blessed

pulling up two of the resurrected (*31*, *32* and *33*) by means of a rosary (an anti-Lutheran symbol of prayer, Pastor, 1886-1933) was believed to be — through the debatable interpretation of the two resurrected as negroes [Stendhal, 1817; etc.] — allusive to the missionary activity of Portugal [Souza Costa, 1906]. For the damned soul who shields one of his eyes (*36*), it has been suggested that the serpent biting his side alludes to repentance, and references were made to the Dantesque episode of Vanni Fucci [Kallab, 1903], to a passage by Honorius Augustodunensis [Jessen, 1883] and the *Legenda aurea* [Sauer, 1908]. For the barely visible devil nearby (*37*), an extraordinary anticipation of Goya has been noted [Mariani, 1953]. As for Charon (*48*), despite the almost unanimous acknowledgement of a connection with Dante's poem, various elements have been pointed out that differentiate this figure from that described in the *Divine Comedy*. This is only one of the reasons why it seems justified to admit that, rather than an illustration based on Dante's poem, on the Scriptures, on Fra' Tommaso da Celano's *Dies irae* or on other sources, the artist carried out freely a personal vision, undoubtedly availing himself of his own religious culture and of the writings of his beloved Dante.

Together with fulsome praise, the unveiling of the *Last Judgement* provoked immediate criticism of a moralist nature (see

Study (det.) for the blessed and the reprobate (pencil, 385×253 mm.; London, British Museum).

pp. 12 and 13). The best known are those made by the pope's master of ceremonies, Biagio da Cesena, while the work was still in progress (hence Vasari's anecdote that Biagio was portrayed as Minos [*50*] whom the serpent seems to punish, instead of assisting him as described by Dante), and, later by Pietro Aretino (1545; whose critical comments, incorrectly considered contemporary with the painting, led to the identification of his portrait in the figure of St. Bartholomew [*17*]). The Council of Trent, engaged in refuting the charges of paganism made by the Protestants against Rome, added its weight. In the Sistine Chapel, nude figures, some in daring attitudes, rose above the very altar of the pope. This explains why, on 21 January 1564, the Congregation of the Council provided for the 'covering' of any 'obscene' part of the painting. The task was undertaken by Daniele Ricciarelli da Volterra, known ever since as 'Braghettone' (the breeches-maker); after him, others applied themselves to the 'covering'. From the comparison with copies made before 1564 (particularly that executed in 1549 by Venusti, now in Naples) and from technical observations, it appears that in ten of the figures the draperies were added to, in twenty-five they were simply painted on outright (the draperies on one hundred and ninety-seven figures are original). The technique utilized (tempera) would allow the elimination of such overpaintings, except in the group of the SS. Blaise and Catherine of Alexandria, which was frescoed on a new layer of plaster, after that painted by Michelangelo had been removed, changing the direction of the male saint's head (originally turned forward) and clothing the figure St. Catherine (who in the original version of this work had been painted nude).

Wilson [1876] pointed out some collaboration by assistants, especially in the draperies. This comment may result from a wrong appraisal of the over-

Study (det.) for the resurrected (277×419 mm.; Windsor Castle), variously interpreted.

paintings, as it seems impossible to pick up in the whole wall any brush-work other than Michelangelo's except, of course, that of the coverers. At most, the faithful Urbino, whose presence next to Michelangelo is documented beyond doubt, may have worked on backgrounds and the like. After the destruction of Perugino's frescoes on that same wall and of the figures painted by Michelangelo himself inside the two lunettes, a masonry 'scarp' was built, sloping forward so that it juts out at the top by some 38 cm. On this, the fresco was carried out in almost four hundred and fifty successive stages,

obviously from the top toward the bottom, in horizontal bands marked by the gradual lowering of the scaffolding. Independently of the coverers and of the official 'cleaners,' the painting was tampered with as early as the 16th century, and in 1572-85, as a result of the raising of the floor, the lower band had to be destroyed up to a height of approximately 70 cm. Around 1710, in 1825, in 1903 and in 1935-36, new restorations are recorded. At present, the fresco is crossed by a deep crack down the centre. It also shows numerous abrasions, especially above the altar (caused by the long-standing custom of erecting a *baldacchino* at the point). There are white hatchings of unknown cause but certainly not intended by the author, and drip stains from the varnish used in the 18th-century restoration of the ceiling.

Notwithstanding the many complimentary and uncomplimentary observations that tended to confuse the aesthetic value of the *Last Judgement* with the quantity of cosmic terror or edifying mortification that it inspires in the onlooker, modern criticism has assimilated, in its attempts to fathom the stylistic substance of the fresco, two opinions which in fact sounded like a condemnation of the painting: Malvasia's denial (p. 13) that the painting is governed by an academically correct perspective framework, and Lalande's (*ibid.*) denial that the groups of figures are in any way firmly linked together. In fact, perusal of the extant preliminary drawings (Florence, Casa Buonarroti; Bayonne, Musée Bonnat; London, British Museum; Windsor Castle; etc.) proves that the artist progressively surmounted all obstacles to this free articulation of the structural arrangement; and there emerges, among other things, that the decision to destroy not only Perugino's old frescoes but also the two lunette decorations within the general scheme of the ceiling frescoes was the consequence of painful changes in the solidity, translating it into the abstract infinity of a boundless sky. He took great pains to achieve this result by means of the very sharp contrasts between the emptiness of the setting — the sky — and the close swarming of the masses that stand out against it. The figures are increasingly darker towards the bottom, while the background tends to lighten into a livid, silvery colour. Having thus eliminated the 'presence' of the wall, Buonarroti arranged the figures on various planes without, however, abiding by the norms of canonical perspective. The figures become smaller from the top downwards, not so much to make up for the 'vanishing' effect (which would have caused the figures in the upper part to appear much smaller, had a single size been adopted), as to upset the immobility of the reciprocal balances, emphasizing the single attitudes of motion. The crowding of the figures into isolated groups compounded this effect: they are utterly autonomous, apart from their general participation in the total rhythmic harmony of the composition.

74 1530

LEDA.

During the siege of Florence (1530), the subject of the 'intercourse of the Swan with Leda,' in which the egg and Castor and Pollux also appeared, was depicted in tempera [Vasari]. The work was intended for Alfonso d'Este, Duke of Ferrara, but it never reached him, because of his envoy's tactless behaviour towards Michelangelo. The latter gave it instead to Antonio Mini (1531), who took it to France and left it there (1532) on deposit with King François I. This sovereign may have purchased it later for the castle

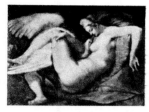

Rosso Fiorentino (attributed, copy of 74), (London, National Gallery).

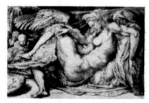

Nicolaus Beatrizet (attr.; 'Michael Angelus inv.'), engraved copy of 74.

of Fontainebleau. Subsequently it seems that a minister of Louis XIII of France had it burned for moralistic reasons, although, according to Milizia, it reappeared, 'badly damaged,' in 1740. Now it is known only through a copy, reproduced here (perhaps by Rosso Fiorentino), now in the London National Gallery (canvas, 105 × 135 cm.), and through others at Dresden, Berlin and Venice (Correr Museum), in addition to various engravings, of which the one reproduced here is by N. Beatrizet (271 × 401 mm.); the latter is even better suited than the London painting, which is considered more accurate, to suggest the original (including Castor and Pollux).

75 1531

NOLI ME TANGERE.

In April 1531 Alfonso d'Avalos, Marquis del Vasto, obtained the cartoon from Michelangelo, then (February 1532) gave it to be executed as a painting to Pontormo, who later made a second version of it. Contrary to early belief [Vasari, 1568; etc.] Michelangelo's original did not end up in France, but remained in Florence in the 'wardrobe' of Cosimo I. All trace of it has been lost. The first painting by Pontormo was identified [Lavagnino, 1925; Briganti, 1945; Arcangeli and G. Morandi, 1956; etc.] with the one reproduced here, belonging to a private collection in Milan (panel, 124 × 25 cm.); while of

Pontormo, Noli me tangere (Milan, private collection), a panel painting.

the two other versions in the Casa Buonarroti at Florence, the better is now attributed to Bronzino [Longhi, 1952; etc.], the other to Clovio or to Venusti; it is known that one copy was also executed by B. Franco.

76 *1532-34*

VENUS AND CUPID.

The Anonimo Magliabechiano [1537-42] mentioned the cartoon for this painting, drawn by Michelangelo (ca. 1532-34) and executed by Pontormo for Bartolomeo Bettini. Michelangelo's original was identified [Thode, 1908-13; etc.] with a cartoon now in Naples, later marked down as a copy [Tolnay, 1943-60, III; etc.]; a preliminary draw-

Pontormo (attributed), Venus and Cupid (Florence, Accademia).

Probable study for the Venus and Cupid cartoon (London, British Museum).

ing is in the British Museum, London (ink, 58 × 121 mm.), and is reproduced here. It is recorded that the painting belonged to Duke Alessandro de' Medici; in 1850 it was recognized in the one reproduced here (Florence, Accademia; panel, 128 × 197 cm.), which is ascribed by some [Berenson, 1896; etc.] to Pontormo, but more generally considered a copy. It seems that Vasari also painted at least two copies after Michelangelo's cartoon; and other imitations survive at Hampton Court, Naples, Rome (Palazzo Colonna) and Hildesheim.

The Frescoes of the Pauline Chapel

The beginning of the pictorial decoration in this other Vatican chapel, consecrated in 1540 by Pope Paul III, dates to October or November of 1542. Around the middle of 1544 the work was suspended because of the artist's serious illness; on 12 July 1545, the first of the two paintings, *The Conversion of St. Paul*, was probably finished. On 10 August of the same year the wall surface had already been prepared for the other, *The Crucifixion of St. Peter*, on which, when a fire broke out in the Chapel, work was probably already in progress. In January 1546, Michelangelo fell ill again and the painting was unfinished in November 1549, when Paul III died. The work may have been completed in March 1550. Frey [1920] expressed the view that the religious subjects merely constituted a pretext for the manifestation of the universal 'power of abstract primordial forces' over human fate. Later scholars, following Dvorák [1928], insisted on the use of 'historical' episodes for the representation of autobiographical facts and 'symbols of faith' [Einem, 1959; Tolnay, 1943-60, V]. Thus, as the reflection of the period of Michelangelo's 'conversion' the Pauline frescoes should eventually be regarded as 'two essential moments of religious life or of human asceticism, conversion and martyrdom' [Argan, 1963]. Until recently (see also Steinmann, 1925-26) it was believed that

the 1545 fire had practically destroyed the 'Michelangelesque' qualities of this cycle, and that what survived was mostly the result of 'coarse' reworking. The 1934 restoration revealed that the spurious parts were limited to a few 'moralising' draperies on the nude angels and to some slight overpainting in tempera, especially in the landscapes.

Recent criticism has tended to see the Pauline frescoes not as the result of involution or decadence, but rather 'another' expression of Michelangelo, consequent upon that achieved in the *Last Judgement*. Moreover, they are at the same time a development of the compositional schemes used in the large Sistine wall, and a renewal or, rather, a reconsideration of the ideas expressed in the *Doni Tondo*. The figural masses of the Pauline frescoes seem free of the surface enclosed within the frames and are so articulated as to produce a thoroughly different spatial organization. At the same time, and more particularly in the *Crucifixion of St. Peter*, there is a perspective succession based on multiple vanishing points, so that the viewer is inserted into the scene, as if he were standing on the very ground where the principal episode in the foreground is taking place. But, with regard to the groups in the back (in the case of the *Crucifixion*, this applies also to the group of mourners in the very fore-

ground, 'outside' the painting, so to speak), the viewer finds himself utterly extraneous. Such participation and non-participation, both equally exacting for the viewer and laden with a dramatic urgency that is lacking in the *Doni Tondo*, constitute the unprecedented achievement of Michelangelo's last painting. It also involves our faculties by means of other highly mediated and violent dissonances, such as the recourse to a plasticism endowed with 15th-century compactness, but resolved with very tender colours that cause it to flake into an impalpable, dazzling structure, or the conferring of a monumental grandeur on characters discernibly stamped with an almost expressionistic ordinariness. Thus is concluded, with a perfect consciousness of the time, a quest for balance projected beyond supreme classical firmness, towards a different conception of art, more dynamic and more deeply felt: more 'our own.'

77 625 × 661 1542-45*

THE CONVERSION OF ST. PAUL.

The painting represents the episode related in the *Acts of the Apostles* (9:3 ff.), and develops the iconographic treatment (which had become established as early as the 13th-century) with Saul — the future St. Paul — knocked to the ground and near him his horse, shown leaping away in fright at the apparition of Christ, while the soldiers disband, terrified by lightning and the voice of God. The city of Damascus is depicted on the right. It is almost unanimously agreed that the unsaddled figure of Saul is Michelangelo's self-portrait. The

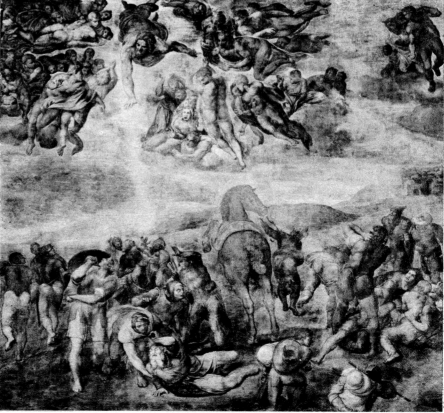

77 [PLS. LIV-LVII]

105

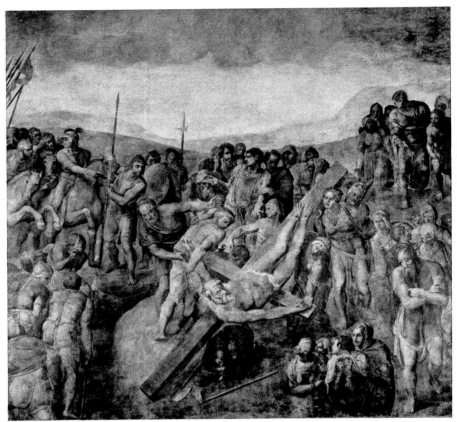

78 [PLS. LVIII-LXIV]

pose has been related to the classical type of the river gods [Tolnay] and, more particularly, to the figure of Heliodorus in the Vatican fresco by Raphael [Einem]. This latter figure derived from a conception of Michelangelo, related, in turn, to antique river god types [Panofsky, 1939]. St. Paul's head has been compared to Hellenistic examples of tormented figures, as in the *Laocoön* [Mariani, 1932], while the horse has been linked to the classical group of the Dioscuri at Montecavallo.

Detail of the cartoon for 78 (Naples, Capodimonte), consisting of nineteen sheets applied on canvas (pencil and watercolour, 263×156 cm.); the whole is seriously damaged and partly restored by later hands. The doubts of its authenticity expressed by Bernard Berenson, who attributed this work to Daniele da Volterra, are by now outdated.

The figures of the soldiers have been compared to those in the reliefs on Trajan's Column and on antique sarcophagi. The retouchings noted during the 1934 restoration involved the head of the horse, which was freed of overpaintings in 1953. As in the Ceiling and the *Last Judgement*, for the transfer of the cartoons onto the plaster the artist had recourse to both perforation and engraving with a stylus, but some parts may have been 'improvised'.

78 ⊞ ⊕ 625×662 *1545-50 目 ⦂

CRUCIFIXION OF ST. PETER.

This episode, which is not mentioned in the *Acts of the Apostles*, is partly connected with a passage in Iacopo da Varagine's *Legenda aurea* and with the long-standing tradition — elaborated iconographically since the 4th century in the mosaics of the Vatican basilica — according to which St. Peter, sentenced to be crucified like Christ, asked to be nailed to the cross upside down, as a

gesture of humility. The saint's execution took place in Rome, alluded to in the painting by the pyramid of Caius Cestius and by the *Meta Romuli*. Horsemen and foot soldiers mix with the followers of the martyr, among whom the foregroup of the sorrowing devout was particularly admired. If compared with previous representations — including the Tuscan ones of the 15th century — Michelangelo's scheme displays the innovation of the cross placed diagonally and of the scene set on a bare hill [Tolnay]. In the general layout, similarities have been noted to the battle reliefs on Trajan's Column and on antique sarcophagi [Mariani], as well as with the *Battle of Centaurs*, sculptured by Michelangelo in his youth, while some figures have been related to the cartoon for the *Battle of Càscina*. According to von Einem, though disputed by Tolnay, the structure of the fresco might have been influenced by the Hellenistic group of the *Farnese Bull*, unearthed in Rome in the year 1545.

79 ⊞ ⊕ *55×40 1545* 目 °₀°

CRUCIFIXION.

An exchange of letters between the artist and Vittoria Colonna records that it was executed for the latter around 1545. It must have been a small painting, which Bottari [1759-60] mentioned as being in the 'Galleria Medicea' (though he may have referred to a copy by Alessandro Allori). The painting is lost; there are copies of it in the Uffizi, Florence, in Rome (Doria and Borghese Galleries) and Naples, in addition to various preliminary drawings, of

which the most important — belonging to the British Museum, London (pencil, 370×270 mm.) — is reproduced here, although it is not unanimously deemed to be authentic. Of the painted copies, the one we reproduce is the Doria panel (55 ×40 cm.), perhaps by Venusti, where it is possible to see, in addition to the two angels of the London drawings, the Virgin and St. John, likewise present in the engraving by Philipp Soye (535×365 mm.; also reproduced here), where Christ's head is bent forward. Since the same variant appears in other engravings (by Gerard de Jode,

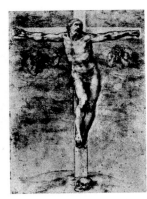

Crucifixion (pencil, 370×270 mm.; London, British Museum); probably the drawing made for Vittoria Colonna in connection with 79, though various critics believe it to be a copy.

Study for the Madonna of 79 (pencil, 230×100 mm.; Paris, Louvre); on the back of the same sheet is a sketch of this figure, for which a man seems to have posed. The authenticity of the present study, accepted by various scholars (Berenson, Thode, Wilde, Goldscheider, Berti), was challenged by Tolnay, who believes it to be a copy (perhaps by Clovio) of a lost drawing by Michelangelo.

Philipp Soye ('Michelangelus Bonarotus inventor // Philippus Scyticus fecit'), burin copy of 79; the plate was incorrectly attributed to Antonio Lafrery, who first printed it in Rome.

Study for the sorrowing St. John of 79 (pencil and chalk on grey paper, 250×83 mm.; Paris, Louvre); considered authentic by various scholars (Berenson, Thode, Wilde, Goldscheider, Berti); Tolnay thinks it might be a copy of a lost drawing by Michelangelo, because of the quality and because of the grey paper, unusual for Michelangelo.

Marcello Venusti (attr.), copy of 79 (Rome, Galleria Doria), obviously connected with the British Museum drawing, while Soye's engraving displays variants in the figure of Christ.

etc.), the unlikely hypothesis of a different prototype was formulated. At the 21st International Congress of Art History (Bonn, 1964), Redig de Campos produced another Crucifixion painted on a panel, and suggested that it might be identified as the original, but Tolnay [1965] maintained its style was unlike Michelangelo's and ascribed it instead to Sofonisba Anguissola. Tolnay considered this panel to be an oil rendition by this artist of one of Michelangelo's drawings of the Crucifixion.

106

Indexes

Index of Subjects

Index of Titles

Index of Locations

Appendix *Michelangelo sculptor and architect*

The following works of Michelangelo are here reproduced to supplement the paintings, the motifs of which are frequently related to motifs used in his sculpture and architecture.

Battle of the Centaurs *or* The Rape of Hippodamia *(marble, 90.5×90.5 cm.; Florence, Casa Buonarroti); carved during his stay in Palazzo Medici, around 1492.*

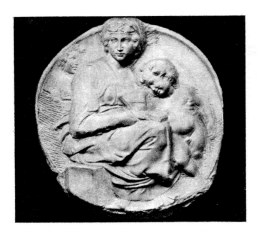

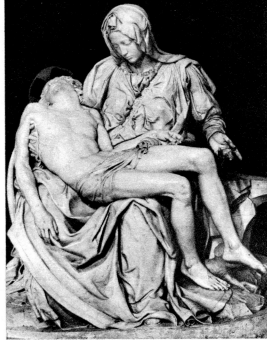

Pietà *(marble, height 174 cm., width of the base 195 cm.; Rome, St. Peter's in the Vatican); commissioned by the French cardinal Jean Bilhères de Lagrulas in 1497 and completed in 1499. It is the only signed work by Michelangelo; the band which crosses the Virgin's breast bears the inscription: MI-CHAEL - ANGELVS - BONAROTVS - FLORENT[INUS] - FA-CIEBAT. Attention has been drawn to its connections with Emilian art and to derivations from northern iconography.*

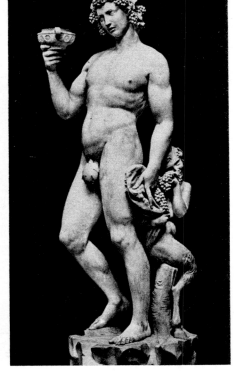

The Drunken Bacchus *(marble, height 203 cm.; Florence, Bargello); executed in Rome in 1496-97 for Iacopo Galli; in Florence since 1572.*

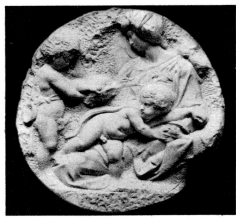

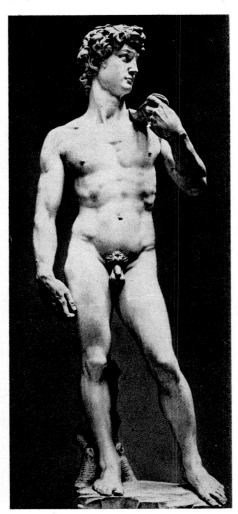

(Above) Pitti Madonna *(marble, 85.8×82 cm.; Bargello), 1504-05 (?). - (Below)* Taddei Madonna *(marble, diameter 109 cm.; Royal Academy) 1505-06 ca.*

(Right) Madonna of the Stairs *(marble relief, 55.5×40 cm.; Florence, Casa Buonarroti); executed between 1490 and 1492, while Michelangelo was staying with Lorenzo the Magnificent; therefore, the earliest of his extant sculptures. The work is informed with Donatello's energy, in addition to the influence of the Pisanos, Giotto and Masaccio.*

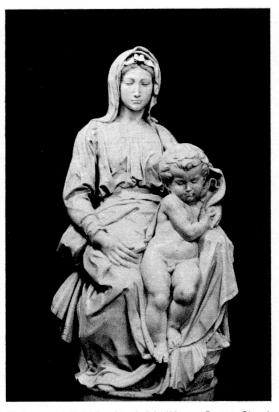

Madonna and Child *(marble, height 128 cm.; Bruges, Church of Notre-Dame); perhaps executed in 1501, sold by the artist in 1506 and later transferred to Bruges.*

David *(marble, height 434 cm.; Florence, Accademia), executed in 1501-04 for the Piazza della Signoria, where it was replaced with a copy in 1873.*

St. Matthew *(marble, height 261 cm.; Florence, Accademia), the only figure roughed out (ca. 1504) of the Apostles planned for the Cathedral.*

Lorenzo de' Medici *(marble, height 178 cm.; Florence, Church of S. Lorenzo; 1524-31 ca.). Below and to the right are the other figures.*

109

Dying Captive (or Slave) *(marble, height 229 cm.; Paris, Louvre); sculptured in 1513 for the second version of the tomb of Julius II.*

Giuliano de' Medici *(marble, height 173 cm.; Florence, S. Lorenzo); executed between 1526 and 1533 with collaboration from Montorsoli.*

Heroic Captive (or Slave) *(marble, height 215 cm.; Paris, Louvre); it was being carved in 1513 for the Tomb of Julius II; unfinished.*

(Left) Madonna and Child *(marble, height 226 cm.; 1521-31; Florence, S. Lorenzo). – (Right, top to bottom) The allegorical marble groups at either sides of Lorenzo and Giuliano respectively: Dusk (length 195 cm.) and Dawn (203 cm.), carved between 1524 and 1531 ca.; Night (194 cm.) and Day (185 cm.), carved between 1526 and 1533.*

(From the left) The Resurrected Christ (marble, height 205 cm.; Rome, Church of S. Maria sopra Minerva; 1519-21); Michelangelo was dissatisfied with it because of the faulty work of an assistant, Pietro Urbano, despite his own and Federico Frizzi's subsequent efforts to repair the damage. - Victory (marble, height 261 cm.; Florence, Palazzo della Signoria); not unanimously dated to 1532-34 (some date it to 1506), and sometimes believed — though incorrectly — to be a work in which others collaborated (the head was thought to be by Vincenzo Danti). The figure of the defeated barbarian is only rough-hewn.

Hercules and Antaeus (clay, height 41 cm.; Florence, Casa Buonarroti); roughed out, perhaps in 1508, for the work for Piazza della Signoria.

Brutus (marble, height 95 cm.; Florence, Bargello); believed to be an ideal portrait of the tyrannicide Lorenzino de' Medici; carved after 1539.

Captives or Slaves (Florence, Accademia), marbles begun for the tomb of Julius II; variously referred to the years from 1519 to 1536; for the most part unfinished. (Left to right) Bearded Captive (height 248 cm.), Young Captive (235 cm.), Awakening Captive (267 cm.), The Captive called Atlas (208 cm.).

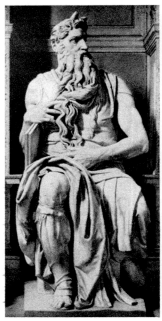

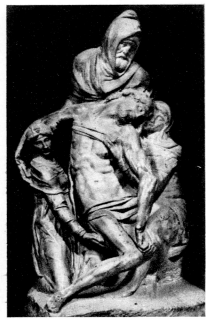

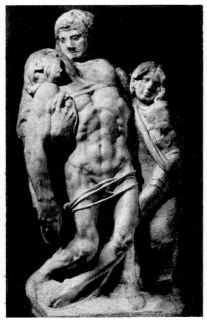

(Left to right) Moses (marble, height 235 cm.; Rome, Church of S. Pietro in Vincoli); begun in 1515 for the tomb of Julius II. - Pietà (marble, 226 cm.; Florence, Cathedral; ca. 1550); Christ's left arm and leg were broken by Michelangelo himself - Palestrina Pietà (marble, 253 cm.; Florence, Accademia); controversial attribution and dating. - Rondanini Pietà (marble, 195 cm.; Milan, Castello); it remained unfinished at the author's death.

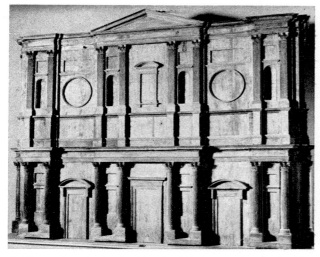

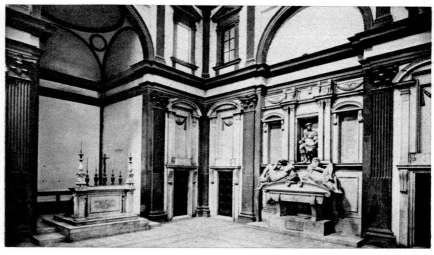

Architectural works for the Church of S. Lorenzo in Florence: (above, left to right) Wooden model for the façade (Casa Buonarroti), not unanimously believed to be by his hand and made in 1517; partial view of the New Sacristy, with the tomb of Giuliano de' Medici (1520-34) put in position by Vasari (ca. 1556). (Below, left to right) Reading hall, and staircase of the vestibule of the Laurenziana Library (1523-71); the tribune on the inner façade of the church (1525-32 ca.).

Church of S. Maria degli Angeli in Rome (perspective of the vaults), the transformation (1561-66) of the ruins of Diocletian's Baths.

Façade of the Palazzo Farnese in Rome, for which Michelangelo finished the third story and the cornice (1546-49).

Model for St. Peter's dome (Vatican, Museo Petriano).

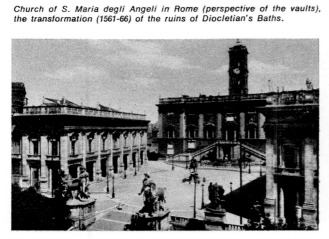

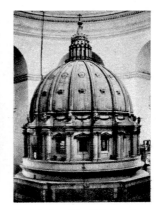

Piazza del Campidoglio, Rome, laid out from 1538 ca., after Michelangelo's designs, later altered; in the original project the groups of the Dioscuri faced each other and were perpendicular to the ramp.

Stairs of the Belvedere courtyard in the Vatican, designed by Michelangelo and later altered; the original balustrade was replaced and the fountain added.

Façade of the Porta Pia in Rome, executed under Michelangelo's guidance, 1561 to 1565 (?).